S0-AVK-385

WRITERS OF THE
AMERICAN SOUTH

Other books by Hugh Howard

Colonial Houses
Natchez (with Roger Straus III)
Thomas Jefferson, Architect (with Roger Straus III)
House-Dreams
Wright for Wright (with Roger Straus III)
The Preservationist's Progress
How Old Is This House?

Other books by Roger Straus III

Natchez (with Hugh Howard)
Thomas Jefferson, Architect (with Hugh Howard)
Wright for Wright (with Hugh Howard)
Modernism Reborn: Mid-Century American Houses (with Michael Webb)
U. S. 1: America's Original Main Street (with Andrew H. Malcolm)
Mississippi Currents (with Andrew H. Malcolm)

WRITERS OF THE AMERICAN SOUTH

Their Literary Landscapes

TEXT BY HUGH HOWARD

PHOTOGRAPHS BY ROGER STRAUS III

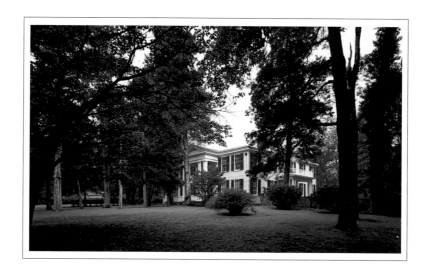

RIZZOLI
NEW YORK

First published in the United States of America in 2005
by UNIVERSE PUBLISHING
A Division of Rizzoli International Publications, Inc.
300 Park Avenue South
New York, NY 10010
www.rizzoliusa.com

© Text copyright 2005 by Hugh Howard
© Photographs copyright 2005 by Roger Straus III

2005 2006 2007 2008 2009 / 10 9 8 7 6 5 4 3 2 1

Designed by Doris Straus

Printed in China

ISBN: 0-8478-2767-4

Library of Congress Catalog Control Number: 2005901953

This book is
dedicated to the Southern writers,
who have brought transcendence
to their sense of place.

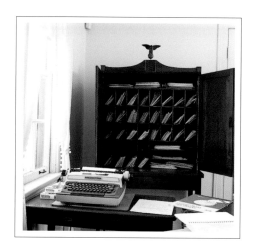

Title page photograph:
William Faulkner's Rowan Oak in Oxford, Mississippi.

Dedication page photograph:
This is Eudora Welty's workplace. The antique organizer beyond her desk is full of letters. It had a place in Miss Welty's fiction, specifically in The Optimist's Daughter. Her description in the novel fits exactly: "The cabinet looked like a little wall out of a country post office which nobody had in years disturbed by calling for their mail."

Contents

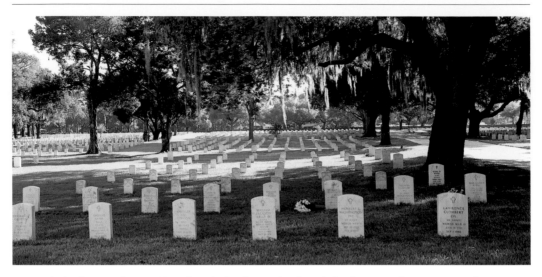

At the close of fighting on Day One, the South seemed to have the battle won; within twenty-four hours, however, a complete reversal had occurred, making Shiloh a fulcrum in the Civil War.

Right: A fine Virginia house built in the Jeffersonian Classical style by a man who trained at Mr. Jefferson's elbow; today, Jan Karon calls it home.

Introduction

Southern writers possess a powerful sense of place. In novels, stories, and poems they convey a rich sense of the setting, climate, natives, and other elements that connect them to their home soil. If the obvious example is Faulkner and his Yoknapatawpha County, then the list must also include Eudora Welty and the Delta, Pat Conroy and the Low Country, and Peter Taylor and Tennessee. Consider Marjorie Kinnan Rawlings and Cracker Florida; and James Lee Burke and River Road Louisiana. What of Thomas Wolfe and Asheville; and Flannery O'Conner's Milledgeville? The list goes on.

This book presumes to visit the personal places where some Southern writers live or lived their literary lives. In images and words, we have sought to illuminate the interconnectedness between life and the fictional *mise-en-scène* readers encounter in the work of each of the writers included. By looking at the facts of their lives and examining the history and character of their places, we aim to offer an approach to their writings.

We began work on this book armed with a modest observation — that many Southern writers leave their readers believing that a given story could have unfolded nowhere else. We wondered whether, in visiting the places these writers chose to live, by seeing their villages and cities, by walking the fields, forests, hills, valleys, and seascapes around them, we might gain some fresh insights into the nature of their writings as well as their lives. The chapters that follow attempt to put on the printed page what we saw and learned.

AN INEVITABLE QUESTION ARISES: *Why these particular writers?*

Perhaps the process by which we came to include these authors offers the best answer. As voracious readers, we assembled an initial list containing several dozen names. Some appeared spontaneously, since Peter Taylor, William Faulkner, Pat Conroy,

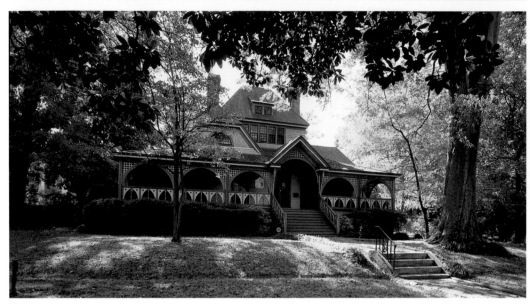

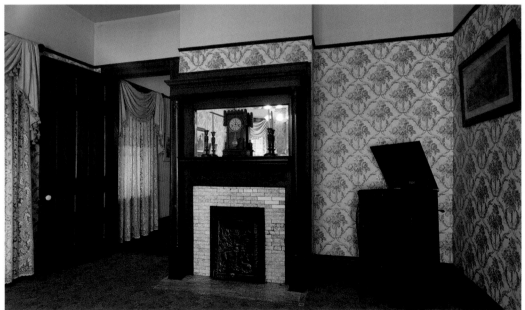

⋙ ⋘

INTRODUCTION

and Eudora Welty seemed to have volunteered. Other essential inclusions such as Flannery O'Connor, Shelby Foote, and Thomas Wolfe joined the team. A list of some seventy candidates emerged following perhaps a hundred conversations with editors, writers, and readers of our acquaintance, and many hours spent in libraries, bookstores, and pursuing other avenues of research, including web searches.

Limitations of space, time, and money meant the list had to be precipitated down. A simple, logistical question — *Is there a site to visit?* — eliminated more than half the writers on the list. For a visual book, we needed photo opportunities, so each writer selected had to be associated with a specific place, preferably a home, that could be recorded in images for reproduction in this volume. We reasoned that each home had to be in the South and its appearance today would have to bear a recognizable resemblance to its look during the writer's tenancy. The writers with whom we could associate no one satisfactory destination included Tennessee Williams, Robert Penn Warren, James Dickey, Truman Capote, James Agee, and many others who chose to migrate north or west, often finding places at universities. African-American writers in particular seem to have sought refuge elsewhere, among them Alice Walker, Richard Wright, and James Alan McPherson.

With our reduced list, we began writing to likely candidates and, while most of those we contacted were willing to participate, some politely declined. Our letters found a few others in transition, with Richard Ford moving to Maine, Anne Rice selling

Left top: Joel Chandler Harris (1848-1908) resided at "Wren's Nest" in Atlanta. Beginning in 1880 with Uncle Remus: His Songs and His Sayings, *he published seven collections of African-American folktales. A newspaperman rather than a trained ethnologist, he gained fame in his lifetime, though later readers would condemn his tales as racial clichés and a white man's rip-off of African-American culture. A more temperate view has subsequently emerged that without Harris's careful reconstruction and recording of the tales, many — if not most — would have been lost.*

Left bottom: The folklore of Brer Rabbit, Uncle Remus, Brer Fox, African Jack, and the Tar Baby were among the characters that Harris recorded. His work influenced such Southern writers of dialect as Flannery O'Connor, William Faulkner, and Mark Twain, as well as providing a controversial link in the folklore chain that also includes Zora Neale Hurston, Toni Morrison, and Alice Walker. Pictured is the west parlor of his home on Ralph David Abernathy Boulevard.

her longtime home in New Orleans, and Edward P. Jones reporting his life was in boxes as he prepared to relocate. Security concerns, a recent death in the family, and illness prevented others from participating. The famously private Nelle Harper Lee chose to remain so, meaning we would make no trip to Monroeville, Alabama. Reynolds Price expressed his reservations clearly, remarking, "My home is an extension of my body, my naked body at that — ergo my steady refusal to reveal it to the world." Less than a handful of the writers elected to leave letters of inquiry unacknowledged.

By various means, then, we found ourselves with the happy task of journeying to the diverse roster of writers who appear in this book.

A COROLLARY QUESTION OFFERS ITSELF: *What constitutes a "Southern writer"?*
No one paradigm fits all, though having written about the South (at least some of the time) ranks as an essential qualification. Birth in the South is preferred, and many of the writers included here are born-and-bred, south-of-the-Mason-Dixon-line Southerners. Long-term residence can also be a qualifier.

The case for Faulkner is self-evident. Born in Mississippi, he never left the environs of Lafayette County for more than a few months at a time and set virtually all of his writings within its boundaries. In contrast, the arguments for Marjorie Kinnan Rawlings and Christopher Tilghman are more distant. Neither can claim Southern birth or childhood, as Rawlings grew up in Washington, D.C., and Tilghman in Massachusetts. But both found their voices only when they determined to write about Southern settings (Cracker Florida and the Eastern Shore of the Chesapeake, respectively). Today, their Southern neighbors happily recognize the nativist correctness of their writings, despite their transplant status.

Most of the Southern writers in this book fall somewhere in the broad, gray swath between Faulkner and newer arrivals, among them Conroy, the child of a Southern mother and a Yankee father, a military brat who moved constantly as a child only to find his place upon arriving in South Carolina. Hemingway (and Key West) makes for a more ambiguous case, since not only did he grow up in Oak Park, Illinois, but there are people who refuse to accept Florida itself as a Southern state.

More important, the Southern writers profiled here share an uncommon capacity to understand and to bring to life the culture, geography, and history of the South. Often that means they found themselves straddling the divide between their

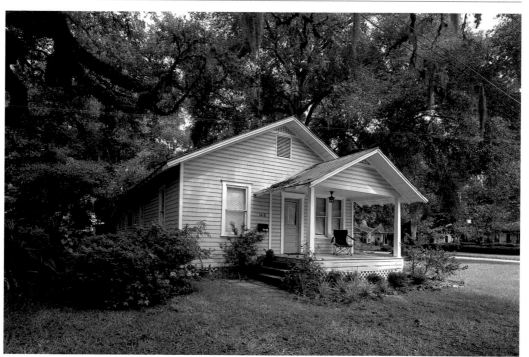

Jack Kerouac . . . a Southern writer? No, not really, although for several years as the 1950s became the 1960s, he lived off and on in this Orlando, Florida, bungalow with his mother. On the Road had become a cultural phenomenon by then, and this nondescript house offered him anonymity and a place to live — and drink — quietly.

own complicated times and the Civil War era in a way that writers from other regions don't feel obliged to do. Again, Faulkner is the prototype: "He was consumed by the Civil War," observed Barry Hannah, Faulkner's cross-town successor as novelist-in-residence in Oxford, Mississippi. But even before moving there, Hannah himself wrote J.E.B. Stuart into a story. Ask a Southern writer twenty questions and, in no particular order, you're likely to discover a periodic preoccupation with the Civil War; the shadow of slavery; a utopian affection for an agrarian society; and a fondness for hierarchy.

While a defining issue for most Americans continues to be race, for the Southern writer the reinvention of the known world after 1861 has never truly reached resolution. Many of these writers share a preoccupation with race. Kate Chopin was one who, in O. Henry fashion, portrayed the self-destructive nature of racial hatred in "Désirée's Baby" (1893). Faulkner's first foray into race, *Light in August* (1932), introduced Joe Christmas, an orphan of uncertain race. For all the brilliance of Allan Gurganus's Widow Marsden (*Oldest Living Confederate Widow Tells All*, 1989), it is the house slave Castalia who, for many readers, walked off the page and into their memories. Flannery O'Connor's work is filled with unabashed references to "niggers," a people she never presumed to understand though she often cast her African-American characters as important agents of change. To the Yankee reader, the surprise is the way slavery comes up. Typically, it isn't some awful family secret for which a collective guilt is inherited. It's more complicated than that. As Gurganus's Widow expressed it, "Can you love an owned one? Can you own a loved one?" Of course, slavery was about ownership; paradoxically, it was often about love, too.

In writing this book, I found a delicate but unmistakable matrix gradually revealed itself. These writers hear the same voices: When asked who influenced them, almost every living writer in this book uttered three names, usually in this order: William Faulkner, Flannery O'Connor, and Eudora Welty (the last, more often than not, identified respectfully as "Miss Welty"). Often Peter Taylor and Thomas Wolfe completed the top five.

Southern writers share dreamscapes. For representatives of three generations — Faulkner, Shelby Foote, and Ann Patchett — it's the battlefield at Shiloh. They see the same ghosts. That personification of Southern gentility, Robert E. Lee, turns up in the works of many of these writers, even as an unlikely spiritual presence in the detective novels of James Lee Burke. The story of Nathan Bedford Forrest, one of only two

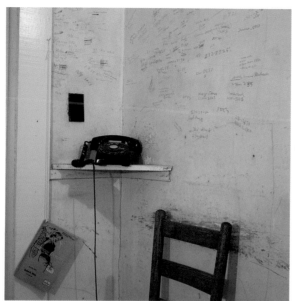

At odd moments, visiting these houses offers eerie glimpses of past lives. Here at Rowan Oak, Faulkner's house, the only phone was in the pantry. Faulkner, his wife Estelle, and other members of the family did what came naturally and scrawled important phone numbers where they would be useful, on the wall nearby.

In his workroom in Key West Ernest Hemingway surrounded himself with trophies from his travels.

"authentic geniuses" in the Civil War according to Shelby Foote, was told to Margaret Mitchell by her grandfather, who had fought under his command.

They shaped one another's dreams. Peter Taylor was the man who advised John Casey, "Don't be a lawyer. Be a writer." Ann Patchett regards her old teacher Allan Gurganus with near reverence. Some of the writers trod the same halls. Christopher Tilghman today is a colleague of Casey's at the University of Virginia, where Peter Taylor formerly taught. Hannah succeeded Faulkner in the town Ole Miss dominates.

The matrix reaches beyond the bounds of the American South. The two Nobelists in this book once became accidental collaborators. When Hemingway, despite the fact he needed money, refused Howard Hawks's invitation to work in Hollywood, the director had another idea. "I'll take your worst book and make a good movie," he promised, "and you'll make money out of it." William Faulkner would be the author of the final script, though the film *To Have and Have Not* had lost its air of Faulknerian tragedy, its scriptwriter and director having turned it into a happily-ever-after love story.

Uncountable coincidences link these writers. The novels of Hemingway and Carl Hiaasen share a passionate concern for the Florida Keys. Both Hiaasen and Eudora Welty relied upon red Royal portable typewriters early in their writing days. Thomas Wolfe's much-loved older brother and Kate Chopin both contracted illnesses at the 1904 Chicago World's Fair and died. Florida bound together Marjorie Kinnan Rawlings and Zora Neale Hurston; Thomas Wolfe shared the same editor with Rawlings and Hemingway, Scribner's legendary Maxwell Perkins. (Upon first meeting Hemingway, Rawlings wrote to Maxwell Perkins, "He is so vast, so virile, he does not need to go around punching people.")

The gossamer of connections involves language, too, including the dialect of the Delta, the fractured English of the slaves, and the class-conscious diction of Peter Taylor's competing Tennessee aristocrats. We encounter Cajun and Cracker accents. The vowels typically elongate, the consonants regularly consolidate, as musical tongues intermingle with the cacophony of the truncated talk of illiterates.

Various bodies of literary theory might be applied here, too, with variant perspectives moving through time from folklorists and Fugitive-Agrarian modernists to African-American and feminist critics. Finally, though, I would argue that the connecting of the dots, the definitive summary of the Southern writer, was done best by per-

INTRODUCTION

haps the sharpest self-critic among these writers, Mary Flannery O'Connor. She identified what they all have in common, namely, "a shared past, a sense of alikeness, and the possibility of reading a small history in a universal light."

THIS BOOK AMOUNTS TO A summary account of a journey (to be accurate, a series of journeys) in which my collaborator Roger Straus and I covered some ten thousand miles on tours that criss-crossed ten Southern states. We enjoyed crawfish in Louisiana, barbeque in Memphis, and crab cakes in Beaufort. With Hurricane Ivan in hot pursuit, we found ourselves heading for the Federal lines. We saw seascapes from deep in the Bayou, from the Tidewater, and along the Eastern Shore; we visited the Great Smoky Mountains in North Carolina and the Blue Ridge in Virginia; we walked city streets in Atlanta, Charleston, and Jackson, Mississippi. We recorded on our tour twenty-one sites, spending days talking to and photographing twelve working writers and visiting the domiciles of nine deceased writers that have become museums.

The sense we had upon beginning this venture was of holding an unopened package. And as it unfolded, what made the experience astonishing were the imaginary places we glimpsed. You cannot go to Oxford, Mississippi, and Faulkner's Rowan Oak without sensing you have just landed in Yoknapatawpha County. At James Lee Burke's suggestion, we stayed at the Teche Motel in New Iberia, as one of his recurring characters, Clete Purcel, often does. When Pat Conroy gave us a tour of Beaufort, he showed us where he had lived, the homes where Hollywood stars lived when filming his books, and places he had adopted for his characters in his fiction. The line between the real and the imagined blurred often on our travels, and we were allowed privileged glimpses into the workings of some magical imaginations.

Whenever possible, the writers speak for themselves in these pages. The photos are unvarnished, as we rearranged no furniture into configurations unknown to the occupants. There are no lightstands just out of frame; natural light was the rule. Finally, though, this book isn't about our experiences. It's about the remarkable men and women who have recorded in their own books rich and enduring understandings of their Southern worlds and the people who inhabit them.

Hugh Howard
Hayes Hill, New York

❧ ❧

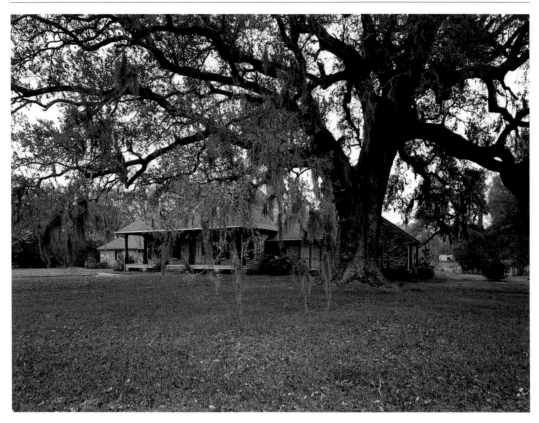

Home to James Lee Burke in New Iberia, some 130 miles west of New Orleans.

Right: Burke at ease behind his home in New Iberia.

"Dave Robicheaux? He's the Medieval Everyman."

JAMES LEE BURKE

(1936 –)

New Iberia, Louisiana

"I cut back on the throttle on the east side of the bay and let the wake take us into a narrow bayou that snaked through a flooded woods. Cottonmouth moccasins lay coiled on top of dead logs and the lowest cypress branches along the banks, and ahead I saw a white crane lift from a tiny inlet matted with hyacinths and glide for a time above the bayou, then suddenly rise through a red-gold, sunlit break in the canopy and disappear."

From *Burning Angel* (1995)

For James Lee Burke, success as a writer came hard. After publishing three early books that went nowhere, Burke remembers, "I went through a fourteen-year period when I couldn't sell anything in hardcover. I wrote a couple of novels which even I thought were failures, but then in 1984, in San Francisco, just down the street from City Lights Bookstore, I wrote the first two chapters of a new book.

"I was in a café, in the sunlight, writing in longhand. I knew it right then. I knew it was going to be a fine book. That was the start of Dave Robicheaux."

The Neon Rain was published in 1987. It has been followed by more than a dozen other novels featuring New Iberia's most independent cop, a man who regularly gets kicked off the force, usually for following his conscience or losing his temper.

Whatever Robicheaux's fictional difficulties, publication of the books in which he appears is quickly followed these days by appearances on bestseller lists.

Although Burke scrawled the opening pages of *The Neon Rain* in San Francisco, Robicheaux's milieu could hardly have been further removed from the casual culture and temperate climate of the City by the Bay. Burke's favorite setting — and still his home for half the year — is the languid bayou country of Iberia Parish. And the locale is essential to the character of the books. "The place is a protagonist in my stories," he explains.

The area has a rich history. Preceded by Native Americans, Spanish settlers floated up the Bayou Teche in 1779 and began ranching and farming along its banks. A large influx of French Acadians from Canada came next, followed by a slow but steady stream of Americans after the Louisiana Purchase in 1803. The intermingling of peoples in the watery landscape produced the unique Cajun culture. New Iberia would become a name cooks all over world recognized from the label on the McIlhenny Company's Tabasco Sauce, the indispensable condiment made just offshore on Avery Island for the last century and a half. Burke traces his own ancestry in the area to 1836.

The subtropical vegetation is hauntingly beautiful, with the thick limbs of ancient live oaks hung with loose tresses of Spanish moss. The brown water of the bayous feeds the marshes and bogs. The watery spectacle features herons and cranes taking flight beneath a rich canopy of trees, but there's a darker side to this bird-watchers' paradise, as the flooded woodlands are home to snakes and 'gators, too.

The same mix among the human inhabitants of sad beauty and unexpected danger provides the tension for much of James Burke's fiction.

THE SMALL CITY OF NEW IBERIA (population: thirty thousand) pays Robicheaux's salary, but the beat he patrols for Burke ranges over a much larger territory. The seamier aspects of New Orleans permeate New Iberia, meaning that daily the police meet up with gambling, prostitution, drugs, money laundering, and the violence inherent in such pursuits. But the widening gyre that Robicheaux confronts in Burke's books includes corrupt federal agents, Latin American drug dealers, and New Orleans mobsters. Usually an unwitting but hardly innocent bystander turns up dead and Robicheaux's job becomes finding out why it came to pass.

� ⋅

JAMES LEE BURKE

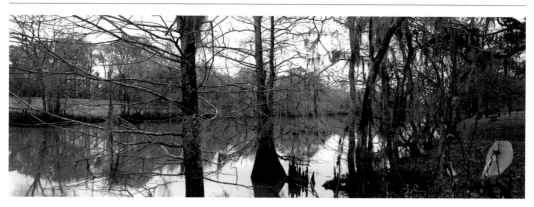

Top: The Louisiana bayou country is a watery world full of wildlife and ancient live oaks.

Bottom: This is Dave Robicheaux's milieu: the muddy water, the trees festooned with Spanish moss, the banks lined with grasses and cane brakes.

Robicheaux brings his share of baggage to his work. His time in 'Nam still wakes him in the night, often with anguished dreams, occasionally with malarial sweats. In the past he numbed himself with alcohol to quiet his demons, but his drink of choice today is Dr. Pepper (Burke himself has been a Twelve-Step man for twenty-eight years). Robicheaux also did a tour in New Orleans's first district in Homicide, where he partnered with one Clete Purcel, the principal recurring character in the series. Now a freelancer, Clete wears a porkpie hat, Hawaiian shirts, and drives a rusty Cadillac convertible. When he dresses for the day, he habitually pockets his Beretta along with his Lucky Strikes. Again and again he proves himself to be a handy man to have around when things get rough out there.

To the casual tourist, New Iberia's main street is archetypal Old South, featuring Shadows-on-the-Teche, an immense brick plantation house, its façade lined with eight white columns. An architectural monument of national significance, the Shadows welcomes tens of thousands of tourists a year who seek to revisit the genteel life of the antebellum south. But the legacy of the past remains a burden in New Iberia: Owners of the Shadows also owned hundreds of slaves, and just downstream along Bayou Teche is the site where the "gentleman pirate" Jean Lafitte conducted his illegal trade in newly imported Africans in the early nineteenth century. The truth in New Iberia is much tougher than its pretty face, and Burke and Robicheaux are not inclined to turn away.

Many of the dangers Robicheaux encounters stem from racial hatred and poverty; the disenfranchised and the poorly educated often find themselves victimized by the rich and the powerful. The users are not limited to the landed gentry of old or even today's organized crime. Burke's list includes greedy corporations, too. "If Americans want to see the future of the petrochemical industry, they should visit Louisiana," he says, his voice brimming with anger. "The damage is enormous. They're rapacious, relentless. They do business with chain saws. They cut down two-hundred-year-old trees like celery stalks. The damage done to this state is so egregious." Many of his recent novels tread this territory — *Last Car to Elysian Fields* (2003) is one — but "Toxic Alley" is a given in Robicheaux's world. It's the region between New Iberia and New Orleans, where a well-charted series of giant industrial plants have despoiled the earth, air, and water around them.

❧ ☙

JAMES LEE BURKE

For many Burke fans, though, all of that is secondary to the storytelling. Tasty plots and onion-peeling revelations are the rule, but with the odor of history informing it all. Some of it is as rank as last week's shrimp, but most of it is consumed with the ease of a po'-boy sandwich. At an elemental human level, says Burke, "Dave Robicheaux is in the life. He sees the whole carnival, the whole theme park." The cop encounters prostitutes, hit-men, and street dealers; the reader learns that those enforcing the law can be as violent as the criminals. More than a few of the villains are lunatic losers, men so debased by their personal histories that their cruel and vicious acts have a terrible logic. For his part, Robicheaux is an angry man on the side of the underdog. He experiences deep outrage fed by a personal need for redemption.

"The crime novel," Burke explains, "has replaced the sociological novel of the 'twenties and 'thirties."

HIS EYEBROWS GONE TO GRAY, Jim Burke has the crinkling around the eyes of a man accustomed to squinting in the hot Louisiana sun. He's tanned, his smile comes easily and often, and his laugh is engaging. Sitting at his desk, he's a kind and gentle man, his demeanor testimony to a happy marriage of more than four decades that produced four grown and successful children.

His home in New Iberia is new; he and his wife, Pearl, had it built to their specifications and occupied it in March 1998. Like his man Robicheaux, Burke lives near the water, his dream house in an alluvial flood zone. Its rear boundary is a tidal bayou, one that empties nineteen miles downstream into salt water.

The interior of the house is largely unadorned. Its white plaster surfaces and exposed woods surround a masonry mass with a fireplace built of old brick salvaged in South Carolina. Tall windows offer full-frame views of the grassy slope that rolls down to the water.

Though born in Houston, Burke grew up in New Iberia. It was segregated in those days, and his grandfather's house backed on the Bayou Teche, just up from Jean Lafitte's one-time quarters on today's East Main Street. Burke left to attend college, earning bachelor's and master's degrees from the University of Missouri. In the years that followed, he lived in Kansas, Florida, and California. He did a tour of duty as a

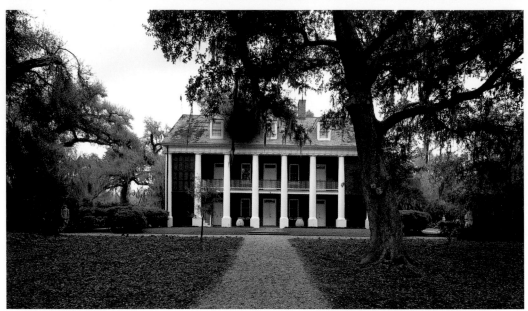

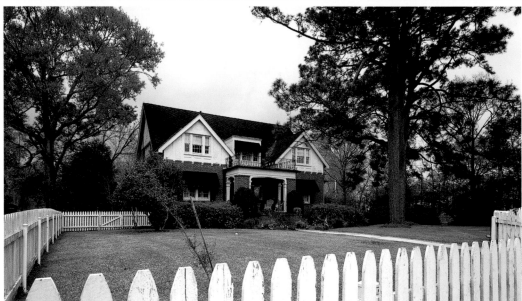

JAMES LEE BURKE

social worker in South Los Angeles. "That was an experience," he says, his voice deepening, "an experience of looking at the world from the bottom up." Today, he spends half the year in Missoula, Montana.

Still, New Iberia remains a place of inspiration for him. He began learning the writer's trade there as a young boy. "I started to write stories in the fifth grade, then poetry in high school." He shared a passion for writing with one his playmates, his cousin Andre Dubus, who was the same age and would himself become a much-admired short-story writer. They took turns winning high school short-story contests in the early 'fifties.

Burke went on to work as a newspaper reporter, surveyor, and pipeline laborer, then found a comfortable niche in the teaching trade. "I taught everything in twenty-eight years at community colleges, three or four universities, and the Job Corps." Along the way, he picked up an admiration for an immense range of writers whose work influenced him. Among those he cites are Gerard Manley Hopkins, Eudora Welty, James M. Cain, and Ernest Hemingway.

Eventually he found the voice that distinguishes his own work. "I'm an obsessive rewriter," he says. "I work all the time, morning to night." During the day, he works at his computer, but his night thoughts go into journals. "They're the beginnings."

Yet Burke the man shares a great deal with the persona in his books. There's the same anger at injustice; he doesn't trust authority any more than Robicheaux does. The books he writes are hard to classify, far from simple police procedurals, with plots that are not always linear. Interleaved with Robicheaux's waking life are his dreamscapes. In some of the books, ghosts from Robicheaux's and New Iberia's past — unresolved mistakes and misdemeanors, crimes and cruelties — come strangely to life, giving

Left top: Once occupied by wealthy sugar cane planters, Shadows-on-the-Teche today welcomes tourists under the aegis of the National Trust for Historic Preservation.

Left bottom: Burke's grandfather resided in this home on New Iberia's main street.

the books a magical, even mystical air. Burke's first allegiance seems less to a straight-forward story than to explicating the gray scale of evil. Burke is a building-block moralist and, in the end, Robicheaux seeks justice at whatever cost.

"Dave Robicheaux always chases the past," says James Lee Burke, "and I've always had the same problem."

In Burke's imagination, New Iberia's past is an unavoidable presence. He explains that the Civil War remains "the most important event in our history, even more than the Revolution. Even today, the same issues are still here." A Civil War battle was fought in New Iberia and, as a boy, Burke excavated minie balls, the half-inch rifle bullets whose accuracy revolutionized warfare during the Civil War. He remembers finding them in the yard of an antebellum mansion at the edge of town. He recalls observing the shocking contrast between the mansion house and its range of outbuild-ings, which then included the humble remains of the slave quarters.

Not all of his fiction is set in Dave Robicheaux's gritty world. In *Cimarron Rose* (1997), Burke moved his tale to Texas, imagining a new contemporary protago-nist, Billie Bob Holland. That book was inspired by Burke's own great-grandfather's diary of the days of the Civil War and Reconstruction, so a historical narrative unfolds together with Holland's. In *Cimarron Rose* and several subsequent novels, defense attorney Holland is ready for anything, invariably finding himself out on the streets, getting to the bottom of the mysteries his clients pose. In another departure

Right top: Burke's spacious and brightly lit office is filled with books and more than a few of the weapons his characters have been known to use. Among them is a Civil War sword with a family pedigree that turned up in a Louisville, Kentucky, flea market.

Right bottom: The living room woodwork is recovered cypress, long submerged but raised, dried, and milled.

JAMES LEE BURKE

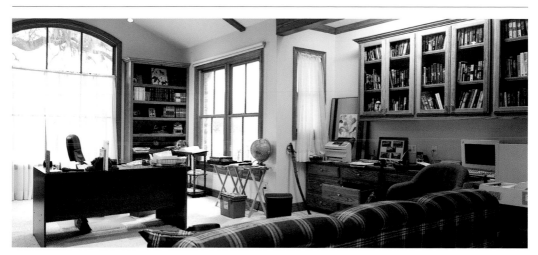

from his Robicheaux books, Burke's *White Doves at Morning* (2002) is a pure historical novel that uses nineteenth-century Louisiana as a backdrop. His best book? "*White Doves,*" he says without hesitation. "It's the most complex and best developed."

Burke's patience as a writer has paid off. His Robicheaux books have made him comfortable and famous, and enabled him to branch out. In a way, though, the tale of the book that immediately preceded the introduction of Robicheaux best summarizes the rocky road the writer has traveled. Over a period of years, his agent submitted the manuscript to no fewer than 112 editors until, finally, Louisiana State University Press agreed to publish it. "That was the most rejected book in the history of New York publishing," laughs Burke. But it was Jimmy Burke — be assured, this informal and welcoming man is most certainly a Jimmy — who got the last laugh not so many months later when *The Lost Get-Back Boogie* was nominated for a Pulitzer Prize. The irony was not lost on New Iberia's angry man.

JAMES LEE BURKE

Books by James Lee Burke

Half of Paradise. Boston: Houghton Mifflin Company, 1965.
To the Bright and Shining Sun. New York: Charles Scribner's Sons, 1970.
Lay Down My Sword and Shield. New York: Thomas Y. Crowell & Co., 1971.
Two for Texas. New York: Pocket Books, 1982.
The Convict. Baton Rouge: Louisiana State University Press, 1985.
The Lost Get-Back Boogie. Baton Rouge: Louisiana State University Press, 1986.
The Neon Rain. New York: Henry Holt & Co., 1987.
Black Cherry Blues. Boston: Little, Brown & Co., 1989.
Heaven's Prisoners. New York: Mysterious Press, 1990.
A Morning for Flamingos. Boston: Little, Brown & Co., 1990.
A Stained White Radiance. New York: Hyperion, 1992.
In the Electric Mist with Confederate Dead. New York: Hyperion, 1993
Dixie City Jam. New York: Hyperion, 1994.
Burning Angel. New York: Hyperion, 1995.
Cadillac Jukebox. New York: Hyperion, 1996.
Cimarron Rose. New York: Hyperion, 1997.
Sunset Limited. New York: Bantam, Dell Publishing Group, 1998.
Heartwood. New York: Doubleday, 1999.
Purple Cane Road. New York: Doubleday, 2000.
Bitterroot. New York: Simon and Schuster, 2001.
Jolie Blon's Bounce. New York: Simon and Schuster, 2002.
White Doves at Morning. New York: Simon and Schuster, 2002.
Last Car to Elysian Fields. New York: Simon and Schuster, 2003.
In the Moon of Red Ponies. New York: Simon and Schuster, 2004.

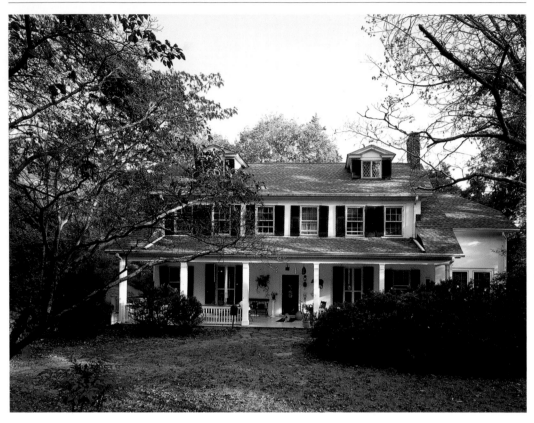

John Casey's rambling house was once home to a doctor who lobbied for seat belts in the 1930s.

Right: John Casey in his garden — talking, gesturing, and telling stories.

"Don't Be a Lawyer. Be a Writer."
JOHN CASEY

(1939 –)
Charlottesville, Virginia

*"I feel the same way about seeing Grandma as I do about com-
ing back to Virginia, into the Great Valley from Tennessee, seeing
the first of the Blue Ridge Mountains that I can name
I'll be thrilled and weepy, but I'm afraid that coming back won't
reach as deep into me as I wish. And I'm afraid that it will."*
From The Half-Life of Happiness (1998)

John Casey was in law school. The son of a
politician, he had spent much of his youth in
statute-making Washington, so earning a degree
in law seemed logical enough. Yet, as Casey tells the
story, he was also "a secret writer of fiction."

During Casey's final year at the Harvard Law School, Peter Taylor was spend-
ing the autumn semester as writer-in-residence at the Department of English. Casey
summoned the courage to go a little bit public with his literary ambitions and, despite
his status as a law student, managed to enroll in Taylor's writing course. He handed
over his thick novel ("whose pages stood on edge crammed in a shoebox," Casey
remembers). Taylor read it with considerable insight, then suggested, "Why don't you
write a short story of, say, fifteen pages, that does the work of a novel?"

In the next few weeks, Casey wrote such a story — actually, several of them —
and entrusted them to his new mentor. He waited nervously for a reaction and soon
received a summons to Taylor's office.

"This won't take long," said Taylor, looking at the clock and making apologies about an imminent social obligation. Casey's spirits fell. He could only imagine Taylor had little good to say and was warning him that the bad news wouldn't be sugar-coated.

Casey was therefore stunned when he heard Taylor say, "Don't be a lawyer. Be a writer."

Suddenly his world was transformed. They were only words — Taylor was not himself a publisher, so there was no implicit promise of publication, much less of any remuneration — but coming from Peter Taylor the words meant a great deal. In two short imperative sentences, Casey knew, Taylor had made his membership in the fraternity of writers official.

But the story doesn't end there.

They went their separate ways that afternoon, Casey still feeling a bit stunned at Taylor's advice. The younger man left for his Army reserve meeting; his time as a reservist would later inoculate him against the draft. For his part, Taylor went to his party and found himself happily trading stories with a former congressman and his wife. They inquired at one point what had brought him to Boston. He told about his teaching post, then added happily that on that very day he had advised a talented young man that, despite the odds, he ought to embark upon a writing career. There was general agreement that, yes, certainly, of course, being a writer was a most worthy undertaking.

At that moment the congressman's son appeared at the table. Taylor glanced up from the conversation and said, a surprised look on his face, "This is the boy I was just telling you about." Knowing nothing of their son's literary aspirations, John Casey's parents were perhaps the most surprised of all that day.

Casey's telling of the tale today has the perfect compression of a great short story — with the exception that the events just happen to have actually occurred. In recollecting that transcendent moment, Casey says, "It's not egotism, it's not narcissism that makes a writer. It's a weird bubble of hope. And Peter gave me that."

CASEY COMPLETED LAW SCHOOL and passed the District of Columbia bar exam in 1965. He wrote legal briefs for a few cases and worked as a congressional aide. But he was coasting on an earlier momentum and, when a fellowship came his way to the Iowa Writers' Workshop, he opted for the $1,750 one-year grant without a second thought.

᪥ ᪥

JOHN CASEY

In the library, where the original owner of the house died decades ago. "My sense of him from this room,"
says Casey, "is that he was a nice man."

He spent the next three years in Iowa and wrote another novel. But a short story proved to be his first sale. Within days of William Maxwell's purchase of that story for the *New Yorker*, *Sports Illustrated* also bought a piece from Casey. He jokes that he'd had to write two novels to sell two stories; despite the one-for-one symmetry, something about the formula didn't seem quite right to him.

Nevertheless, he purchased a four-acre island in Rhode Island, using the income from the two magazine sales as a down payment. Working from his new home in Narragansett Bay, he wrote magazine articles and fished. "I did a lot of sports writing, which was very helpful," he remembers. "Kind of like the charcoal sketches that precede the oil painting." The *New Yorker* was a financial mainstay during that period, but at one point Maxwell warned him, "The bank is full." That was shorthand for *I won't be buying any more of your stories for a while. We have a surplus in our inventory.*

Maxwell added that perhaps this would be a good time for Casey to try his hand at another novel. But Casey felt quite literally out in the cold. It was the bitter winter of 1972 and he was in chilly New England with a wife, two children, and not enough income to sustain his family into the foreseeable future. Then, quite unexpectedly, his providential friend Peter Taylor telephoned and offered a solution. Taylor, happily ensconced at Mr. Jefferson's university, extended an invitation: "Why don't you come on down here?"

The solution proved a happy one as, three fine novels and more than thirty years later, Casey is still writing, teaching, and residing in the milder clime of central Virginia.

JOHN CASEY'S LARGE HOUSE in Charlottesville reflects the complacent ease of its time, having been constructed in the years preceding World War I. The house is a full two stories tall, with extra bedrooms behind attic dormers, and mature trees shading the two-acre site. When Casey acquired the place upon moving to Virginia, it had been vacant for five years and its deep backyard, once an elaborate ornamental garden, had become a jungle of vines and waist-deep weeds and grasses.

Upon arrival at the Rugby Road home, Casey moved his writing life into a book-lined library at the rear of the house. Large windows line its east end, illuminating his desk. He wrote his first published novel, *An American Romance*, in that room, recollecting and reformulating his time in Iowa City. Today, surrounded by teetering piles

&§ §&

JOHN CASEY

of papers, books, and manuscripts, he writes only essays and scraps of poetry there, along with an occasional translation from the Italian.

His fiction writing has migrated to another place. To get there, Casey descends the several steps from his rear porch. Defined by shrubs and low plantings, a garden path leads to his writing shed deep in the backyard. "My job is the bushes and my wife does the gardens," he observes of the dense vegetation.

His other environment is a free-standing building where he keeps a few tools — among them a felling axe and a splitting maul — in part because he wishes to think of the place as a workshed. Among the equipment not found in The Workshed, however, is a computer. Casey writes in longhand, which a graduate student transcribes. Casey then edits on hard copy, working in pencil. It's not that simple, of course, as it takes him a great deal of time to get a novel right. In the case of his National Book Award-winning *Spartina*, he spent years writing and rewriting an immense manuscript, from which he and his editor finally extracted a much smaller book. That same rich pile of living-by-the-water lore also proved to be the starting point for his present work-in-progress.

Son of *Spartina*?

"No," he says with a sly laugh. "It's daughter of *Spartina*."

IN THE CASEY LIBRARY, dozens of pipes line a rack on a shelf and the reassuring smell of pipe tobacco lingers.

Casey's pipe proves an unself-conscious prop as he talks and smokes. In his hand, it's useful for emphasis. When it needs tobacco or a light, it's a distraction, providing a thoughtful pause in conversation. Once the pipe is lit again, its fragrant smoke floats upward and the talk continues.

His beard is salt and pepper (mostly salt), and his thinning hair has marched well back on his head. Wire-rimmed spectacles concentrate his gaze. He's a solidly built man, and he works at it, cutting wood and rowing on clement days (he owns two singles and shares in two-man and four-man shells). When it rains, he uses exercise machines in his laundry room, disciplining his workouts by aligning his exercise sessions with the washing-machine cycle.

At the University of Virginia, he teaches both creative writing and literature. His last book, *The Half-Life of Happiness*, takes place in central Virginia; in fact, John

❧ ❧

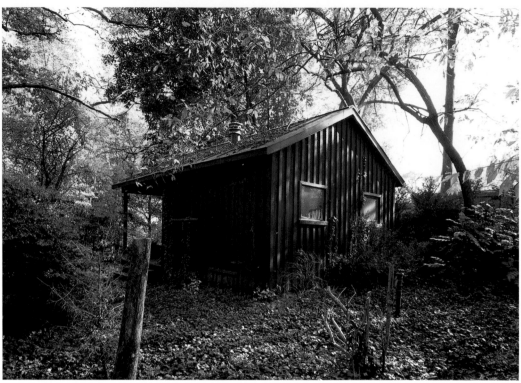

Casey writes his fiction behind his house in the building he calls "The Workshed," a rough-hewn space as unprepossessing inside as it is out.

JOHN CASEY

Casey's three novels parallel the moves in his life, having been set in Iowa, Rhode Island, and Charlottesville. As is the case with most writers, many parallels, geographical and otherwise, can be identified between Casey's life facts and his characters' lives. But one correlation offers a means of thinking about his work.

Breece D'J Pancake, a protégé of Casey's, committed suicide before his twenty-seventh birthday. A posthumously published collection of his stories was much admired. That book also contains an afterword in which Casey characterized the way he found himself reminded of Breece Pancake in the weeks after the younger man's death.

"Perhaps memory, perhaps a ghost," he wrote. "I'm not sure what ghosts are. The reflective skeptical answer I give myself is that the vivid sense of dead people that you sometimes have may be like the phantom-limb syndrome — you still feel the arm that's been cut off, still touch with the missing fingers. In like manner, you feel the missing person." Almost twenty years later, a reinvented Breece D'J Pancake would make a cameo appearance as Bundy, a character in *The Half-Life of Happiness*. But in life, Pancake was obviously a friend whose absence was and still is the object of both sadness and wonder.

Yet only rarely is a Casey novel explicitly autobiographical. Casey talks offhandedly of meeting the man who inspired Dick, the protagonist of *Spartina*. Casey talked to him one day at a boatyard in Rhode Island. But between puffs on his pipe, Casey is quick to disclaim any detailed correlations between his life and work.

"It comes from the feelings you've had, but making a novel is like building a stone wall. You sit there a long time trying to fit a stone — *Does it fit?* You're using moments from your life, stuff from other people's lives. They add up, but then, at the end, you have to go back and make sure everything holds together, like a good stone wall with a flat, finished top."

When asked about "daughter of *Spartina*," he's quick to say, "I can't talk about it." Then, roughly a heartbeat later, he proceeds to talk about it. He sets a scene, sketching the characters as if they are friends in an anecdote, perhaps people from his past he is remembering fondly. His pipe goes out, but he doesn't seem to notice. He seems equally unaware of his listener as he tells of a self-conscious teenage girl who's been embarrassed, quite accidentally, by her dad. Perhaps that's the scene he's wrestling with in The Workshed; that isn't clear because the conversation has become a riveting monologue. He relights his pipe, his words never ceasing, and once again becomes

❦

shrouded in a cloud of smoke. The characters are alive as he directs them, but he seems to be watching and listening, too; his characters are assuming positions on his mental chessboard as he tests strategies. John Casey is clearly story-building, completely in the moment — *their* moment, that is — as he slips off into their world.

When Casey talks of his work, he inhabits a special place that is neither real nor entirely fictional. His novels parallel the passages of his life: falling in love; fathering daughters; becoming a public man; recovering from divorce; testing a man's limits on the water. He has written wisely of the pleasures of craftsmanship; of the marvels and terrors of nature; of rough-edged men good-heartedly careening through their lives.

In conversation, as in his writings, Casey reveals himself repeatedly as a man with a capacity for wonder, for discovery. Of his life with four daughters, he observes as the conversation resumes, "A moment in life I really love? When children are wiser than you are." Those words bring to mind the moment in *The Half-Life of Happiness* when he describes Mike, the middle-aged father and would-be politician, as one of those aging fathers who "inevitably turn into captive Merlins, waiting spell-bound in their solitary caves for their daughters [who are now] . . . the ones who can appear at will, or vanish."

While watching Casey blithely lose himself in his fictional world, that name "Merlin" — that archetype, perhaps — comes to mind again. Casey himself is wont to refer to his late, lamented friend, Peter Taylor, as Merlin; after all, he was the man who caused Casey to address a different sword in another stone with the words, "Don't be a lawyer. Be a writer." But if the character Mike and Peter Taylor have their Merlin-esque aspects, then so does John Casey. He is a man who from The Workshed causes his characters to appear or vanish within the intimate landscapes of his books.

Books by John Casey

An American Romance. New York: Atheneum, 1977.
Testimony and Demeanor. New York: Alfred A. Knopf, 1979.
Spartina. New York: Alfred A. Knopf, 1989.
Supper at the Black Pearl. Northridge, California: Lord John Press, 1995.
The Half-Life of Happiness. New York: Alfred A. Knopf, 1998.

JOHN CASEY

The Casey house is home to the writer, his artist wife, Roz, and their daughters.

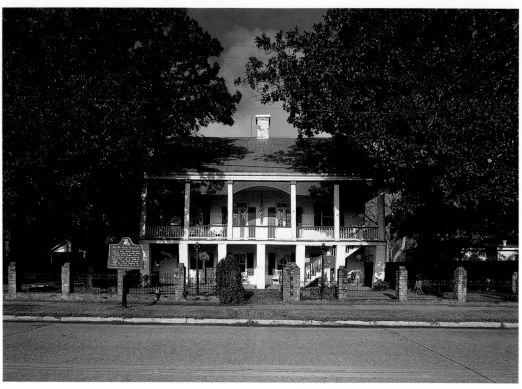

The Kate Chopin House in Cloutierville, a town where the people prided themselves on a diverse culture in which the language was French, the food Spanish-influenced, and the religion Catholic.

Right: Kate Chopin in her writing days, after her return to St. Louis.
Photo courtesy The Newberry Library, Chicago.

The Creole Bovary
KATE CHOPIN
(1850 – 1904)
Cloutierville, Louisiana

"Mrs. Pontellier was beginning to realize her position in the universe as a human being, and to recognize her relations as an individual to the world within and about her. This may seem like a ponderous weight of wisdom to descend upon the soul of a young woman of twenty-eight . . .[b]ut the beginning of things, of a world especially, is necessarily vague, tangled, chaotic, and exceedingly disturbing."
From *The Awakening* (1899)

Today, Kate Chopin's fame cannot be separated from *The Awakening*. Her novel appeared just as the new century approached, following two collections of stories published earlier in the decade. *The Awakening* proved to be the book that both destroyed and, well after her death, remade her reputation.

Bayou Folk (1894) and *A Night in Acadie* (1897) had met with warm receptions. The forty-four stories they contained had been selected from some ninety stories Chopin had written in the course of the nineteenth century's closing decade. Set in New Orleans and rural Louisiana, the tales portrayed upper-crust Creoles, the descendants of European settlers, and Acadians, the less educated and poorer descendants of the French Catholics who settled in the Louisiana bayous after the British drove them from Nova Scotia in the eighteenth century. Many of Chopin's characters emerged as survivors making their way in a world radically transformed by the Civil War not so many years earlier. While regarded by some readers as charming but regional curiosities,

the stories won favorable comparison to the writings of Guy de Maupassant. Chopin herself acknowledged her debt. "I read his stories and marveled at them," she wrote in her diary. "Here was life, not fiction."

At the recommendation of the editor of *Bayou Folk*, Chopin set to work on a novel. In *The Awakening*, she shifted from the local color of her short sketches to a more universal portrait of a woman, Edna Pontellier. The young wife and mother grows dissatisfied with a life that has all the outward appearances of a reasonably happy and fulfilling existence. She embarks upon an extramarital affair, pursues her artistic inclinations, and eventually leaves her husband. Chopin created an intimate psychological portrait of a woman discovering desires in herself she had not previously known. Awakened to a life outside the one she has known, she recognizes her need to resist being dragged "into the soul's slavery for the rest of her days."

Her solution is to walk to the shore where, "beside the sea, absolutely alone, she cast the unpleasant, pricking garment from her, and for the first time in her life stood naked in the open air, at the mercy of the sun, the breeze that beat upon her, and the waves that visited her.

"How strange and awful it seemed to stand naked under the sky! how delicious! She felt like some new-born creature opening its eyes in a familiar world that it had never known." She then swims out to sea until her exhausted arms and legs can no longer keep her afloat.

Chopin concluded her book with Edna's suicide and, in so doing, effectively ended her own publishing career. When Nora slammed the door at the close of Ibsen's *A Doll's House* twenty years earlier, the shock had reverberated; but Kate Chopin roiled Victorian mores just as violently with her frank portrayal of Edna's sexual awakening. In the year after the novel's publication Chopin found herself without a publisher, the contract canceled for her next book, *A Vocation and a Voice*, which was to have been a third collection of stories. Dismissed by most critics as immoral and unhealthy, her work began its decline into obscurity even before her unexpected death from a cerebral hemorrhage in 1904.

The Awakening was not reissued until 1964; a critical biography and Chopin's complete *Works* followed in 1969. In changed times, feminism flowered, and *The Awakening* quickly gained entry to the American canon.

৵৶ ৹৶

KATE CHOPIN

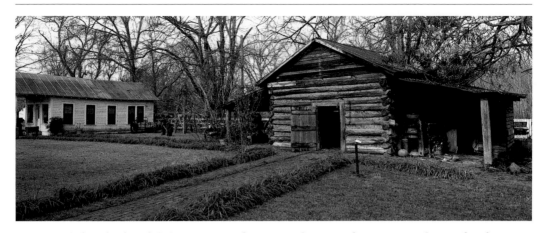

The log cabin behind the house was moved from a nearby farm and stores some of the agricultural collections of the Bayou Folk Museum.

KATE CHOPIN

ANOTHER EVENT THAT ANTICIPATED the rediscovery of Kate Chopin also occurred in the 1960s. Mildred McCoy established the Bayou Folk Museum in Natchitoches (pronounced *NACK-eh-tosh*) Parish, Louisiana, in 1965. Intended to interpret early French Creole culture, the museum collections soon included several buildings, many local farm implements, and a range of furniture and artifacts. But its central holding was a gracious Creole home constructed in 1805 for Alexis Cloutier.

The house overlooks the main street of Cloutierville, the town that grew up around the family plantation. In 1820, the Cloutiers modified the original house, raising the roof to enclose two floors, making the upper story the primary living quarters with the kitchen and other working areas below in the raised basement. The plan incorporated no hallways; instead, every room opens onto one of the porches or "galleries" that line the front and back of the house to capture every precious breeze in central Louisiana's near-tropical climate. The house is of brick, laid and mortared by slave labor.

Through marriage and inheritance, the Cloutier place came into the hands of Oscar Chopin and his family in the 1870s. He had married a young lady from St. Louis in 1870 and, as a result of her rediscovery a century later, the Bayou Folk Museum has evolved into the historic site known today as the Kate Chopin House. The home underwent a restoration in 1999 reinterpreting it to the time of the Chopins' residence. Over the years, descendants have donated family objects, including a piano (Chopin was an accomplished pianist).

The landscape has changed little since Oscar Chopin managed the eighty-acre estate. There are no chickens or cows in the yard as there were in Kate Chopin's time, but the Red River still flows by on the other side of the road, its banks lined by a cane brake. The setting is richly atmospheric, offering a small window into the place that inspired Kate Chopin when she began her work as a writer.

Left top: Watching — and being watched by — one's neighbors is a time-honored small-town pastime; it's a practice easily done from the upstairs gallery at the Kate Chopin House.

Left bottom: A space interpreted as a child's bedroom.

∽

KATHERINE O'FLAHERTY WAS BORN in St. Louis in 1851. Her father, a fast-rising Irish immigrant who married the daughter of a well-placed French Creole family, died when Kate was five, leaving her to be mothered by three generations of widows.

At twenty Kate O'Flaherty married for love. Oscar Chopin had left Louisiana at sixteen to escape a violent father, making his way to St. Louis, where he found employment in a bank. After their marriage, Oscar and Kate Chopin moved to New Orleans, where he bought and sold cotton as a cotton factor. Five sons and a daughter were born to the couple before two consecutive failed crops brought financial ruin to Oscar's business and the Chopins were forced to retrench. In 1879, they left the comforts of New Orleans for the more rustic Cloutierville. There Oscar opened a general store and managed several plantations in the vicinity.

Although it was precipitated by her husband's business reverses, the move in no way humbled Kate Chopin. She arrived a woman of the world, born and raised in St. Louis, her honeymoon spent in Europe, the first years of her marriage lived in New Orleans. She smoked little cigars and drank tall glasses of beer at a time when women in rural Louisiana just didn't do such things. She crossed her legs at the knee, and her fashion sense struck her new neighbors as flamboyant in the extreme. The ladies of Cloutierville thought her liberated ways dangerous. They shielded their daughters from Kate Chopin.

She reveled in the life of the store. Diverse peoples rubbed shoulders in Cloutierville: Creoles, Acadians, and people of color coexisted in a town that consisted of just one street with her husband's store as its focus. Social boundaries were more flexible within the microcosm of Cloutierville than those she had known in her city life; the people she saw introduced her to all levels of a heterogeneous society in which lives were shaped by status, culture, language, race, and gender.

Right top and bottom: Chopin worked in her living room, typically writing her stories at one sitting, despite frequent interruptions by her children. A sketch survives, drawn by one of her sons, portraying her at work in a Morris chair.

KATE CHOPIN

❧ ❧

Oscar died suddenly in 1882 of "swamp fever," probably malaria. Though deeply in debt, the widow Chopin continued to run the store. She further risked her reputation, apparently embarking on an affair with a married man. In 1884, she returned to St. Louis and would remain there for the rest of her life, but memories of her time in Louisiana would inform her fiction.

Although she had kept diaries in childhood and her own children recollected Chopin writing in Cloutierville, apparently she began writing in earnest only in 1889. She aimed at the ready market at popular magazines for "local color" stories, a genre that offered readers exotic locales; to her Chicago and New York publishers, rural Louisiana certainly represented the strange and foreign. The early writings grew in some measure from the storytelling culture she came to know in Cloutierville, and some of those stories today appear mechanical, dependent upon surprise endings, plot twists, and literary devices such the discovered diary of a recently dead woman ("Elizabeth Stock's One Story"). Yet her bayou stories amount to much more than genre exercises.

She did not content herself with writing stock characters or simply amusing her readers. In 1893, *Vogue* published one of her most famous stories, "Désirée's Baby," in which a child of color is born to a white couple. She developed a style in which the perspective subtly shifts. She addressed taboos such as miscegenation, infidelity, and venereal disease; she portrayed racial tensions and, often, the limitations posed to a woman by the conventions of marriage. Not all her unhappy wives opt for an end like Edna's, as the title character in "Athénaïse" chooses to return home, reconciled to her husband.

She worked toward the creation of Edna Pontellier, who, like Flaubert's Emma Bovary, confronted limits imposed by her society and her era. Chopin herself had a certain boldness and independence, born of an upbringing by three generations of strong-minded women, nurtured by a permissive husband, reinforced by the necessity of making her own way after his death. But Kate Chopin was no radical. She flouted fewer social conventions than Edna Pontellier did, for the most part living within the restrictions of her class and time, preferring to revel in ideas and feelings which she realized with great skill on the printed page.

While most of her life was spent in St. Louis, not a little of the freedom Kate Chopin felt in her literary life came from her time in Louisiana. The years there offered

❧ ☙

KATE CHOPIN

her a distance from the more structured society in St. Louis; she set almost all her stories in New Orleans, the Gulf coast town of Grand Isle, or Natchitoches Parish. Chopin's time in remote Cloutierville also proved to be a formative period when, in quick succession, she experienced the culture shock of small-town life and then, just three years on, became a widow.

In her determination to become a writer, she would adopt as her subject matter some of the six or seven hundred denizens of the bayou town whom she had come to know intimately. She wrote about the place and its social and racial tensions. But it was a narrower, more personal world that she knew best. If her early characters behave on instinct and within the context of a rich and unusual culture, it was Kate Chopin's unconventional view of marriage that jarred with the accepted thinking of her time. She is remembered today for bringing to life a woman who felt imprisoned by marriage and motherhood. Her character's self-destructive act of freedom would condemn Chopin to literary oblivion in her final years but, decades later, would bring her essential recognition.

Books by Kate Chopin

At Fault. Privately published, 1890.
Bayou Folk. Boston: Houghton Mifflin Company, 1894.
A Night in Acadie. Chicago: Way and Williams, 1897.
The Awakening. Chicago: Herbert S. Stone and Company, 1899.
The Complete Works of Kate Chopin. Baton Rouge: Lousiana State University Press, 1966
A Vocation and a Voice. New York: Penguin Books, 1991.
Kate Chopin: Complete Novels and Stories. New York: Library of America, 2002

Pat Conroy's house is located at the end of a cul-de-sac reached via another dead-end road which is, in turn, at the end of a coastal highway.

Right: Pat Conroy, where he belongs.

Word-Stung in Beaufort
PAT CONROY

(1945 –)
Beaufort, South Carolina

"My wound is geography. It is also my anchorage, my port of call."

From *The Prince of Tides* (1986)

I was raised by my mother to be a Southern writer," Pat Conroy explains. "There was a geographic tension in our lives — my dad was from Chicago — but shrimp and grits won hands down."

Conroy's hair is going to white, his face ruddy from the sun. He offers a conspiratorial smile, then laughs, knowing his listener is in on the joke. Anyone who has read his books understands.

Today, Conroy resides on an island not far from his adopted home of Beaufort, South Carolina, midway between Charleston and Savannah, Georgia. Beaufort exists because of its fine natural harbor, which French, Spanish, and then English explorers visited in the sixteenth century, though it wasn't until the eighteenth century that the cash crops indigo and cotton made the place wealthy. One result of that prosperity is still on view downtown in the fine colonial and antebellum houses in the town's historic district.

Yet the essence of the place, its lifeblood, has always been the water. The Low Country seems afloat, an ever-changing landscape bounded by the tidal waters of the

ocean and an arterial system of rivers and streams that feeds countless lagoons. It's a richly atmospheric place, where shrimp boats disappear into the mists and, in reality as well as in Conroy's fiction, a white porpoise has been known magically to appear.

PAT CONROY AS TOUR GUIDE: At the wheel of his big American sedan, he cruises the streetscapes of Beaufort (rhymes with *VIEW-fert*). The town was unspoiled by its Union occupiers, and it hasn't yet lost its equilibrium to development, with a population that hovers around 10,000.

In the Old Point section of town, Conroy gestures through an opening between immense tree branches hung with Spanish moss. "People call that *The Big Chill* house," he says as a large house comes into view. "The movie was made there." To Beaufort natives, the place has long been known as Tidalholm, but for Conroy, since the 1979 making of the movie of his book *The Great Santini*, the house has also been home to the Meechum family, whose patriarch was the title character.

Easing past a horse-drawn carriage loaded with tourists, Conroy continues the Hollywood tour. "Nick Nolte lived there." He indicates a handsome Grecian-style house on a raised basement. "That was during the filming of *Prince of Tides*." Nolte played Conroy's protagonist Tom Wingo, an unemployed coach and English teacher. On North Street Conroy points out the house Barbra Streisand rented. She directed and produced the movie, casting herself as Dr. Susan Lowenstein, the New York psychiatrist charged with caring for Wingo's suicidal sister, Savannah, but who ends up ministering to Tom. Conroy says of Streisand, his tone philosophical, "She didn't mix well with the locals."

His car creeps along the quiet streetscape. "That was Blythe Danner's place during the filming of *The Great Santini* with Robert Duvall. Her daughter, Gwyneth, just loved it here. She was a little kid then, maybe seven or eight."

Conroy continues nosing along on the streetscape but his narration shifts to more intimate moments in his personal history. There's a glimpse of the house he inhabited when he taught English at Beaufort High immediately after college. Just up the street he points out the house where his first wife lived with her children from her

❧ ☙

PAT CONROY

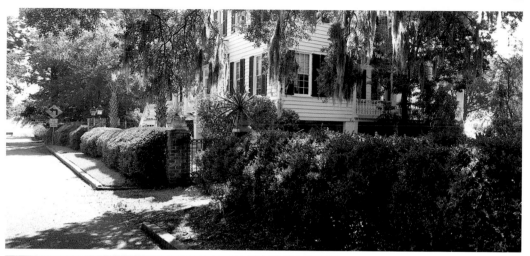

Above: Beaufort can claim a style-book array of historic homes.

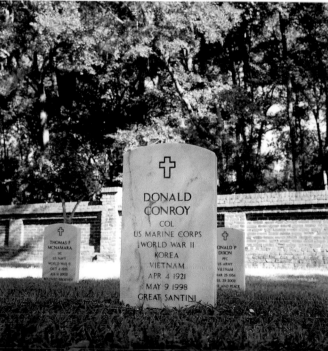

Left: The gravestone of Conroy's father.

☙ ❧

PAT CONROY

A seascape near Beaufort.

first marriage. Widowed by the Vietnam War, she subsequently married Conroy, and her daughters became his stepchildren.

"My mother's house," he says, pointing. "In *Prince of Tides*, I mean. She never lived there . . . but Lila did in the book." A home where his father lived is on the tour, too, as well as a house once owned by his stepfather.

Conroy's patter sobers when he drives through an iron gate. Beaufort National Cemetery was established by Lincoln in 1863 as the final resting place for Civil War soldiers and, in keeping with Beaufort's historic air, the dead from that conflict — Confederate, Union, and a few African-American — still outnumber those from subsequent wars. Conroy parks on an access road surfaced with oyster shells, then leads the way into the rank and file of stone tablets.

He stops at the one that bears his father's name. After a moment, he walks around to its back. His mother's name and dates are there.

Beaufort has become home to Conroy. He arrived there as a high school junior, an army brat who moved twenty-three times before he began college at The Citadel, less than fifty miles north, in Charleston. He returned to Beaufort repeatedly over the years since, and, after periods of residence in Atlanta, Rome, and San Francisco, he moved to the area in 1989.

To judge from his tour of the town, Conroy has found in Beaufort a special harmony that only he can hear. His personal history plays one part, featuring his parents and siblings, as well as a marriage of his own. The arrangement also incorporates characters from *Beach Music*, *The Prince of Tides*, and *The Great Santini*. A prettified Hollywood layer can be identified as well. Taken together, the real, the imagined, and the cinematic are parts of a unique Conroy mythology.

He is quite evidently attached by some sort of metaphysical umbilical to Beaufort County, South Carolina. It is no accident that he closes his tour at the cemetery. As he stands before his parents' gravestone, he points at the inscription beneath his father's name. "They couldn't fit it all on," he observes, ruefully shaking his head at inflexible miliary regulations. The grave, you see, in abbreviated form, acknowledges the son's book, labeling the father as "Great Santini."

❧ ❧

PAT CONROY

"I GOT HIT WITH THE BUG EARLY," he recalls. "My mother read to us every night of our lives." He pauses, thoughtful. "She was word-stung, too."

He remembers her setup for her favorite book, *Gone with the Wind*, a novel that she reread for her own pleasure every year. One day she explained to her children the correlations to their own lives: An uncle was Ashley Wilkes, an aunt Melanie Hamilton, their dad Rhett Butler, and the reader herself . . . why, she was Scarlett O'Hara, of course. She proceeded to read Margaret Mitchell's book aloud to them, cover to cover. Pat Conroy was five years old.

He recalls reading Thomas Wolfe's *Look Homeward, Angel*. That book he read to himself, and it proved to be his literary conversion experience. "I was one of the clichés of Southern life, a boy set on fire by *Look Homeward, Angel*." A few years later as a college freshman (a plebe, that is, at The Citadel), he declared his adoration for Wolfe with his first published poem. An upperclassman edited Wolfe's given name and dropped the final "e," but Conroy's "To Tom Wolf" began with this stanza:

> Oh sleep now, Tom, your pen is quelled.
> You have a grace to show it.
> But I have heard an eagle say
> "These mountains need a poet."

His sense of kinship with Wolfe is easy enough to explain given a working knowledge of Conroy's subsequent writing. Both are Carolinians; both are writers struggling in an uncongenial world; both are children of parents in conflict. The affinities are numerous and real, and include literary similarities, too, as the styles of both men tend to the lush and lyrical, their stories to sprawl. Yet the key lesson Conroy may have learned from Wolfe was the way in which the life of an individual and its painful truths — facts altered, names changed, narrative reshaped, all elements transformed but recognizable — can be the basis of a writing career.

ஜ்ஜ்

Cassandra King, author of The Sunday Wife *and* The Same Sweet Girls, *shares her husband's house, but works in her own upstairs study.*

&❦ ❦

PAT CONROY

"IT CAN HAPPEN SIMPLY," SAYS CONROY. "With a question like, 'Why do I hate my father?' or 'Why is my sister crying?' *The Prince of Tides* began with my sister's attempted suicide."

He keeps a blotter-sized pad at hand. He jots down story elements and ideas as they occur to him. Some are real stories, others imagined. Gradually the big sheet becomes cluttered with miscellaneous jottings that seem to have been dropped there at random. "At first, I don't know what the book is that's rolling around my head. But a character will keep insinuating himself."

Eventually he'll tear off the first sheet and start a new one, organizing the earlier ideas into an informal storyboard. This can take time and many sheets from the giant pad.

He also keeps journals. "I start every year with a journal. I make a January or December resolution. Later . . . I get to the point where I stop." He stops his story, too, leaving the room, and returning a few moments later with a stack of journals. Every one he opens was begun in earnest, with his careful handwriting filling the early pages. Then the entries become fewer and, eventually, cease altogether.

Over time the journals, the big pad, and his daily writings coalesce.

"I know I'm on my way when I write the prologue," he says.

"I'm not a reviser. I write in longhand, and when I put it down, I make a commitment." To emphasize the point, he hops up and disappears again, this time reappearing with a small stack of lined, yellow paper. The sheets in the neat, stapled stack are covered with a precise, rolling script, with virtually no scratchouts and edits. It's the original manuscript of the opening pages of *The Lords of Discipline*.

Conroy points at the pages and explains. "I have the sentence in my mind. I'll come across the way I want to write it, then I'll put it down."

After a pause he adds, matter-of-factly, "They're just there."

CONROY IS A PASSIONATE RACONTEUR. In person, as well as on the page, his stories are often at his own expense.

The one about his getting published is a classic. The naïve young man was teaching English at Beaufort High School. Determined to become a writer, he sat down and wrote about what he knew best, The Citadel, from which he had just graduated. The armature of the book was the assistant commandant, a man whose nickname became the book's title, *The Boo*, and who would reappear as The Bear in Conroy's *The Lords of Discipline*.

When the manuscript was finished, Conroy recalls, he showed it to Lt. Col. Thomas Nugent Courvoisie (The Boo), who assured him it was most definitely prize-winning stuff. "We gotta publish this!" said he. But how? A little research identified a possible publisher nearby. Conroy made an appointment, donned a tie and jacket, and went to seek his publishing fortune. To his surprise the man behind the desk agreed to publish the book. "It'll cost you twenty-five hundred bucks," Conroy remembers being told. That seemed fair enough, he and The Boo decided, and they went about raising the money. In fact, it was money well invested, as the book would sell out the first printing before publication.

Conroy, the newly published writer, then went back to work and produced another manuscript. This time around, he persuaded the courtly Julian Bach, a noted New York literary agent, to act on his behalf in finding a publisher. Bach quickly found a publisher for the manuscript that would become *The Water Is Wide*.

He called Conroy with the good news. "I've got a publisher for your book," Conroy remembers being told. Then Bach added, hesitating because the advance the publisher was offering to pay Conroy was small, "The money . . . it's just $7,500."

Conroy was stunned.

"But, Julian," he responded, "I can get it done for less down here!"

After the nonplused Mr. Bach recovered himself, he gave Mr. Conroy a short lesson in publishing economics.

PAT CONROY'S HOUSE WAS BUILT IN the 1970s as part of an island development begun in the previous decade. The home is shadowed by a towering palmetto forest, its entrance set back a short distance from a quiet cul-de-sac. The back of the house,

❧ ❦

PAT CONROY

Conroy writes in longhand, never having mastered the keyboard. When he enrolled in a typing course in high school, his father withdrew him from the class, dismissing the subject with a stern reprimand. "Typing is for secretaries and corporals," spat Marine Corps Colonel Donald Conroy.

much of it glass, overlooks a sloping green that meanders down to a lagoon. "We've got a blue heron here," says Conroy. And alligators, too, he reports, laughing at the shock elicited from a group of recent guests when a ten-footer climbed, unbidden, up the bank and onto the lawn.

The interior of the house is cluttered with books and papers and comfortable furniture. After all, this is the home of two writers, with Conroy's wife, novelist Cassandra King, occupying a study upstairs and Conroy himself working in a space that opens off the master bedroom. Just inside the front door are knee-high piles of manuscripts and advance proofs. Conroy's is a generous spirit: He admits to having little time to read books of his own choosing because of the books by friends (and strangers) that arrive daily. His memory of a critical silence early in his career has led him to attempt to help as many people as he can. Thus the many packages, each accompanied by a letter asking for a quote. "Blurbing," he calls it, his voice suddenly tired, edgy.

The house doesn't seem as important to Conroy as the larger sense of place and its setting. The lagoon he sees outside the window over his desk feeds into a salt marsh and, eventually, the ocean. This is his chosen place, one where Conroy watches the tides rise and fall.

CONROY'S RECENT MEMOIR WAS A departure for him. *My Losing Season* recounts the events of a single basketball season. The subject would hardly seem calculated to appeal to Conroy's readership, specifically to the many women devoted to his work. He felt he had to write it but recognized the risks. "I thought I'd ruin my career with that book," he observes. That made the memoir's subsequent appearance on numerous bestseller lists all the more satisfying. "I've had whole girls' basketball teams come to book signings," he says proudly.

His audience demonstrated an abiding commitment to him, and he rewarded them with a great deal more than a basketball book. In *My Losing Season*, Conroy uses his senior year at college as a frame: He tells the story of a disappointing season in which the Citadel Bulldogs won only eight and lost seventeen games. In the process, he also

❧ ❧

PAT CONROY

recounts his own trip back in time to reacquaint himself with his teammates, coaches, and others from 1966 to 1967 ("I stepped back into their lives thirty years later"). For readers familiar with his other work, however, the narrative of Conroy's own life offers a context for his novels.

One passage of the book is a gutsy melding of fact and fiction that suggests once again the intimate comingling of Conroy's life and work. In a book that was laboriously researched, one that is chockablock with factual accounts of real games and events from Conroy's life, an imagined character from *The Lords of Discipline* suddenly appears in the locker room afer a game. Will McClean was "a boy I created with a fountain pen while sitting at a desk," writes Conroy. Thirty-some years after the real events, twenty-some after appearing in Conroy's book, the "changeling" walks back into his life and imagination.

"He caught me by surprise," Conroy remembers.

Conroy's capacity to be surprised is among his great gifts. Like many of his characters, he is credulous, open, interested, and caring. He decided as an undergraduate to fulfill his mother's wish and become a writer; he fashioned a writing life based on his own, often publishing variant versions of a childhood and adolescence that he himself has described as "trial by father." He has written what he describes as "wounded books," having forced himself "to consider the perilous and shifting nature of memory itself." He has chosen to set many of his stories on the shores of his adopted South Carolina, in Charleston and Beaufort, places that are full of shades and shadows, like those of his parents and Will McClean; the Wingos and the Boo; the Great Santini and Jack McCall.

What kind of writer would he have been without his sense of place? It has been a constant for Conroy, an anchor in rough waters. As Tom Wingo observed, "There were many things wrong with my childhood, but the river was not one of them." As Conroy himself is quick to acknowledge, the Low Country surrounded by its tidal waters has proved to be an essential place, central to his life and his work.

❧ ❧

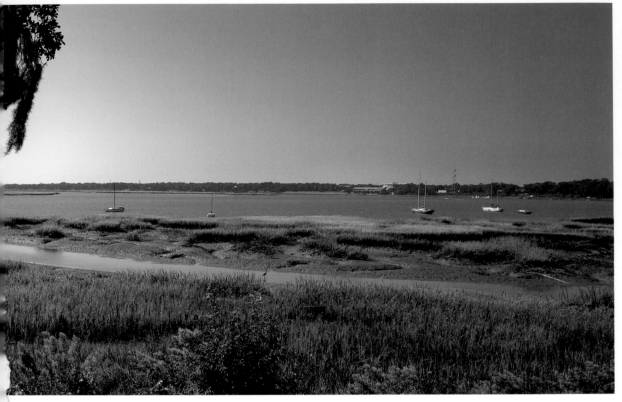

The meandering shoreline of Conroy's Low Country goes on and on, bounding broad salt marshes, their watery surface obscured by undulating grasses, with the sea beyond.

PAT CONROY

A tidal lagoon bounds the rear of Conroy's property.

❧ ❧

PAT CONROY

Books by Pat Conroy

The Boo. Verona, Virginia: McClure Press, 1970.
The Water Is Wide. Boston: Houghton Mifflin Company, 1972.
The Lords of Discipline. Boston: Houghton Mifflin Company, 1980.
The Prince of Tides. Boston: Houghton Mifflin Company, 1986.
Beach Music. New York: Doubleday, 1995.
My Losing Season. New York: Doubleday, 2002.

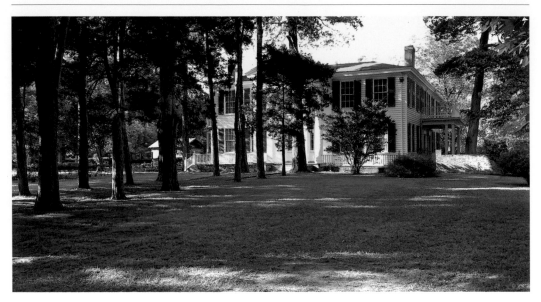

Above: Jill Faulkner Summer, Faulkner's daughter, sold Rowan Oak to the University of Mississippi a decade after her father's death. The house, subject to an intensive recent restoration, looks much as it did when Faulkner died on July 6, 1962.

Right: In front of Oxford's City Hall sits a bronze sculpture of the town's most famous citizen.

The Master of Rowan Oak
WILLIAM FAULKNER
(1897 – 1962)
Oxford, Mississippi

"I was using what I knew best, which was the locale where I was born and had lived most of my life. That was just like the carpenter building the fence — he used the nearest hammer. Only I didn't realize myself that I was creating a pageantry of a particular part of the earth."

From *Faulkner in the University* (1957)

William Faulkner arrived in Oxford in time for his fifth birthday; sixty years later he died of a heart attack, still a resident of his "little, lost town." In the intervening decades, he had left Oxford for military service and periodically went off to work as a scriptwriter in Hollywood and to teach at the University of Virginia. He traveled abroad numerous times both for pleasure and as a cultural ambassador for the State Department. Despite forays elsewhere, the longest of which was thirteen months, Oxford always remained very much his home in body and spirit.

He made fast his connection to Oxford in 1930 when he purchased a property known locally as "the Bailey Place" for $75 a month against a purchase price of $6,000. Located seven-tenths of a mile from Courthouse Square in downtown Oxford, it was a four-acre estate consisting of a two-story Greek Revival house and several dependencies, including a barn, summer kitchen, and tenant house. Later he

❧ ❧

would acquire the twenty-nine adjoining acres of "the Bailey Woods," a forest of cedars and hardwoods in which he had played as a boy.

He renamed the place "Rowan Oak." At first he ran the two words together, insisting the name be pronounced like the Virginia city of Roanoke, even while insisting its derivation was the rowan tree which, according to pagan legend, offered protection from evil spirits. But the house he purchased needed more than talisman trees: It was a deteriorating hulk, its foundations uneven, the roof leaking, with paint flaking off outside and wallpaper peeling within. "It looked as if it was going to collapse with the next rainstorm or high wind," Faulkner observed. The old house had never been electrified and had no indoor plumbing. A capable handyman, Faulkner jacked up the house to install new sills. Together with a motley group of helpers, he replaced the roof, plastered, and installed new bathroom and kitchen fixtures ordered from Sears, Roebuck.

Faulkner brought the house into the twentieth century but he did so with careful regard to the original character of the place. He valued its history, which dated back almost a century to the arrival of the builder, Colonel Robert Shegog, who had settled in the frontier town of Oxford in 1844 and completed the L-shaped home by 1848. The house in its original form consisted of two rooms up and two rooms down in the main section, with a kitchen ell to the rear. It was hardly a mansion, but it bore a frontispiece that added a distinct grandeur. The Grecian-style porch anchors the front façade, its triangular pediment supported by four piers.

The proportions of the façade have a country-boy gawkiness, yet the tall and narrow portico conveys a sense of stature and of pridefulness. When the Faulkners arrived in 1930, William had recently assumed large responsibilities for the first time, including Estelle, the wife he had married a year earlier, her two children from a previous marriage, and the baby the couple was expecting in the coming months. Faulkner was working to establish himself as a promising author, and as Jill, Faulkner's daughter, would recall years later, Rowan Oak became "the symbol in Pappy's life of being somebody . . . a nice old house [that] had a certain substance and standing to it."

WILLIAM CULBERT FALKNER'S EARLIER LIFE offered few indications he would achieve worldly success. As a student, he proved bright but truant, failing to finish both high school and a later attempt at college. He enlisted in the R.A.F., but World War I

ဆင် ၆ာ

WILLIAM FAULKNER

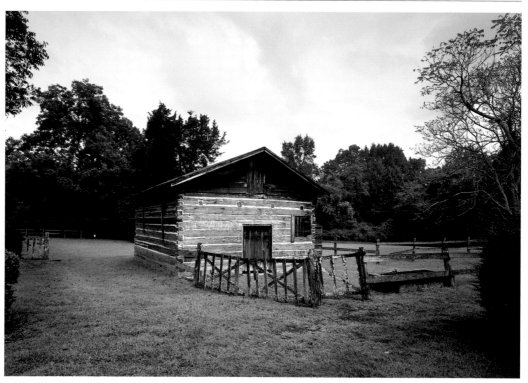

The "Post Oak Barn," built of hewn logs notched at the corners and chinked with local clay, was home in Faulkner's time to two Jersey milk cows.

ended before he could complete his training in Canada. Having added a letter to his name (he thought "Faulkner" seemed suitably British), he returned to Oxford and, despite being discharged a cadet before ever seeing action, he encouraged people to believe he had served with distinction, recounting tales of combat and war wounds, and affecting an officer's uniform.

In the coming years, he would lose a job as a scoutmaster on account of drunkenness. He was forced to resign as postmaster at the University of Mississippi when caught playing cards on duty by a postal inspector. Only when he and a friend underwrote its publication was his first book published, a collection of poems titled *The Marble Faun* (1924). It achieved neither acclaim nor commercial success.

He lived for a time in New Orleans, and his first two published novels, *Soldier's Pay* (1926) and *Mosquitoes* (1927), drew upon his abbreviated military service and literary life in New Orleans, respectively. But it was a friendship established with Sherwood Anderson, already the much-admired author of *Winesburg, Ohio*, that gave Faulkner the literary direction he had previously lacked.

In an appreciation published after Anderson's death, Faulkner recounted the advice the older man had given him. " 'You have to have somewhere to start from: then you begin to learn.' he told me. 'It don't matter where it was, just so you remember it and ain't ashamed of it. Because one place to start from is just as important as any other. You're a country boy; all you know is that little patch up there in Mississippi where you started from.' "

The immediate result of Faulkner's shift in focus was his third novel, *Sartoris* (1929), set in a fictional Mississippi county called Yocona. "Beginning with *Sartoris*," Faulkner later explained, "I discovered that my own little postage stamp of native soil was worth writing about and that I would never live long enough to exhaust it, and that by sublimating the actual into the apocryphal I would have complete liberty to use whatever talent I might have to its absolute top. It opened up a gold mine of other people"

The Sound and the Fury (1929), *Sanctuary* (1930), and *As I Lay Dying* (1931) quickly followed. With those books, Faulkner established himself as a writer with the oblique eye of a prose poet, a dramatist's skill with voice, and a historian's sense of the burdens of the past.

◄§ §►

WILLIAM FAULKNER

Rowan Oak is both obscured and enhanced by the cedar trees (Juniperus virginiana) that frame the view of its front façade.

WILLIAM FAULKNER

THE *ALLÉE* OF RED CEDAR FRAMES the portico. Their bark sloughing off, the out-of-plumb tree trunks reach for the sky, a stark contrast to the bright white of the freshly painted house beyond. While the classical details of the house look austere, rectilinear, and man-made, the trees add a discordant note of asymmetry.

A tour of the interior of the house suggests the push-pull quality of so much of Faulkner's life. Upon entering the hallway, the visitor enters the nineteenth-century stair passage, a space little changed since Colonel Shegog's time. It's a zone of separation, with Estelle's world to the right, on the left William's.

Estelle's parlor looks backward in time, with Victorian gentlemen's chairs and the baby grand piano she played with pride. The formal parlor opens directly to the dining room, a stately space with a long table where proper decorum reigned, with Estelle acting the relaxed and confident hostess, her manners and conversational skills well honed, her needs tended to by servants who waited on table. For his part, the shy Faulkner had little interest in small talk and felt more comfortable across the hall. There in the library are signs of modern times and foreign climes. He exercised his taste for sculpture, acquiring primitive and abstract pieces on his travels for the State Department. Rather than antiques, Faulkner chose contemporary furniture, overstuffed and comfortable.

Faulkner's life at Rowan Oak could hardly be described as blissful. He and Estelle drank self-destructively and he regularly visited Wright's Sanitarium to dry out after drinking binges. After their daughter Jill's birth in 1933, the couple rarely shared physical intimacies, and he found companionship with other women, notably Meta Carpenter in Hollywood and, later, the much younger Joan Williams, with whom he collaborated on the play *Requiem for a Nun* (1951). In the 1930s, the financial burden of

Left: Four generations of Faulkners line the walls in the library. William looks down from the mantel, joined by his father, grandfather, and great-grandfather. The bookshelves are lined with first editions by other twentieth-century masters, among them Lie Down in Darkness *by William Styron,* Life Studies *by Robert Lowell, and* Elmer Gantry *by Sinclair Lewis.*

A nineteenth-century spool bed was moved downstairs near the end of Faulkner's life when back pain had become a constant irritant. The outline notes for A Fable *line the wall.*

Note the riding breeches and boots in Faulkner's bedroom.

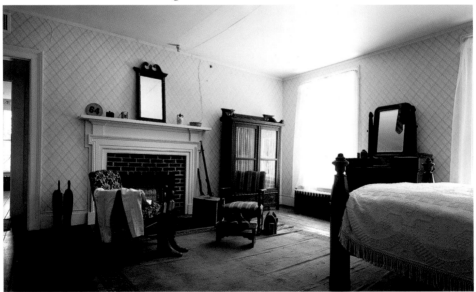

WILLIAM FAULKNER

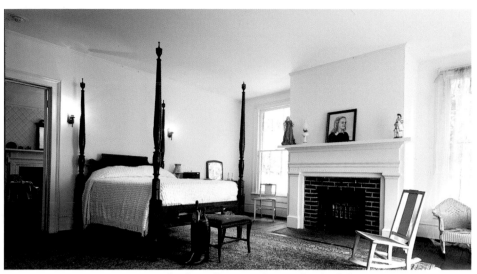

A portrait of daughter Jill rests on the mantel in her bedroom.

The room that became Estelle's bedchamber, with an easel positioned to take advantage of the natural light.

his family led him to accept scriptwriting work in Hollywood; Faulkner needed the money but resented the time spent away from Oxford. He wanted to write his books, but as he remarked to his agent in the winter of 1945, "I ought to know by now I don't sell and never will earn enough outside of pictures to stay out of debt."

Circumstances began to change in 1946 with the publication of *The Portable Faulkner*. Interest revived in his earlier work, and his out-of-print novels were re-released. Honors accumulated quickly, culminating in the Nobel Prize for literature, awarded in 1950. The Nobel prize money underwrote the addition to Rowan Oak in which he installed a study that today is the room in the house where Faulkner's ghost is most easily imagined.

The author's writing is literally there: On the plaster walls, Faulkner penned the outline for *A Fable* (1954). His retelling of the Christ story in the context of World War I, the book had already required years of writing and rewriting when he tried to impose order on the unwieldy manuscript in 1952. He posted the seven-day story line for easy reference in a fashion akin to the storyboards he had come to know in Hollywood. The notes are there today, as are the desk his mother gave him, his type-writer, and his pipes.

A MAP HANGS IN THE FRONT PASSAGE at Rowan Oak. Obviously hand-drawn, it delineates the topography of Yoknapatawpha County (that's *YAWK-naw-pah-TAW-fuh*). The northern Mississippi county is rectangular, 2,400 square miles in area, and bounded by the Tallahatchie and Yoknapatawpha Rivers. At center is the county seat, Jefferson, where all the rail and road vectors meet. The population is noted ("Whites, 6298; Negroes, 9313"). The map bears a signature, too: "William Faulkner, Sole Owner & Proprietor."

Right top: Faulkner's typewriter remains as it was when he died, down to the repair ticket on its case ("Oxford Repairworks . . . 7/26/52 . . . William Faulkner"). There's a bag of pipe tobacco, too. "My mixture," says the Dunhill label; it was blended to Faulkner's specifications.

Right bottom: Faulkner's office, added after 1950.

WILLIAM FAULKNER

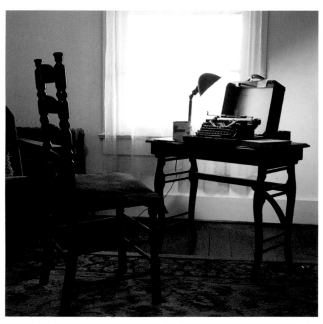

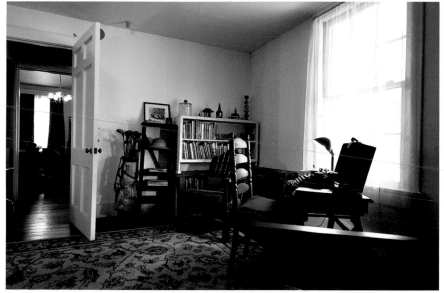

᪥᪥

Although Estelle's Chickering piano is the largest object in the room, the defining presence is the portrait above the mantel. In the painting Faulkner wears the membership jacket from the hunt at the Farmington Country Club in Charlottesville, Virginia.

WILLIAM FAULKNER

Readers of *Absalom, Absalom!* saw the map first, since it appeared in the pages of that novel when it was published in 1936. An annotated version was included a decade later in *The Portable Faulkner*, by which time the cartographer had added book titles, among them *The Sound and the Fury*, *The Unvanquished*, and *Light in August*, imposing the titles on regions of the county where the Sutpen, Compson, and Sartoris families resided.

Yoknapatawpha County existed only in William Faulkner's literary imagination, but the resemblances to the actual county of Lafayette and the city of Oxford, Mississippi, are unmistakable. Places drawn from life had a way of inserting themselves into Faulkner's books, such as the County Courthouse and the Confederate Monument that appear in the closing pages of *The Sound and the Fury*. But in writing more than a dozen novels and many short stories set in Yoknapatawpha County, Faulkner created an intricate — and largely imaginary — history.

Faulkner's books would entrance a future Nobel Prize winner, Gabriel Garcia Márquez; like Garcia Márquez's Macondo and Australian Patrick White's Sarsaparilla, Yoknapatawpha County has come to exist in the world's literary atlas as an international destination. Some readers complain that the dialect spoken by some of Faulkner's characters is impenetrable; it is not, of course, any more than Faulkner's modernist experiments with nonlinear narratives are incomprehensible. He rendered his characters and their stories onto the page in his own fractured and idiosyncratic manner; like other geniuses of his generation such as Frank Lloyd Wright and Edward Hopper, he created a world that, in Reynolds Price's words, is "too bizarrely private to be of real use to anyone else." Of utility to other artists? No, imitation isn't possible, though his work does live up to the observation he made in his Nobel Prize acceptance speech. "The problems of the human heart in conflict with itself . . . alone can make good writing because only that is worth writing about, worth the agony and the sweat."

For Faulkner those problems, those conflicts, were best enacted within not so many miles, literal and literary, of his microcosm, the house on Old Taylor Road.

Above: Oxford's old courthouse survives today in part because of a letter campaign by Faulkner in 1947 when others in town lobbied for its demolition.

Left: The Civil War had a way of resurfacing in Faulkner's literary imagination.

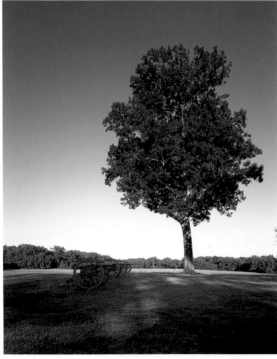

WILLIAM FAULKNER

Books by William Faulkner

The Marble Faun. Boston: Four Seas, 1924

Soldier's Pay. New York: Boni & Liveright, 1926.

Mosquitoes. New York: Boni & Liveright, 1927.

Sartoris. New York: Harcourt, Brace, 1929.

The Sound and the Fury. New York: Jonathan Cape and Harrison Smith, 1929.

As I Lay Dying. New York: Random House, 1930.

Sanctuary. New York: Jonathan Cape and Harrison Smith, 1931.

These 13. New York: Jonathan Cape and Harrison Smith, 1931.

Light in August. New York: Harrison Smith & Robert Haas, 1932.

Doctor Martino and Other Stories. New York: Harrison Smith & Robert Haas, 1934.

Pylon. New York: Harrison Smith & Robert Haas, 1935.

Absalom, Absalom! New York: Random House, 1936.

The Unvanquished. New York: Random House, 1938.

The Wild Palms. New York: Random House, 1939.

The Hamlet. New York: Random House, 1940.

Go Down, Moses and other Stories. New York: Random House, 1942.

The Portable Faulkner. New York: The Viking Press, 1946.

Intruder in the Dust. New York: Random House, 1948.

Knight's Gambit. New York: Random House, 1949.

Collected Stories. New York: Random House, 1950.

Requiem for a Nun. New York: Random House, 1951.

A Fable. New York: Random House, 1954.

The Town. New York: Random House, 1957.

The Mansion. New York: Random House, 1959.

The Reivers. New York: Random House, 1962.

Flags in the Dust. New York: Random House, 1973.

A courtyard outside Foote's longtime home in Memphis.

Right: Shelby Foote, at home, seated in his study.

SHELBY FOOTE

(1916 – 2005)

Memphis, Tennessee

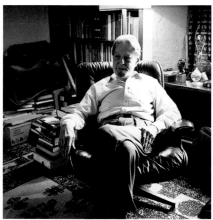

"I had lost my horse in the charge at the Fallen Timbers. Now I held onto the tailgate of a wagon filled with wounded, letting it pull me along because my boots had not been made for walking. Rain fell in slanted, steely pencilings. There was a constant murmur, the groans of the wounded as the long slow agonized column wound between weeping trees and wet brown fields."

From *Shiloh* (1952)

S ince we lost, we have a sense of tragedy," Shelby Foote says, his tone matter-of-fact. "It is of inestimable value to Southerners that we lost that war." His words as well as his quick, sly smile suggest the sense of irony with which he regards the world.

An edge of sadness is detectable whenever Shelby Foote speaks of "that war" – it was the Civil War, of course – about which he probably knows more than anyone else alive. He speaks of the conflict with the same gentle authority that millions came to admire with the 1990 airing of Ken Burns's "The Civil War," the Public Broadcasting Service documentary series. In the memories of many, the haunting photographic images of the war seem inseparable from Foote's vivid asides and his gift for the apposite quote.

His defining presence in that show brought the seventy-four-year-old Foote a sudden and unexpected celebrity. His own masterpiece, *The Civil War: A Narrative*, a monumental three-volume history of the conflict, made an unlikely climb onto bestseller

lists. *Fort Sumter to Perryville*, *Fredericksburg to Meridian*, and *Red River to Appomattox* (volumes I, II, and III, respectively) are immense books, amounting to nearly a million and a half words. They had been published years before (1958, 1963, and 1974), but Foote and his books found a fresh currency.

Shelby Foote's art is richer and more complicated than either the rebirth of his trilogy or his emergence as a television talking head of unusual charm and intelligence. Once introduced to his histories, eager readers found his novels, too. Widespread recognition came to him late in life both as a writer and as a public man valued for his sense of conscience about his region and the terrible war that still defines it.

Shelby Dade Foote was born in Greenville, Mississippi, the only child of parents with Delta roots tied to King Cotton. Most of the money was gone by the time of Shelby's birth, but his father was rising rapidly as a manager in the meat-packing concern Armour & Company. Work had taken the family to Vicksburg, Mississippi; Pensacola, Florida; and finally to Mobile, Alabama, when the elder Foote died suddenly of septicemia after a minor operation. Five-year-old Shelby and his mother returned to Greenville, then a modest-sized town of some twelve thousand inhabitants. There he would spent most of the next thirty years.

Foote's mother found work as a secretary while he attended school, learned to hunt ("I think hunting is a good exercise for a young man about to become a man"), and, in particular, read for the simple joy of it. His usual fare was of the ilk of *Tarzan* and *Tom Swift*, but, as he recalls, "One of the signal adventures of my childhood was being given *David Copperfield* as a Sunday-school prize." He read the tale of Dickens's orphan with growing interest, discovering a rich and deep literary experience he had not previously known. "By the time I finished, I knew the characters better than myself and my family. It showed me a world." During these years his enduring friendship with his contemporary Walker Percy was also established.

As a teenager he would often turn to fiction. He relishes the recollection of the summer he was sixteen and read *Ulysses*, *The Magic Mountain*, and *Remembrance of Things Past*. To this day, a photograph of Marcel Proust, another man haunted by the past, hangs over his desk. Despite his precocious reading tastes he was an indifferent student, investing his energies in what interested him to the exclusion of subjects that did not. He did become editor of his high school paper. One of Foote's proudest memories remains the national prize the paper was awarded.

❧ ❧

SHELBY FOOTE

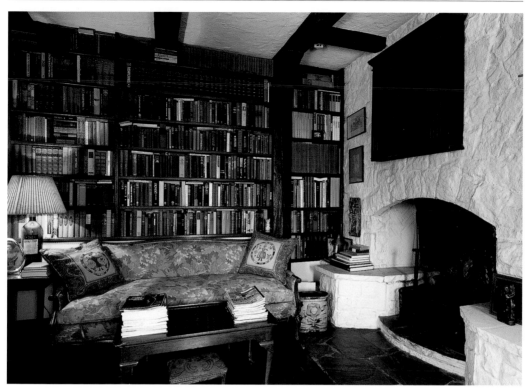

These bookshelves bear the considerable burden of a fine edition of Henry James, left to Foote by Walker Percy when he died in 1990. "He was my best friend in the world," Foote says, as he explains their understanding. Had Foote died first, his Limited Edition Club set of Shakespeare would have gone to Percy.

He attended the University of North Carolina from 1935 to 1937, but there too he was a less than disciplined student. "I never wanted a degree of any kind and spent most of my time in the library," he remembers, although he did find time to write stories and book reviews that appeared regularly in the university's *Carolina Magazine.*

After leaving college, he found odd jobs but also the time to complete the first draft of *Tournament.* A novel about a farmer recognizable as Foote's grandfather, *Tournament* is set in the years after the Civil War and possesses recognizably Faulknerian overtones; it wasn't destined to see print until after World War II, as Foote received the inevitable summons from the U.S. army in 1940 and headed for officer training school in Oklahoma. By 1944 he had reached the rank of captain. He was stationed in Ireland when he butted heads with a superior officer and was court-martialed. He returned to America, though not to Mississippi, remaining in New York to work for the Associated Press. He enlisted in the Marines in 1945, but the war ended before he could see action.

Following the war, he settled again in Greenville, along with his Irish wife, and worked intently at becoming a writer. He sold a story adapted from *Tournament* to the *Saturday Evening Post* in 1949 and then the entire novel was accepted for publication. He was forced to set aside the second book he had been working on, *Shiloh;* his editors regarded its form as too experimental (seven different voices recount the great battle in free-standing monologues). In succeeding years other new novels were published, including *Follow Me Down* in 1950 and *Love in a Dry Season* in 1951. Both those books examine in intimate detail the divided nature of Southern culture, though the characters in the first are poor and in the second well-to-do. His look at one Mississippi county from numerous fictional angles, *Jordan County*, appeared in 1954.

Ironically, it was the delayed publication of *Shiloh* (the novel finally appeared in print in 1952) that would recast Foote's writing life. That book caught the eye of publishing impresario Bennett Cerf.

"He wrote me a letter," remembers Foote. "He wanted a history series and asked would I undertake to write a one-volume history of the Civil War." As the request came from the founder and publisher of Random House, Foote took it seriously.

"I decided it would be an interesting way to spend a year," he says, his intense eyes darkly amused.

"I blocked it out, and sent him a letter. I knew it was a spread-eagle job even then."

❧ ❧

SHELBY FOOTE

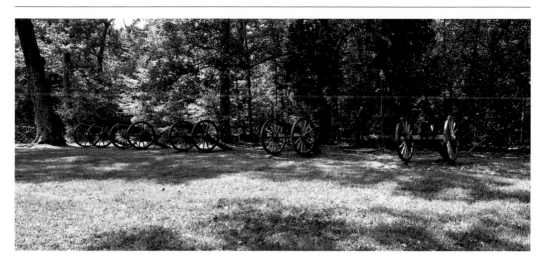

The two-day battle at Shiloh in 1862 has commanded Foote's attention three times — in a novel, his history of the Civil War, and later on television.

❧ ❧

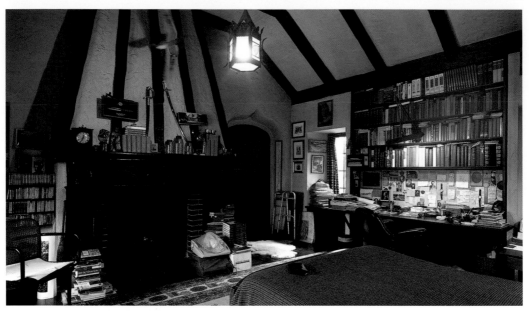

SHELBY FOOTE

What he didn't know was that it would take him almost twenty years to finish and that the three-volume opus that emerged would become his *chef d'oeuvre*, despite such fine novels as *Love In a Dry Season* and his last, *September September*, the book he had begun before *The Civil War* and finished many years later.

Cerf had recognized a storytelling strength that he believed could be employed to great effect not only in writing fiction but in recounting history. As anticipated, Foote found the adjustment no particular challenge. "I found there was no difference," he says simply. "It was just a matter of where the facts come - whether they come from history or from memory."

The result was a historically accurate rendering of the war, battle by battle, but one enriched by the novelist's psychological insight into both Southern and Yankee soldiers. The editors at Random House hired an expert to check the facts of the first book, but he found little to quibble with in a volume that critics, recalls Foote, regarded as "amusing to read but not real history." The second book got more general approval, and by the time volume three arrived, professional historians were largely onboard.

The books became the classic work on the war, a basic text to be referenced by any serious scholar. The novelist had become a historian.

THE GREAT, HALF-TIMBERED TUDOR HOUSE was built for a cotton broker in 1930, but Foote and his third wife have lived there since July 4, 1966. The house sits beside a generous parkway in a comfortable neighborhood on the outskirts of Memphis, its solid brick construction almost indistinguishable behind a dense line of trees. The immediate landscape has grown unruly; the life of the house is indoors, its owners long since having given up grooming the yard.

Foote is generally to be found, as he says, "in the large room with the fireplace in the back where I do my work." It is a tall room, and there is indeed a fireplace, an immense one with an angling chimney breast that pitches to the ceiling. Yet his floor-

Left top: Foote's study where he has worked for nearly forty years.

Left bottom: "I had it made," he says of the desk. It consists of thick oak shelves milled from beams recycled from a dismantled mill in New England.

to-ceiling desk and bookshelves are substantial enough to compete with the fireplace for attention. It is immediately apparent that his writing life has been focused there.

The desk is cluttered with papers and pipes (they're throughout the house), as well as such mementos as a minie ball. That's a reminder of how technology changes war: The deadly accuracy of the lead projectile at a distance of several hundred yards rendered the infantry charge suddenly obsolete, although, as Foote points out, some Civil War officers were slow to recognize the change — with tragic consequences. There are notes and postcards and prints, among them a Paul Klee of Jason, the legendary Greek hero.

No computer is in evidence; Foote eschews not only computers and typewriters but also ballpoint and fountain pens. His writing utensil of choice is a dip pen, consisting of a wooden handle with metal tip or nib. ("They don't make them anymore. I found a supply in New York years ago.") There's no internal source of ink — as the name implies, the tip must be dipped into an inkwell — and wielding the pen requires considerable skill. For Foote, it enhances the connection between him and the paper that receives his composition. He admits to grave doubts about writing teachers, word processors, and anything else that resembles a shortcut. One result of his insistent independence is that his manuscripts and letters are such evident handworks that you can almost hear the soft scrunching of the pen as you read them.

He has his own ideas about writing but shares only a few of them. "I have a dislike of adverbs," he admits. "I use them rarely." Writing for him is hard, slow work — his output is five hundred words a day. His routine is to transcribe his writings with ritual care at the close of each day. "Revision is a form of agony for me," he says with resignation in his voice.

THE IMMENSE CANVAS OF THE CIVIL WAR stretched across more than a dozen states, but one brief battle near an obscure church, Shiloh Chapel, presents in miniature much about the war and its chronicler, Shelby Foote.

The battle at Shiloh played a recurring role in Foote's life. He has recounted the two-day drama in each of his storytelling roles, first as a novelist in *Shiloh*; later as a historian in the first volume of *The Civil War*; and then a third time on television in the Ken Burns/PBS documentary. The story elements are unmistakably rich. It was the first great battle of the war, one in which the South at first prevailed, only to be pushed

❦

SHELBY FOOTE

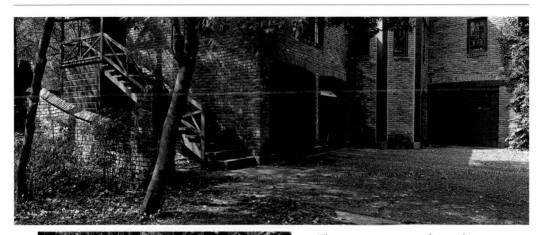

The vegetation appears to be marching on
Shelby Foote's house.

❧ ❧

back in the second day of the battle. Both armies fought with great bravery and sustained terrible losses. Mother Nature collaborated in setting the scene, providing the breathtaking beauty of cherry blossoms that floated down upon the fallen soldiers in the orchard. A poetic touch was at hand, too, in that the log church's name meant in its original Hebrew "the place of peace."

Foote found in the person of Lieutenant Colonel Nathan Bedford Forrest one of only two players in the entire drama of the Civil War whom he chooses to call "authentic geniuses" (the other? Abe Lincoln). Forrest, a Tennessean with no formal military training, had the mix of courage and self-preservation essential to a great soldier. He led many a charge and, in a quirk of fate that no novelist or historian could help but appreciate, he was wounded by the last shot fired at Shiloh. Still he managed to keep control of his horse and get back to his line.

Shiloh surfaces at yet another moment in Foote's life, on a day when one can only wish the cameras had been rolling. William Faulkner, by then a great man of American letters, asked the promising young novelist to take him on a tour of the battlefield. Foote agreed and they set a date. Foote arrived early that Sunday morning at Faulkner's house, Rowan Oak, and they set off. Some ninety miles later they stopped in Corinth, Mississippi, for breakfast in a hotel. When they had finished eating, Mr. Faulkner suggested that a little hair of the dog was in order. Foote, himself no stranger to alcohol, had to admit he wouldn't know where to find a drink on a Sunday morning in Alcorn County.

"Just ask that man," Foote remembers Faulkner suggesting, indicating a man at the other end of the hotel lobby. The well-dressed gentleman was having his shoes shined, and Foote thought he was more likely to be preparing for church than to visit a bootlegger. But Faulkner insisted, and to Foote's surprise, the man proved accommodating: "I was just heading there myself. I'd like to ride along."

After their detour they drove the last twenty-odd miles to the battlefield. Foote identified the essential sites, among them the so-called Hornet's Nest, where an outnumbered band of Union solders had made a brave stand, as well as the site where Confederate General Albert Sidney Johnston had bled to death surrounded by his officers. Foote explained in detail the ebb and flow of battle and how the tide had finally turned with the crucial though belated arrival of Union General Don Carlos Buell.

⤜§ §⤏

SHELBY FOOTE

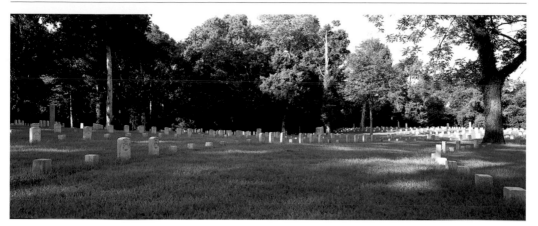

The army of gravestones at Shiloh National Cemetery.

Foote recalls a rapt and attentive Faulkner. "He had an immediate under-standing of the topography," says Foote in an admiring way. But when he talks of Shiloh, inevitably, the high tone must fall. As he explained to Ken Burns and the millions in the television audience, "Shiloh had the same number of casualties as Waterloo. And yet when it was fought, there were another twenty Waterloos to follow." His voice is gray, leaden.

Therein lies the terrible paradox of Shiloh. It's a brilliant, multifaceted story, with high drama, worthy players, and higher stakes; but, in the end, it represented a terrible reverse for the South and a staggering loss of life for both sides. For Foote, it's a painful story but one he felt he must keep alive.

SHELBY FOOTE CHERISHES HIS SOUTHERN-NESS: "Southerners have the ability to put up with eccentrics," he observes. His novels are dotted with wry portraits of ambitious Yankees (from *Love In a Dry Season*: "His son . . . [was] a rising politician, a leading light in the state legislature despite the handicap of a Harvard education"). He once observed ruefully that had his father lived, his business success might well have led to a transfer to his employer's home office in Chicago. To Shelby Foote, a childhood spent in an Illinois suburb seems irreconcilable with his Southern roots.

Yet he's no regional apologist. He is the first to acknowledge that the last word has not been written on emancipation. For him, freeing the slaves was a glorious moment, a turning point in the war and in American history. "But also a tragedy, because four million people were suddenly free — with no jobs or trades or learning."

He has worried about the legacy of emancipation and evinces anger and sadness as he recalls the battles over segregation that were fought while he was writing *The Civil War*. In a closing note to the second volume of his history, he acknowledges that "I am obligated . . . to the governors of my native state and the adjoining states of Arkansas and Alabama for helping to lessen my sectional bias by reproducing, in their actions several of the years that went into the writing of this volume, much that was least admirable in the position my forebears occupied when they stood up to Lincoln." He explored the same territory in his last novel, *September September* (1977), a book that unfolds during a racial confrontation in 1957.

A sense of loss pervades the story of Shelby Foote's life and work. He is elderly now, and he suffers chronic back problems that limit his mobility. But the same

❧ ☙

SHELBY FOOTE

intense intelligence looks out from beneath his gray hair, parted just off center, and through the neatly trimmed beard. His conversation is still punctuated with tobacco pauses, the packing and the lighting of the pipe, the smoky exhalations, the thread of the story resumed. He watches his listener intently, his penetrating look checking his guest's comprehension as he himself continues to struggle with paradoxes concerning the war, racial inequality, and the South of which he feels so much a part.

As he nears the end of his ninth decade, Foote has retired from writing books. "I won't write any more histories or novels," he says. "I am editing and writing introductions." He says it with no apparent sadness, but rather as if it were a business decision that had to be made.

Still, though, he remains engaged in considering the past, near and distant. "I'm reading Tacitus," he allows. "Now he's my idea of a historian."

Books by Shelby Foote

Tournament. New York: The Dial Press, 1949.
Follow Me Down. New York: The Dial Press, 1950.
Love In a Dry Season. New York: The Dial Press, 1951.
Shiloh. New York: The Dial Press, 1952.
Jordan Country. New York: The Dial Press, 1954.
The Civil War: A Narrative. Fort Sumter to Perryville. Volume I. New York: Random House, 1958.
The Civil War: A Narrative. Fredericksburg to Meridian. Volume II. New York: Random House, 1963.
The Civil War: A Narrative. Red River to Appomattox. Volume III. New York: Random House, 1974.
September September. New York: Random House, 1977.

Lush vegetation screens the entrance, adding privacy and even a sense of secrecy to Gurganus's home.

Right: Surrounded by his books and a miscellany of objects, Gurganus talks of his writing. "I do a first draft in longhand before I type it. Then I print it out and edit in longhand." He pauses, then adds, "I'm never more than one generation from longhand."

The Natural Archivist
ALLAN GURGANUS
(1947 –)
Falls, North Carolina

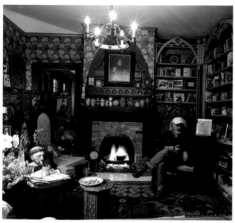

"Looking back, I see this urge to run barefoot in Manhattan was one early warning sign of homesickness for North Carolina."
From *Plays Well with Others* (1997)

Allan Gurganus was born and raised in Rocky Mount, North Carolina, but the U.S. Navy turned him into a writer. Art had enraptured him as a child ("Drawing paper was as important in the kitchen as bread was"). At eighteen he ventured north to study at the Pennsylvania Academy of Fine Arts, only to drop out after a year. Then a draft-board detour took him to sea, and, quite by accident, his life took another tack.

An itinerant apprenticeship followed, with station stops at Stanford, Duke, the Iowa Writers' Workshop, and Sarah Lawrence College. Inevitably, perhaps, his fiction took a turn toward home. An imaginary town called Falls, North Carolina, began to take shape in Gurganus's mind. Finally, a quarter century after he left, he returned to North Carolina, buying a home in a small town not far from Chapel Hill in 1991.

The house he purchased sits in a historic district, with the home of a signer of the Declaration of Independence on one side and an aged graveyard on the other. The setting suits Gurganus nicely, not least because his work has a way of inhabiting the past. Some of his stories explore variations on his 1950s boyhood, along with

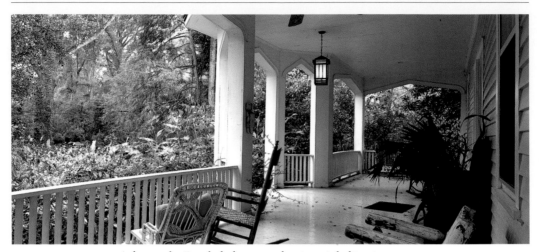

A deep porch offers shade, breezes, and a view of the historic streetscape.

⊸§ ҉ ⊱

ALAN GURGANUS

characters belonging to his parents' and grandparents' generations – though he's quick to say, "I'm not an autobiographical writer." His penetrations into the past go further, too, notably in his best-known book, *Oldest Living Confederate Widow Tells All*. Its title character, Lucy Marsden, is a ninety-nine-year-old survivor who, despite being wheelchair-bound in a nursing home in the time of Reagan, guides a tour that reaches back to Civil War days.

Old Lucy Marsden lived in Falls, too, as did her husband and children. "I can imagine walking the streets and seeing where my Widow lives," explains Gurganus. "I have a map of the place in my head. It's neither Rocky Mount nor this town but draws on both."

He concludes, with emphasis: "It's a compendium and a dream."

GURGANUS (PRONOUNCED *GRRR-GAIN-US*) spent most of his time in the Navy on an aircraft carrier. He worked as a cryptographer, locked away in a secure room. His hidden-away space proved to contain more than military secrets, as Gurganus, not yet twenty, found his new vocation.

"Luckily the ship had a library," Gurganus remembers, "and I started reading seriously." He reels off a syllabus-like litany of great works, then explains that his prodigious reading jag was made possible by a locked door that could be entered only by keying in a code. When visitors to his high-security domain began fingering the key pad, Gurganus was given ample warning to stow his illicit Shakespeare or Chekhov.

"I feel like I learned to be a writer in prison," he admits, smiling happily as he recalls his furtive readings. "During my Navy time I think I read about twelve hundred books."

His literary explorations inspired him to begin putting words to paper. He wrote imitations of Jane Austen, Jorge Luis Borges, and a wide range of other writers. "Once I had started reading seriously – specifically, Henry James's *Portrait of a Lady* was the epiphany – I suddenly thought, 'I could do this, too.'" He began to develop the voices that distinguish so much of his work.

After his Navy discharge, he sought out Grace Paley and studied with her as he completed his undergraduate degree. Thanks to a Danforth Fellowship he worked with Stanley Elkin in Iowa City, but still another mentor there, John Cheever, was

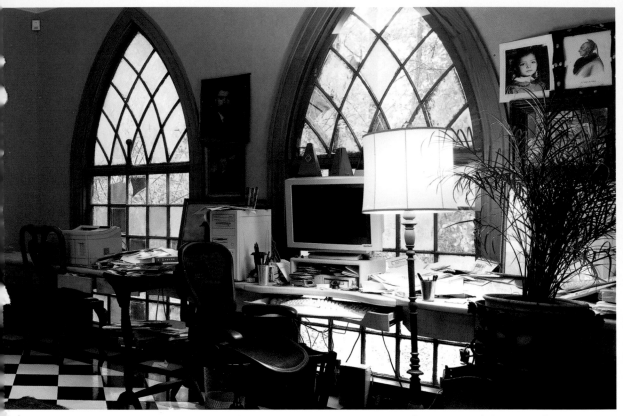

Gurganus reoriented a large room at the rear of his house to welcome morning light. "I'm up before the sun," he says, "and at work by 6:30. I stay at it till 3:30 or 4:00; that's an honest day's work."

❦

ALAN GURGANUS

Gurganus has not forgotten his roots as a visual artist. Working in tandem with a friend, David Faust, he reproduced larger-than-life figures in oils for his upstairs hall, based on the Parthenon frieze. "It always seemed to me an emblem of perfection. And a timeless work of art."

ALAN GURGANUS

instrumental in getting his first story published when he submitted it on the younger man's behalf to the *New Yorker*.

In that story, "Minor Heroism," Gurganus invited his readers to see the world through the eyes of his characters, in particular a boy and his military dad. He had begun behind those closed doors on the USS *Yorktown* to inhabit the minds of his characters, to listen to them as they recounted moments in their lives. The cryptographer developed his characteristic prose. It's layered, rich with allusions, wordplay, small jokes and large; it asks the reader to examine more than its surface. Thanks to Henry James and the U.S. Navy, Gurganus conducted an experiment; to his joy, he found he really could write.

"The beauty of belief," he recalls, "is that it offers you an apprenticeship."

AT HOME HE DRESSES CASUALLY, favoring jeans and layered woolens when the weather is cool. His face is framed by a neat gray beard that gives him a sober and reserved air. But in person, as on the page, Gurganus is a coiled spring. He doesn't have to speak first; he doesn't talk rapidly; and he doesn't feel the need to fill silences. But when he starts talking, it's in a sudden burst of erudition and energy that amuses and compels.

The Gurganus clan has inhabited North Carolina since a Welshman named Gurgan arrived at Jamestown in 1610. A cluster of Gurgans lived in coastal Wilmington, North Carolina, by the time the first constitutionally mandated census was conducted in 1790, and somewhere along the line the name got pluralized to Gurganus. The family tree is heavy with farmers and merchants, not a few of them in the business of tobacco.

"I bought this house," he says, gesturing around a book-lined sitting room, "because it reminded me of my grandparents' house. It has the same foursquare construction, with large rooms and some whimsical touches." The house has arts-and-crafts detailing, with lots of shellacked woodwork and a staircase with a butternut balustrade. Its generous space encloses some 3,600 square feet, ample for Gurganus's own whimsical touches, such as his excerpting of the Elgin marbles in an upstairs hall and the Gothic windows he added to his writing room.

As these elements suggest, Gurganus's artistic inclinations were not entirely eclipsed by his literary ambitions. "I've always been very visual in my orientation," he

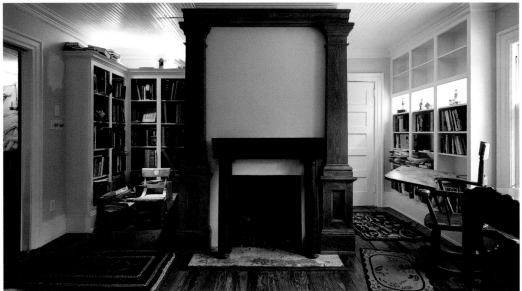

Top: An acre behind the house has become a generous garden. "My mother was not to be interrupted when she worked in the garden," says Gurganus. "I didn't understand then — now I do." Even the plant matter has a history: "The peonies in my garden were transplanted from my parents' land in Rocky Mount; they'd earlier been moved from my great-great-grandparents' land in Illinois."

Bottom: On the upper level is another library in a comfortable bedroom.

ALLAN GURGANUS

says. "I like to think of myself as a visual glutton." Some of his books feature his art-work, including his calligraphy on the jacket of *Widow*. More important, his writerly imagination sees the world in artistic terms. He describes autumnal light as "full of spun gold out of the Dutch pictures." A maiden lady in the title story in *The Practical Heart* dignifies her otherwise quotidian life by inveigling John Singer Sargent to paint her portrait. In another story from that book, "Preservation News," the reader encounters a passionate preservationist, Theodore Hunstable Worth. Tad sees Monticello not merely as a monument to a founding father but also as a "ferocious Palladian blueprint, a golden mean of absolute proportion underwriting all our messy doings and our failed designs." For a Gurganus character, it is possible to love a building like Jefferson's house because of its "good faith," "modesty," and "frontal candor, almost virginal."

In his own house, Gurganus's visual orientation is apparent, particularly in his collections. There are books, of course, but also dozens of mirrors, many with Federal-era frames and *églomisé* paintings of buildings. He has surrounded himself with a small army of statues and busts. Some are religious, others classical, but they represent something else to him. "They're objects of meditation, and while I do meditate on them in the orthodox way the sculptor intended, I also find having lots of figures here comfort-ing. They're theatrical stand-ins for the characters I'm working on."

In his writing, Gurganus has repeatedly demonstrated a sensitivity to voices of the past. Perhaps that predisposed him to the house. It had been built for the town's physician about 1900, but he admits he hadn't expected to be welcomed by a ghost shortly after moving in. The shade wasn't Doc Durham's, but that of a subsequent inhabitant, a piano teacher. In her declining years she had taken to sleeping on the ground floor in a room Gurganus much later designated as his dining room. The spirit of the former inhabitant protested, Gurganus reports, by turning on the lights in the middle of the night.

He devised a suitable method of exorcism. He moved a boombox into the room, programming it to repeat continuously a CD of Glenn Gould's first recording of Bach's "Goldberg Variations." Then he went out of town, leaving the pianists together for the weekend. Gould's playing would no doubt be welcome to almost any piano teacher's ear, but, as was Gould's eccentric way, the taping also captured the man at his most concentrated; to the careful listener, his audible breathing and periodic humming

makes it eerily possible to imagine him in the room. Thanks to the agency of Gould, Gurganus reports, the ghost took her leave.

GURGANUS ADMITS, WITH A SHRUG OF RESIGNATION, "I'm always the one who settles the memory disputes." That comes as no surprise to readers of his work, with its atmospheric details. He's a natural archivist, a man for whom such incidental records as address books assume an almost totemic importance.

"Memory is a mixed blessing; you're carrying an immense honeycomb of information. I used to find myself telling stories. Of my family and of the South. And people would say, 'You must write that down.' That's how it started.

"But all those memories also allow me room for invention, for things that spring from the actual." With an ironic smile, he adds, "Memory makes you a very good liar."

He laughs. "Part of lying well is taking things beyond what anyone would believe. But that's reality. The joy of doing what I do is the making up. It's that leap that allows you to succeed." He's rolling now, thinking, talking, explaining, looking for a closer and he finds it.

"A novelist is a professional rememberer. A noticer. A Borgesian keeper of the lore."

His work reflects his attitude. Gurganus doesn't limit his mnemonic adventures to his personal history. The shadow of the Civil War seems to loom for every Southern writer, but Gurganus decided not merely to allude to it but also to wrestle it into the pages of a book. His aged widow takes an epical approach to her life and her husband's, but Gurganus isn't content with locating them in their times. He also casts Abe Lincoln as a peripheral character; he gives cameos to J.E.B. Stuart and Robert E. Lee. Slavery lingers like a low-lying fog on an overcast day.

There's a fearlessness about his work. Race may be a defining issue for America, but for Gurganus it's a given. "Growing up, I lived a very integrated life. My first memory is of a black woman singing me English folk songs. When I heard footsteps coming down the hall in our house, I never knew whether they were a white person's or a black person's." He has created such black characters as Castalia, a former slave who plays a supporting role and more in *Widow*. A man not given to braggadocio,

<div align="center">⤙§ §⤚</div>

<div align="center">

ALLAN GURGANUS

</div>

Left: The arrangement on Gurganus's kitchen table resembles a still-life painting.

Below: The upstairs bath is grand and spacious, with decorative tiling and ample natural light as well as artificial illumination.

Gurganus speaks with evident pride of that book: "One of my vindications is that *Widow* is being taught in African-American literature classes." He looks at slavery in a way that makes the unendurably sad funny and does it without diminishing anyone.

In the same way, he can look at a homophobic father who is unable to fathom his own son, a boy who was described as "artistic" back in a time when that was a euphemism for what we now call gay. Gurganus's most recent novel, *Plays Well with Others*, concerns the joys of friendships made and lost in the age of AIDS. A trio of young New Yorkers — a composer, an artist, and a writer — aspire and dream and, along with the reader, watch as one of their number, the angelically beautiful composer Robert, moves blithely toward his meeting with the grim reaper. It's a novel about the universals of love and death, but the sense is not so much of loss as of being lost when confronted with a death.

Plays Well with Others, despite its New York setting, is the first book he wrote at the North Carolina home he has dubbed Sunnyside ("Like Joyce? He had to go to Paris to write of Dublin," he says with a laugh). The novel is a love letter to lost and absent friends: "Having retreated from New York the day after the funeral of a close friend, I moved here and, having escaped with my life, I felt obliged to tell the tale."

His work is very much about tales he feels obliged to tell. His characters share his passions: language, art, architecture, and the history of his region which, like some ghostly rocking chair, won't stop creaking in the background. His writing is the prose equivalent of the floor exercise in gymnastics — full of flips (some of them remarkable) and racing steps and thumps. His stories are literate and playful — a dog is named "Circa" (because she's always around). Aphorisms abound ("History is all self-interest," his Widow observes). The displays of wit are essential to it, but these are brief distractions from the deeper part of the performance. Underlying it all is a kindness.

Gurganus has a protective patina of mischief about him, one that shields a certain sadness. But he ministers to the characters tenderly, and they seem to deserve one another in a happy sense, as they push and probe. He is a man who left home to see the world and found his calling. Yet in many ways, it seems, he never abandoned North Carolina, having always maintained his voter registration there ("to vote against Jesse Helms").

❧ ☙

ALLAN GURGANUS

Of his residence, he says simply, "This house is a kind of retreat." Clearly it's a place of solace; he refers to it, only half in jest, as "Sunnyside, that house as bedroom slipper." He's happy to be back, in a place full of secrets and stories to be told in a uniquely Gurgantuan fashion.

Books by Allan Gurganus

Oldest Living Confederate Widow Tells All. New York: Alfred A. Knopf, 1989.
White People. New York: Alfred A. Knopf, 1991.
Plays Well with Others. New York: Alfred A. Knopf, 1997.
The Practical Heart: Four Novellas. New York: Alfred A. Knopf, 2001.

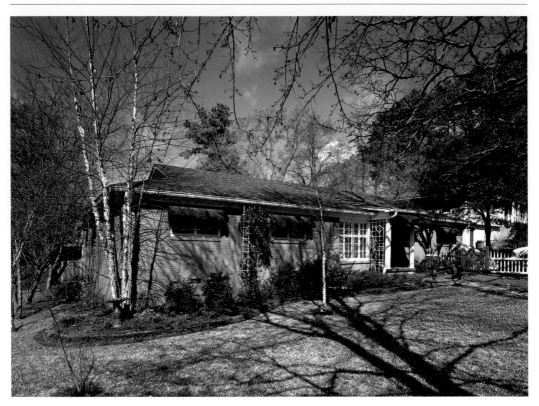

Barry Hannah's home, built into a hill, is a convenient distance from the Ole Miss campus.

Right: He describes his Kawasaki Vulcan as "a beautiful instrument of sculpture."

"It's a Beach House"
BARRY HANNAH
(1942 –)
Oxford, Mississippi

" 'You great Bastard,' I yelled up there. 'I believed in You on and off all my life! There better be something up there like Jane or I'll humiliate You! I'll swine myself all over this town. I'll appear in public places and embarrass the shit out of You, swearing that I'm a Christian!' "

From "Love Too Long" in *Airships* (1978)

A s a young man, Barry Hannah was the kind of guy you can imagine driving around with a cardboard box (perhaps an empty beer case?) filled with eight-track tapes. Readers of his books, especially the early ones, embark on a kind of windows-open, music-blasting joy ride. Hannah's talking the whole time, cracking jokes and returning periodically to the story he started telling, but the steady undercurrent of the music on those tapes rumbles just above the wind and engine noise.

His first novel, *Geronimo Rex* (1972), demonstrated his mastery of the riff. His characters get up a head of steam, fueled by language and lust. His protagonist, Harry Monroe, grows up in its pages and adopts as his spiritual mentor Geronimo, the Apache warrior who spent much of the second half of the nineteenth century terrorizing white settlers in the Southwest. "What I especially liked about Geronimo," reports Monroe in the pages of *Geronimo Rex*, "was that he had cheated, lied, stolen, mutinied, usurped, killed, burned, raped, pillaged, razed, trapped, ripped, mashed, bowshot, stomped, herded, exploded, cut, stoned, revenged, prevenged, avenged and was his own man"

❧ ❧

Hannah's junior Geronimo is a much less violent man. A typical Monroe escapade is his visit to the college library. Once in the stacks, he breaks wind loudly, attracting the attention of a graduate student working in a nearby carrel. The stranger happens to have every book in the catalog concerning Geronimo, which, under threat ("I'll hit you in the face unless you give me the books"), he relinquishes to Monroe. After a stop in the rest room to evacuate his bowels of the red beans and rice, Tabasco, and extra sausage that produced the flatulence, Monroe climbs out the window. "I felt clean, fit, and mad as an elk," Monroe reports, books in hand.

A Mississippian by birth, Hannah grew up in Clinton, outside the state capital, Jackson. He earned his bachelor and master of arts degrees in 1964 and 1966 at Mississippi College; *Geronomo Rex* is loosely based on Hannah's years there, and that novel put Hannah on the literary map early (he was thirty), winning him prizes, recognition, and a place on the writer-in-residence circuit, enabling him to spend time teaching in Vermont, Alabama, Iowa, and Montana. His novel *Nightwatchmen* was published in 1973, but it was his first collection of short fiction, *Airships* (1978), that got him major review attention once more and prompted a call from director Robert Altman summoning him to Hollywood. No films resulted from his labors, he says resignedly, though a book did — an eccentric crossbreed called *Power and Light: A Novella for the Screen from an Idea by Robert Altman* (1983). But the time spent was agreeable. "I was broke, recovering from alcohol, and he likes writers," Hannah observes.

One of the most admired stories in *Airships* anticipates a change in Hannah's writing as his subject matter broadened and deepened. In "Dragged Fighting from His Tomb," he wanders back into history. The narrator recounts the story of how he shot Confederate hero Jeb Stuart; the shooter recollects the tale from the distant vantage of his own dying days decades later at the turn of the twentieth century. It's vivid and violent and, in its oblique manner, conveys the cruelty of war in the way that the acrid smell of gunsmoke suggests danger.

"I like Jeb Stuart because he was the last of the great cavaliers," says Hannah when asked about the story. "His life was short, but I loved his dash."

He grows silent for a moment. "There was almost a death cult when I was growing up — Hendrix, Jim Morrison." Another pause. "Jeb Stuart was the Confederacy's rock star." He laughs, the connection made. "He had glory, eccentricity, style, and real courage." And, ultimately, a certain self-destructive charisma that many of Hannah's characters share.

◦§ §◦

BARRY HANNAH

The garden is his wife Susan's province.

Two figures in Hannah's private life — one of his six dogs and a garden sculpture out back.

117

"I HAD A CONTEMPT FOR HISTORY because I heard so much of it," remembers Barry Hannah. "But it's been a revisiting for me since 1982." That was the year he moved to Oxford.

The weight of history is a welcome burden in his adopted town. Its founding occurred when three Lafayette County residents donated land and named the village they established after the ancient English university town; they hoped their Oxford would become home to the state's first university. A few years later – in 1841, to be exact – the Mississippi legislature chartered the school now known as Ole Miss.

The chief spirit that haunts the place, however, never spoke with an Oxonian accent. Most of the twelve thousand residents happily accept the presence of William Faulkner's ghost (his home for more than thirty years has become a museum on the other side of town from Hannah's house). Hannah's own home bears little resemblance to Faulkner's two-story Greek Revival manse, Rowan Oak. And Hannah shrugs off the burden of being heir to Faulkner's role as Oxford's writer-in-residence. "I'm just happy to have found a hometown," he says.

The unprepossessing Hannah house was built in 1958. It is a generic ranch like millions of others across the country constructed for the parents of the baby-boomer generation. It's a short ride from Courthouse Square, the center of old Oxford, and not far from the University of Mississippi, where Hannah runs the masters of fine arts program in creative writing.

"It's a beach house," Hannah deadpans when asked about his house. Strangely – after all, the setting is a land-locked suburb – the description almost fits. Hannah added a meandering porch around the back of the house overlooking the quiet, half-acre backyard. Even from inside, there's an indoor-outdoor feel to the house, the result of French doors added in the renovation, which offer direct access to the yard from the kitchen, living room, and his office. "I wanted the openness," he explains.

The experience of the place changes upon entering Hannah's office. Music plays; he routinely writes with music in the background. "Bob Dylan has given me a lot of jokes," he observes, "and a title, too" (*Yonder Stands Your Orphan*, 2001). "He's the poet of my day."

Music performs a more subtle role in his life as well. "It needn't be a spoken line. But something beautiful in a musical line can open up your heart for expression.

BARRY HANNAII

I'm given over to music." He smokes as he talks, his gravelly voice emerging in thought-ful, hesitating bursts. "I can gauge my health by my interest in listening to music. When I'm healthy, the music is almost always going."

He talks passionately of Hendrix, his "sheer volume, the distortion, the lim-its." The mention of Miles Davis causes him to relax visibly in his cushioned desk chair. "I'm a trumpet man," he confides. The shelf of trumpets over his desk has already betrayed his secret, as has the tendency of marching bands to strut into his fiction.

On his desk sits a typewriter, a now classic Smith-Corona electric, and that, too, has an aural importance. "I like to hear the keys," says Hannah. "I've done all my work on it." Using a now quaint technology, though, has its downside. "You can't get them repaired anymore, so I have to buy them when I see them." He has several machines in reserve.

BARRY HANNAH'S FAVORITE CLASS AT Ole Miss is a graduate-level fiction course, with a syllabus that includes Kafka, Camus, Dostoevsky, Günter Grass, and Henry Miller. "Those are the novels that converted me," he explains. The list makes complete sense to readers of Hannah's fiction: He revisits the preoccupations of his adopted mentors, as his characters, too, are men captured by their unexpected circumstances. Consider his novel *The Tennis Handsome* (1983), in which a tennis match is played at gunpoint; and the much-admired novel *Ray* (1980), in which a small-town doctor who happens also to be a drunken philanderer wrestles with the ghosts who returned with him from Vietnam.

For a time, Hannah concentrated on shorter fiction, producing such brief novels as *Boomerang* (1989) and *Never Die* (1991), along with the short-story collections *Captain Maximus* (1985), *Bats Out of Hell* (1993), and *High Lonesome* (1996). The shorter forms suit his imaginative bursts and his distrust of plot lines.

When offered the label "Southern Writer," he hesitates, calling it "reductive but useful. A facet? An identifier." He happily embraces the spirits of Eudora Welty, Faulkner, and Flannery O'Connor. One of his characters (in his most recent novel, *Yonder Stands Your Orphan*) calls Miss Welty "the grand dame of American letters." Hannah himself has been compared (by no less than Larry McMurtry) to Flannery O'Connor. And, of course, "Bill" Faulkner's familiar figure survives in the memories of

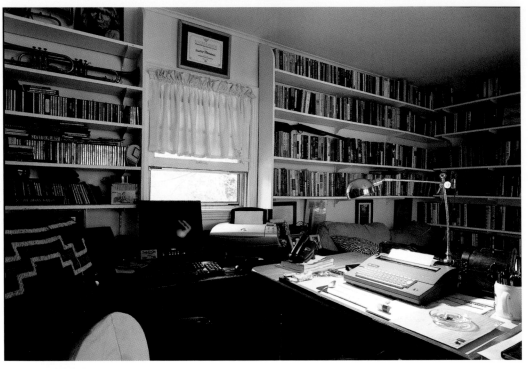

*Above: Barry Hannah's office, with his trusted
electric typewriter front and center.*

*Left: The witty motorcycle beneath a nearby tree
makes two.*

BARRY HANNAH

many people around him in Oxford. If you triangulate the topography between the short stories of Welty, O'Connor, and Faulkner, you might find yourself on the perimeter of Hannahland. He would be flattered, by the way, if Mark Twain lived in the neighborhood, too. "Mark Twain just seems to have begun talking," Hannah says. "I think that's what I'm after."

While his wildest days are behind him, Hannah still loves his motorcycle. It's a Kawasaki Vulcan, though to bike aficionados there's an unmistakable resemblance to a circa 1950 Indian Chief, a legendary American motorcycle. The big machine hulks in his driveway, not quite hidden below a tarpaulin. He rides it often. "I like the liberation. It's a spiritual vehicle for me," he explains, before adding, "and also, I guess, vain and arrogant." He smiles without a trace of guilt.

He's been called post-war, post-modern, post-adolescent and, most recently, post-cancer. In 2000, Hannah was diagnosed with lymphoma. He fought it off with the help of chemotherapy, along the way nearly dying of pneumonia. But as he recuperated, he had a vision of Christ in his sleep. As a non-believer, the visitation bemused him as much as it moved him but, in his obsessive way, he tries to understand. In his fiction, perhaps, he's trying to do the same for us.

Books by Barry Hannah

Geronimo Rex. New York: The Viking Press, 1972.
Nightwatchmen. New York: The Viking Press, 1973.
Airships. New York: Alfred A. Knopf, 1978.
Ray. New York: Random House, 1980.
Power and Light. Winston Salem, NC: Palaemon Press, 1983.
The Tennis Handsome. New York: Random House, 1983.
Captain Maximus. New York: Random House, 1985.
Hey Jack! New York: The Viking Press, 1988.
Boomerang. New York: Houghton Mifflin Company, 1989.
Never Die. New York: Houghton Mifflin Company, 1991.
Bats Out of Hell. New York: Houghton Mifflin Company, 1993.
High Lonesome. New York: Grove Press, 1996.
Yonder Stands Your Orphan. New York: Grove Press, 2001.

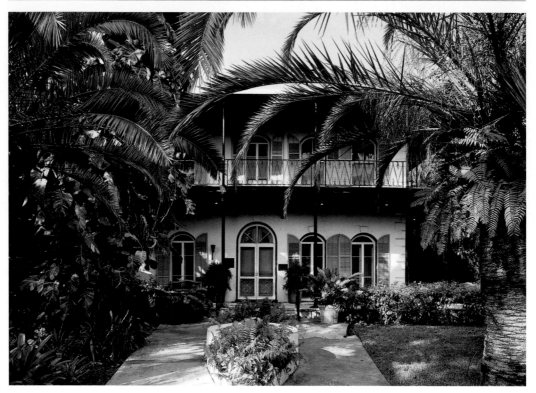

When Ernest and Pauline Hemingway first saw their future home, it didn't look like this. In 1930, broken windows, crumbling stucco, and collapsing shutters gave the house a desolate aspect.

A Place to Come Back To
ERNEST HEMINGWAY
(1899 – 1961)
Key West, Florida

"I could see . . . the wireless mast at Key West and the La Concha hotel up high out of all the low houses and plenty smoke from out where they're burning garbage. Sand Key light was plenty close now and you could see the boathouse and the little dock alongside the light and I knew we were only forty minutes away now and I felt good to be getting back and I had a good stake now for the summertime."

From *To Have and Have Not* (1937)

The peripatetic John Dos Passos suggested a visit to Key West. Ernest Hemingway took his friend's advice and, along with his new wife, Pauline, journeyed there by ship. They exchanged the winter cold and damp of Paris for the sultry Caribbean spring, disembarking in April 1928 for a vacation. Quite unexpectedly, Ernest, Pauline, and their growing family (Pauline arrived six months pregnant) would soon become residents of the down-on-its-luck little town built atop a coral reef.

During the decade he called Key West home, Hemingway wrote some or all of *A Farewell to Arms, For Whom the Bell Tolls, Green Hills of Africa, Death in the Afternoon,* and *To Have and Have Not*; his time there would prove to be among the most productive years of his writing life. Yet had circumstances not conspired to keep them in town on that first visit, Key West might have been no more than a brief stopping place on their way somewhere else.

❦

123

The delay was occasioned by their Model A roadster. Pauline, the daughter of a well-to-do Arkansas cotton family, planned to return home to Piggot for the birth of the baby. But the automobile her Uncle Gus gave the couple had yet to be delivered to the local dealership. Left no choice but to wait for its arrival from Miami, the future Nobelist explored the beaches of Key West, its disused Navy installation, the busy restaurant and bar scene. As was his way, Hemingway quickly found an audience, surrounding himself with a "Mob" of friends and admirers.

Key West also suited his writing rituals. Though living in temporary quarters over the Ford garage, he went to work on the half-finished penciled manuscript he had brought with him. He wrote in the mornings; then, ever the sportsman, he fished away the afternoons, catching tarpon, amberjack, barracuda, and red snapper. When he reached the threshold of one hundred completed pages on the novel — which he referred to as "my long tale of transalpine fornication including the entire war in Italy and so to BED" — he issued invitations to old friends to come and visit. Reinforcements soon arrived, adding to the Mob American and expatriate friends, among them the poet Archibald MacLeish.

After seven weeks in Key West, Hemingway finally climbed behind the wheel of the Ford Runabout to follow Pauline, who, escaping the heat, had already departed for her parents' home in Arkansas by train. But they would return to spend the winter of 1928-1929 in a rented house where he would complete work on the novel that became *A Farewell to Arms*. The following winter the family established 907 Whitehead Street as their permanent home in Key West, in a house that the ever-generous Uncle Gus purchased for them.

DREAMS OF THE FOUNTAIN OF YOUTH drew the first Europeans to Florida. Ponce de León and his men happened across the Keys in 1513, pausing just long enough to nickname the jagged-seeming islands *Los Martires* (The Martyrs). The islands would remain home to Native Americans for a century before a slow trickle of Spanish and English settlers began taking up residence and the name *Cayo Hueso* began appearing on European maps and sailors' charts. Over the decades, *Cayo Hueso* got anglicized to Key West.

❧ ☙

ERNEST HEMINGWAY

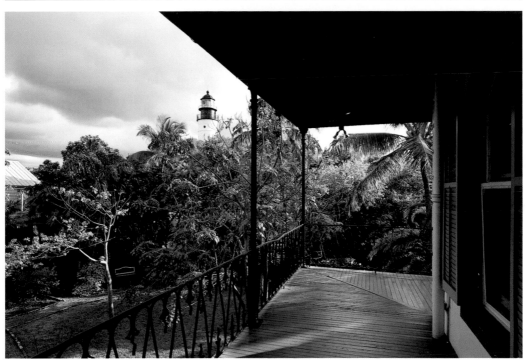

The gallery affords a view of the virtual forest that gives the house privacy; among the trees are weeping fig, Royal Poinciana, and a Chinese banyan. In the middle distance is the nineteenth-century lighthouse, also a Key West museum.

For a time Caribbean pirates found safe haven in the islands, but that would change after 1819 when Florida, which had been both a Spanish and English possession in the eighteenth century, was ceded to the United States. The American naval presence established in 1822 drove off the pirates and altered the economic course of the Keys' history. For more than a century, the Navy in Key West helped drive local business, but the arrival of federal forces also led to the establishment of a custom house on the island. As a designated port of entry, Key West began to receive foreign cargoes, much of which came from the ships that were forever foundering on the treacherous reefs offshore. Warehouses were constructed to house the goods, and outsiders arrived to bid on them. The salvage business proved highly profitable, and by 1850 Key West came to be regarded as the wealthiest community per capita in the United States.

Other businesses would prosper, too, among them salt manufacturing (from the sea), cigar-making (Cuban workers immigrated to produce hand-rolled cigars), and sponging (rich sponge beds thrived in nearby waters). Much later, contraband liquor arrived from Cuba and Nassau during Prohibition, once again providing a source of easy cash.

When Hemingway came to Key West, its prosperity was merely a memory. The navy base was almost empty, competition had effectively shut down the salt and cigar-making businesses, and deadly fungi had killed off most of the sponges. With a scarcity of local jobs, the population had shrunk by two-thirds to just ten thousand in 1928. The natives who remained, called Conchs, subsisted largely on fishing and liquor smuggling from Havana. The natural beauty of the place attracted some tourism, especially after the construction of the railroad in 1912, which connected little Key West – just nine square miles in area – with the Florida mainland 120 miles away. But a stark contrast remained between the lives of visitors to the comfortable hotels and those of the struggling local population.

While Hemingway fell hard for the astonishing natural beauty of the place, he couldn't help but see that Key West's lucky streak had ended. The paradox appealed to him. When he wrote to John Dos Passos, his Chicago-born expatriate friend, inviting him to join the Mob in Key West, he called the island "the St. Tropez of the poor."

❧ ☙

ERNEST HEMINGWAY

Above: The headboard in the master bedroom once served as a Spanish monastery gate. Its breadth suits the king-sized bed the Hemingways devised by bolting a pair of twin beds together.

Left: The second-floor bath, installed to Pauline's specifications.

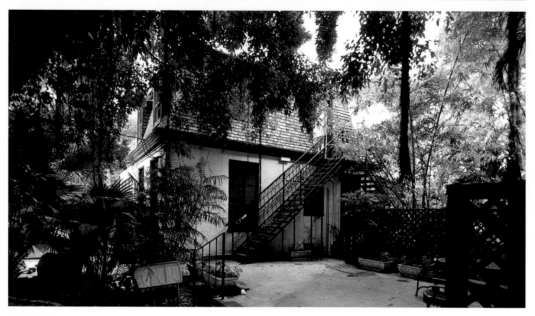

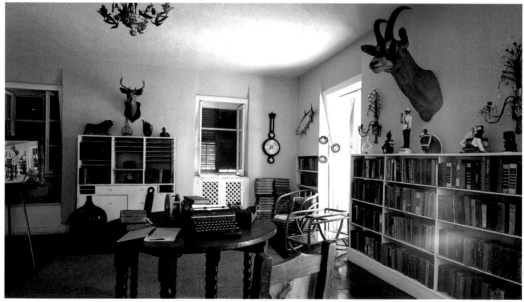

ERNEST HEMINGWAY

CONNECTICUT YANKEE ASA TIFT TRAINED as a marine architect but made his fortune as a salvage baron in Key West. In 1851 he built himself a grand house that looked proudly down on its neighbors from one of the highest spots (elevation: sixteen feet above sea level) on the low-lying island.

Designed to withstand hurricane-force winds, the walls were of fossilized coral, eighteen inches thick, quarried on the property (the hole became the basement, one of the only cellars in Key West). Tift shipped in lumber from Tifton, Georgia, a town he helped found. His eclectic design approach adopted elements of the popular Italianate style, which included boxy proportions and arch-topped windows. He incorporated Spanish and Caribbean elements, too, broadening the low-pitched roof to protect two-story galleries on all four sides from the hot sun and frequent rain showers. Asa Tift's grand house on Whitehead Street expressed not only his wealth and success but that of nineteenth-century Key West.

That had all changed when the Hemingways took up residence. The mansion had been shuttered for years and rumors circulated that the place was haunted. The roof leaked and many windows were broken. Its recent past featured unpaid tax bills and mortgage defaults. Clear title to the property was to be had for $8,000, and the property's new owner became Ernest Miller Hemingway. His contractual address was listed as "4 Place de la Concorde, Paris, France," a final echo of his expatriate past in Europe.

While the money to buy the place came from Uncle Gus Pfeiffer and the deed bore Ernest's name, it was Pauline who decorated the house. When they moved in

Left top: One appeal of the property for Hemingway was the outbuilding to the rear of the house. Under previous owners it had served as a carriage house and toolshed, but once he owned the house, he immediately turned the upper floor into his writing room.

Left bottom: A sable antelope oversees Hemingway's workroom. "Papa," as he liked to be called, bagged the beast on his first African safari in Kenya in 1933.

six days before Christmas of 1931, extensive repairs were still being made. Crews busily installed new plumbing and electrical systems and replastered walls (a temporary safety net of cheesecloth was required over the boys' beds upstairs to protect Patrick and Gregory from falling paint and plaster chips). But the tall rooms with bold moldings retained their Victorian dignity, and Pauline, a fashion writer for Paris *Vogue* prior to her marriage, filled them with her own furniture shipped from Paris. She replaced the ceiling fans (she thought them unsightly) with chandeliers of Venetian glass.

If Pauline's presence is almost palpable in the main house, it is Hemingway's ghost one encounters in the carriage house to the rear. Within the mansard roof of the upper story he established his workroom, which began as little more than a repository for boxes of manuscript and memorabilia. There were his lieutenant's uniforms and helmet from his Italian army days in the Great War, as well as the research material he had accumulated, including hundreds of photographs, for his book about bullfighting, *Death in the Afternoon*. Over the years bookshelves, an oversized manuscript organizer, and a range of souvenirs from his safaris and other travels would accumulate. Pauline was unimpressed, observing that the place looked like a "lightly organized wastepaper can."

The essential furnishings in Ernest's writing room were a round table, placed in the middle of the floor, along with a low cigar-maker's chair. When Hemingway was working — and he regularly took respites for hunting, fishing, and travels abroad between projects — he maintained a newspaperman's discipline, producing three to seven hundred words a day. He first wrote in longhand, then typed up what he wrote on his Royal portable. Then began the obsessive editing, rewriting, revising, and polishing. Usually at work by 6 A.M., he wrote through to lunch. Most days he would dine with his family, then go fishing. Many an evening during his Key West days was spent reading the day's pages to his friends at a bar called Sloppy Joe's, watering hole to Hemingway's devoted Mob and a tourist attraction today.

In 1937 he met Martha Gellhorn in that same bar and his marriage to Pauline ended soon thereafter. After ten coming-and-going years, his sojourn in Key West ended, too. When he departed with soon-to-be wife number three, he took his manuscripts with him but left everything else behind.

❧ ❧

ERNEST HEMINGWAY

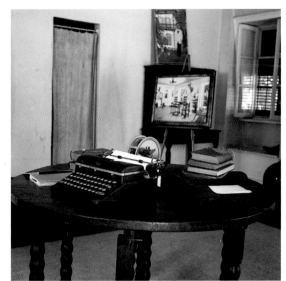

Left: Hemingway's Royal typewriter, a vestige of his days as a reporter for the Kansas City Star.

Below: Prowling the lush gardens that surround the house are some sixty cats descended from the felines Hemingway owned; roughly half of them have six-toed feet, an inherited trait passed down through nine generations of cats on the property.

≈

HEMINGWAY'S LIFE HISTORY HAS been explicated so many times that the bibliography of books about him runs far longer than the list of the great man's own writings. He was his own biographer first, shaping his image as a man of great physical courage, who boxed, hunted big game, fished, skied, and survived when 227 shrapnel fragments ripped into his flesh in Italy in 1918. His nonfiction occasionally crossed the line into fiction; his novels and short stories can easily be mined for people, places, and events drawn from his life.

He wrote *To Have and Have Not* in and about Key West. The town's inhabitants and glimpses of Hemingway's life and his passion for the place abound in its pages. There's a writer who cheats on his wife, and an unscrupulous attorney named "Bee Lips," who bears an unmistakable resemblance to Hemingway's friend, Key West attorney Georgie Brooks. Most of the characters cross paths at a bar called Freddie's Place, a joint so like the real-life Sloppy Joe's that Hemingway chose to memorialize his friend, "Josie" Russell, as the bar's proprietor.

Hemingway's Harry Morgan was no more an autobiographical creation than were Jake Barnes and Robert Jordan. But the worlds that Hemingway's characters inhabited, including Key West, came to life because of his ability to absorb a place and to locate his characters there. *To Have and Have Not* was Hemingway's take on the tough life of a Conch fisherman pincered by hard times and his own stubborn unwillingness to seek a better life someplace else. The waters off Key West and the little town itself were what both Harry Morgan and – for a time, at least – Hemingway himself needed and wanted.

After Ernest's departure, Pauline continued to live in their house; she died in 1951, but the house remained in trust, as the divorcing couple had agreed in 1941. After Hemingway took his own life in 1961, the house that Uncle Gus bought for $8,000 sold for precisely ten times that sum. On January 1, 1964, the Hemingway House opened as a tourist attraction. Today, it is owned by a private foundation, and tours are given 365 days a year to the tens of thousands of people who visit annually.

≈ ≈

ERNEST HEMINGWAY

Hemingway was Key West's first literary celebrity, but later it became home to writers as varied as Tennessee Williams, John Hersey, Robert Frost, James Merrill, and Elizabeth Bishop. It's a brash and busy place, packed with art galleries, T-shirt stores, and street entertainers, along with its share of beautiful beaches and quiet neighborhoods lined with fine Victorian architecture. As Harry Morgan prophesied in *To Have and Have Not*, "They're going to come in and make it a beauty spot for tourists." Unwittingly, perhaps, Morgan's creator made a major contribution to the latter-day rebirth of Key West, Florida.

Books by Ernest Hemingway

Three Stories and Ten Poems. Paris: Contact Publishing Co., 1923.
In Our Time. Paris: Three Mountains Press, 1924.
The Torrents of Spring. New York: Charles Scribner's Sons, 1926.
The Sun Also Rises. New York: Charles Scribner's Sons, 1926.
Men Without Women. New York: Charles Scribner's Sons, 1927.
A Farewell to Arms. New York: Charles Scribner's Sons, 1929.
Death in the Afternoon. New York: Charles Scribner's Sons, 1932.
Winner Take Nothing. New York: Charles Scribner's Sons, 1933.
Green Hills of Africa. New York: Charles Scribner's Sons, 1935.
To Have and Have Not. New York: Charles Scribner's Sons, 1937.
The Fifth Column and the First Forty-Nine Stories. New York: Charles Scribner's Sons, 1938.
For Whom the Bell Tolls. New York: Charles Scribner's Sons, 1940.
Across the River and Into the Trees. New York: Charles Scribner's Sons, 1950.
The Old Man and the Sea. New York: Charles Scribner's Sons, 1952.
A Moveable Feast. New York: Charles Scribner's Sons, 1964.
Islands in the Stream. New York: Charles Scribner's Sons, 1970.
The Dangerous Summer. New York: Charles Scribner's Sons, 1985.
The Garden of Eden. New York: Charles Scribner's Sons, 1986

The house, built on stilts, stands a full story above grade.

Right: Carl Hiaasen is a third-generation Floridian; his grandfather arrived there in 1922.

CARL HIAASEN

"The Trashing of the Planet, Writ Large"
CARL HIAASEN
(1953 –)
Islamorada, Florida

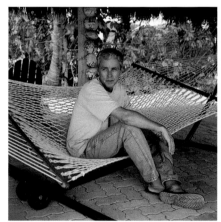

"If one knows where to look, and which tides to ride, it's still possible to be the only human in sight, to drift along crescent banks while shoals of bottle-nosed dolphins roll and play ahead of your bow. These luminous moments become more rare with each tick of nature's clock. The Keys are in desperate trouble."

From "The Florida Keys" in *Paradise Screwed* (2001)

I need to be mad to write," says Carl Hiaasen flatly. His look is not that of an angry man – he's tan, trim, and at times seems almost languid as he talks. Still there is a wariness in his tone that suggests a man who must work very hard indeed to channel his feelings.

Hiaasen (his Norwegian surname is pronounced *HIGH-uh-son*) has two complementary writing careers, both of which provide constructive outlets for his large store of righteous indignation. He joined the staff of the *Miami Herald* in 1976, working as an investigative reporter before being given a column for the paper in 1985. Hiaasen has since demonstrated an aptitude for ridicule while working within the strict limitations of eight-hundred-word pieces written on deadline. Most often he recounts the deeds and misdeeds of "the kinds of crooks that end up in public office." His Metro columns have found an eager audience amused by his wit and outraged by the true tales he tells.

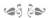

Writing novels is his second career, one that has enabled him to hone further his talent for "using laughter as a weapon." His chosen fictional manner is satire. He happily admits that Joseph Heller won his admiration early. "When I read *Catch-22*, it opened my eyes to the possibilities of what you can do in print." Hiaasen's catchy titles, as well as his talent for mockery, recall Evelyn Waugh's early satirical novels while, in a different vein, John D. McDonald was an inevitable influence, too, given his South Florida protagonist, Travis McGee. "I spent a lot of my childhood near where Travis lives. But the thing was the way McDonald worked in his social commentary. That's going back years, but nothing's changed in Florida."

Crimes against nature make Hiaasen the maddest, so his ire is most often directed at real estate developers and wrong-headed, venal public officials. Hiaasen has known the twin treasures of the Everglades and the Florida Keys since boyhood and witnessed their environmental deterioration. He has seen delicate ecosystems bulldozed to make way for highways and houses.

When he started writing novels, all of which are set in South Florida, the reception surprised him. "I thought they'd be local books," he observes, so the appearance of his novels on bestseller lists was a surprise. The explanation for their popularity only gradually became apparent as he went to signings and met his public. Readers continually approached him with tales to tell. "They'd tell me their own stories of despoiled land," he explains. "They know what I'm talking about."

Even if the books didn't sell, he would probably write them anyway. "I have to write about what I care about," he says simply.

"I WAS VERY FORTUNATE THAT I discovered early on what I wanted to do." He never felt tempted to follow his father's and grandfather's chosen career path, Hiaasen recalls. Both of them had practiced law in Fort Lauderdale, but he knew at a young age he wanted to be a writer. "I asked for a typewriter at six. My dad got me one, a little red manual."

He immediately put it to use. "Humor was my salvation as a kid," he remembers. When his papers were read to the class, he got his first taste of the pleasures of authorship. "I was a small kid, and it was a thrill to make people laugh." Enrolled at Emory University as an English major, he studied Faulkner, Hemingway, and

&❦❧&

CARL HIAASEN

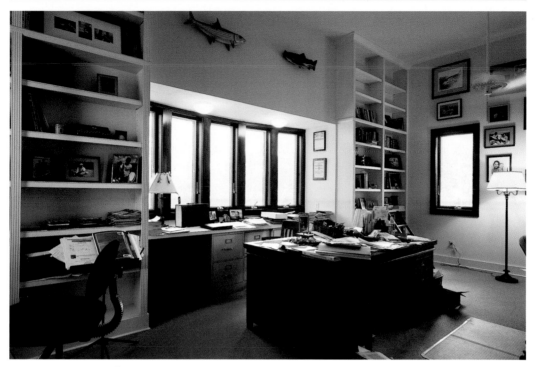

Just as he started at a young age on a typewriter, he joined the ranks of word-processor users very early on. "Newspapers were among the first places that went to computer technology," Hiaasen recalls. "I learned at twenty-one to write on a keyboard." Asked if he ever works in longhand, he laughs, "I couldn't read my writing if you paid me."

Hiaasen and his wife, Fenia, remodeled the interior, adapting the house for themselves and two sons. There's a gym upstairs as well as a new kitchen.

CARL HIAASEN

Steinbeck but soon decided he wanted to be a journalist, not a literature professor. He transferred to the University of Florida at Gainesville, graduating with a journalism degree in 1974.

After a few years at the *Miami Herald*, Hiaasen and his editor, Bill Montalbano, decided to write a thriller based on the cocaine trade, the violent and wildly profitable business that was the stuff of daily headlines even in that pre-"Miami Vice" era. The collaboration would produce three published novels in the early eighties, prior to Montalbano's departure for a posting in China.

"The next thing was to do it by myself, " Hiaasen explains. *Tourist Season* (1986) was the result, and it has been followed by nine other adult novels along with one for young adults, *Hoot*. All can be loosely categorized as crime novels, with murder, violence, pornography, bribery, and shady dealings of every sort. But Hiaasen's trademark humor sets them apart from most books in the category. The circumstances in his novels have varied from the murder of the head of the Miami Chamber of Commerce in *Tourist Season* to a corrupt bass fishing contest operated by a television preacher in *Double Whammy*. One novel was set in the aftermath of a hurricane (*Stormy Weather*), and another used the music business as its milieu (*Basket Case*).

Hiaasen has chosen one locale for his books — the South Florida he knows so well — but he elected not to create his own Travis McGee ("I need to stay interested," he observes). So rather than a single recurring character, each book has a new protagonist, among them an investigative reporter (*Basket Case*), an FBI clerk-turned-stripper (*Strip Tease*), and the winner of a lottery (*Lucky You*). But the energy in his books often comes from the array of peripheral characters. One memorable (and recurring) character is former governor Clinton "Skink" Tyree, an eco-warrior, among the most memorable and likable vigilantes, real or imagined, of all time.

In his newspaper columns Hiaasen sees himself as what he calls "a voice of reasonable and proper disgust." But characters such as "Skink" and Twilly Spree (*Sick Puppy*) offer more than mere commentary: They sometimes commit outrageous acts. People who offend Skink's and Twilly's sense of environmental propriety put themselves at risk; their crimes and misdemeanors are subject to whatever punishment the eco-warriors choose to mete out. In one case, Twilly dumps a garbage truck full of refuse into a litterbug's BMW convertible; in another, Skink bloodily incises the word

"shame" on a man's buttocks, using a vulture's beak. As bizarre as some of the happenings are, there is a certain inevitability. "My novels are character-driven," says Hiaasen. "They bump into each other. They surprise me all the time."

In Hiaasen's hands, satire is the healthy and often hilarious by-product of anger.

"IT'S A BUNKER, A HURRICANE BUNKER," explains Hiaasen, glancing at his house. He bought the home in 1996 from the family who commissioned its construction twenty years earlier. The owners of a local insurance agency, they needed to be available to their clients in the event of tropical storms, so the house was designed to withstand high winds, torrential rains, and flooding. "It's like a fortress," explains Hiaasen. "It's hurricane-proof, all concrete, with double the rebar."

A fortress it is, but the house isn't what draws the eye upon arriving at Hiaasen's generous two-acre property — it's the view beyond. The warm blue of Florida Bay extends to the horizon, broken only by a few tiny islets and, to one side, a bank of the mainland that Hiaasen identifies as the southernmost acres of Everglades National Park. Inside the home, too, there's a wall of glass that invites the visitor's gaze to reach beyond the comfortable furnishings to the saltwater sea.

The Florida Keys represent what is perhaps the most essential tension in Hiaasen's life, the ancient coral reef that developed on a base of limestone and bedrock and evolved into a chain of islands. There are almost nine hundred of them and they seem to drift gently westward from the tip of Florida. Today, thirty or so of the islands are home to some eighty thousand people who glory in a life lived near the water, but in an area that has been radically redefined by man's habitation. Its beauty and character are still the result of the seas that surround it, the Atlantic Ocean to the east and Florida Bay to the west. But for most of the inhabitants, Overseas Highway (a.k.a. U.S. 1) has become just as important.

The 112-mile tarmac stripe snakes down the length of the islands, across connecting causeways and bridges. Inland farming has siphoned off fresh water that once flowed into the bay and runoff from high-density development pours in; the result is a cloud of algae that is poisoning Florida Bay. The loss of habitat and the encroachments of man (to wit: the constant hum of traffic) are driving wildlife away. Many sea birds, shellfish, and other animals once found in abundance are now rare.

❦

CARL HIAASEN

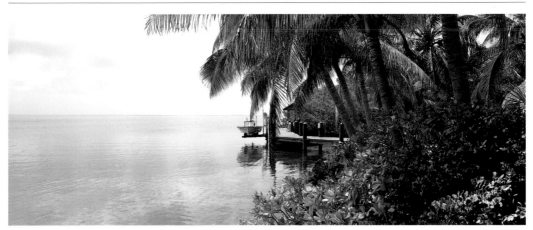

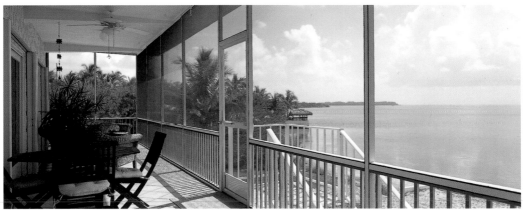

*Top: People in Islamorada take fishing seriously, and Hiaasen's own boat is always
at the ready.*

*Bottom: The view is of Florida Bay: Not as pristine as it may appear, its delicate ecosystem is threatened
by Florida's continuing rapid development.*

At a site as beautiful as Hiaasen's, it is easy to understand why so many people have regarded Florida as paradise.

❧§❧

CARL HIAASEN

Hiaasen settles down to work by 8:30 or 9:00 A.M. and works through to two or three o'clock. "Then I might go out on the boat. Fish for bonefish and tarpon. Game fish." He pauses, then glances up quickly, the eco-conscience that animates him surfacing once again. "We let 'em go." He points to the waterline out his living room window and explains that manatees, porpoises, and even little sharks regularly visit there. "We pat the manatees," he says, adding quickly, "though I guess we're not supposed to."

With his success, he could cut and run. But he has chosen to stay and fight.

FOR HIAASEN, AS WELL AS FOR his readers, the novels are an escape. In the fictional Florida-according-to-Hiaasen, there's an ongoing battle between good and evil, and the bad guys tend to be vile despoilers with bizarre sexual tastes. Some of them smoke stinky cigars; others have appalling table manners. Most of his villains are well-imagined kinkos and wackos who get their comeuppance. As carefully leashed as his journalistic tone must remain, his imagination is unfettered when it comes to his fiction. Example? For *Skin Tight* he conceived a hit man named Chemo who, upon losing a hand in an accident, opts not to replace it with a standard-issue prosthesis but with a *weed whacker.*

In contrast, his good guys are usually looking for love and are, in their way, lovable. They're people who prefer affectionate intimacies to gratuitously violent or obscene encounters. Yes, they tend to have a penchant for anarchy, but their hearts are always in the right place. Hiaasen endows them with a strong moral compass, one that dictates their behaviors, often in directions that society's laws would strongly discourage.

No bashful humorist, he's out there doing *shtick.* Stock gags are routine in his books, like the obituary writer who is helplessly preoccupied with the age at which famous people died. ("I'm now forty-six," Jack Tagger tells the reader of *Basket Case.* "Elvis Presley died at forty-six. So did President Kennedy. George Orwell, too.") One of the maladroit villains in *Sick Puppy* can be counted on regularly to misquote song lyrics (the Rolling Stones' "Brown Sugar" becomes "Blonde Sugar" and "Nowhere Man" is reduced to "No Place Man"). And Hiaasen doesn't mind if the details date. Asked about a joke concerning online book retailer Amazon's stock price, he explains, "I need the novels to be topical. I need them to feel current."

❦

CARL HIAASEN

Hiaasen's hair has gone to gray (whose wouldn't, with the madhouse of characters that inhabit the brain beneath), yet he looks at least a decade younger than he is. His blue eyes are intense, even as he nods in quiet recognition of the aptness of the term "ghastly revenge novels" when applied to his writings. "Most satirical writers aren't a lot of fun to be around," he observes.

His work as a columnist keeps him grounded. He gets to rail at what Disney has done to Florida ("Disney isn't in the business of exploiting Nature so much as striving to improve upon it. . . [Disney]'s an agent of pure wickedness"). He's no fan of Wal-Mart, either, in Florida or anyplace else. In his *Miami Herald* column he excoriates duplicitous politicians and seeks out injustice, corruption, and crime.

But in his fiction, he gets to visit major humiliation and even death upon his bad guys. "It's a legalized outlet for these feelings," he admits. And not a few of us are happy to go along for the ride.

Books by Carl Hiaasen

Tourist Season. New York: Putnam Publishing Group, 1986.
Double Whammy. New York: Putnam Publishing Group, 1987.
Skin Tight. New York: G. P. Putnam's Sons, 1989.
Native Tongue. New York: Alfred A. Knopf, 1991.
Strip Tease. New York: Alfred A. Knopf, 1993.
Stormy Weather. New York: Alfred A. Knopf, 1995.
Lucky You. New York: Alfred A. Knopf, 1997.
Sick Puppy. New York: Alfred A. Knopf, 2000.
Basket Case. New York: Alfred A. Knopf, 2002.
Hoot. New York: Alfred A. Knopf, 2002.
Skinny Dip. New York: Alfred A. Knopf, 2004.

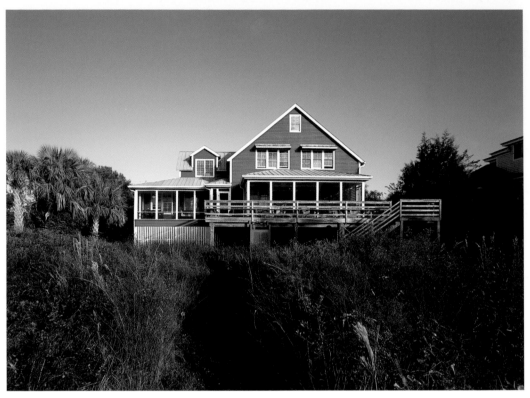

The Humphreys' property found itself inland, separated from the sea by a virtual maze of ten-foot-tall wax myrtles.

Right: "I'm the best sandcastle builder on the island," she says proudly.

"Charleston Is a City that Has a Hold on Its Young"
JOSEPHINE HUMPHREYS
(1945 –)
Sullivan's Island, South Carolina

"Our water is gray-blue, our marshes yellow-green, and everything seems to have a wash of pink over it. I had seen paintings of the city of Venice that reminded me of Charleston. A creamy city emerging from a haze of pinks and grays and blues."

From *Rich in Love* (1987)

"I always thought I was a writer. It was my secret identity." Josephine Humphreys offers a slow smile, then adds, her voice softer, "Even at seven, I knew."

The sitting room in her house glows with morning light, the air as salty as the sea. But the place feels suffused with her personality. Her blonde shoulder-length hair suits the soft curve of her face; she seems relaxed yet reserved. Her comfortable pose on a red upholstered sofa, coffee cup in hand, suggests her ease at being in her house.

She comes by that sense of belonging honestly. Her family has inhabited various cottages on Sullivan's Island, South Carolina, for three generations. Charleston, just ten miles to the south, has been home to her family for more than a century. She left for college, spending her undergraduate years at Duke, not so far away in Durham, North Carolina, then invested a year earning a master's degree at Yale. Just weeks into her Ph.D. studies, she recalls, "I looked out the window from Jacobean drama class and saw that it was snowing." That September cold snap in New Haven cued her return to the South.

❧ ❧

She became a teacher, working at a small Baptist community college near Charleston. "I got really interested in teaching remedial reading," she recalls. One of her chief goals was to help her students "learn to live a literate and literary life." She speaks with obvious pride of several pupils who went on to become writers.

Her own writing came later. "I delayed it," she says. "But not doing it began to hurt and, at about thirty-three, I had a crisis."

She hesitates as if reluctant to continue, then finishes the thought.

"So I quit teaching and began writing the next day."

HER WRITING IS AS UNDERSTATED AS SHE IS. Not that Humphreys's work hasn't attracted attention, starting with her first book, *Dreams of Sleep*, which won the 1985 PEN/Hemingway Award as that year's best first novel. But that story involved no earthquakes or murders: The subject was marriage, one in particular that hadn't improved over time.

"It book me five years to write that first novel," she remembers. Her second book, *Rich in Love* (1987), came more quickly. Once again she chose as her subject a domestic situation (an unhappy housewife simply disappears), but this time the story is told from the point of view of the daughter, Lucille Odom, who finds herself picking up the pieces. She is savvy, precocious, funny, and likable. But Humphreys created her for her own reasons.

"I wanted to write about the odd girl," she says, "the girl that didn't fit in." She casts Lu, as she is affectionately known, as the pathfinder for her family. Lu is an old soul who recognizes her bemused father as an innocent. She realizes that her older sister, who has returned home pregnant and just married, has lost her usual confident equilibrium.

In Lucille, Humphreys creates a youthful character with subtle intelligence. She admits that she and her character share certain things. "I was always shy, too. I was totally a reader, bad at sports." Yet Lu is an original. She intuits the needs of her family members with a maturity beyond her years, but her insights into herself are less acute. That becomes a central tension in the book as she finds herself resolving the conflicts of those around her at the same time that she is defining herself as a young woman. Other people's challenges inform her own advance into adulthood.

&⸙ ⸙&

JOSEPHINE HUMPHREYS

The broad beach at low tide, looking south toward Charleston.

There's a strong sense of place in *Rich in Love*. Like *Dreams of Sleep*, the book is set in and around Charleston, and Lucille, with her usual acute understanding, recognizes even at age seventeen the changes her native landscape is undergoing. Bound for a standard-issue roadside plaza, she remarks, "I'd like to have taken him to spots I know off the beaten track, where you could still see what I thought of as the original landscape."

Humphreys portrays a young woman taking on the world on her own terms ("Morality governs conduct, not feeling," Lu says to herself). Yet it is possible to imagine Humphreys imagining Lucille and endowing her with some of her own way of looking at the world.

HUMPHREYS'S GRANDFATHER PURCHASED A waterfront lot on Sullivan's Island in 1911. He built a cottage of materials he found on the beach, among them parts of a ship. Over time the relationship of that original cottage to the water shifted.

Sands eroded from barrier islands to the north were deposited on the beach by the pounding surf. Like a great embracing arm, a jetty just south of the island that had been constructed to protect Charleston Harbor began to contain an immense volume of the shifting sands, effectively moving the cottage on Sullivan's Island away from the ocean. The broad strip of new land made possible the creation of two additional streets. After World War II, Josephine Humphreys's father purchased one of the lots between the old cottage and the sea and built a modest plywood summerhouse.

On the family's beachhead at the water's edge, Jo Humphreys spent great chunks of her childhood. By the time Hurricane Hugo came along in 1989, the property had become the seaside escape for her immediate family, which included her husband and two teenage sons. The eye of the hurricane passed directly over the island,

Right top: The living room has a leisurely look, the light warm, softened by the varnished and beaded boards lining the ceilings and walls.

Right bottom: "As a younger writer, I got in the habit of writing away from home. But now that the kids are gone, I can work here." She works at a desk in a tall, second-floor space with its own expansive water view.

JOSEPHINE HUMPHREYS

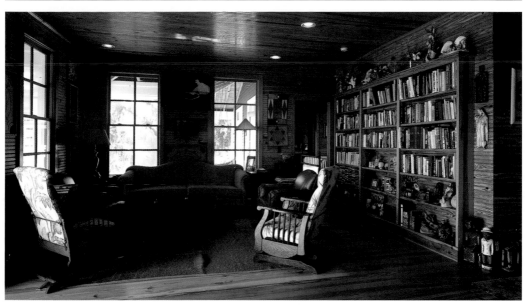

but most of the damage was done by the accompanying tidal surge, which reached almost twenty feet above mean sea level. The storm demolished their cottage, along with countless other buildings. For a time, Sullivan's Island was submerged.

With each generation, the family seems destined to begin anew, though Humphreys is quick to say, "The old house that Daddy built is still here in spirit." Humphreys and her husband, Tom, enlarged upon what had been the footprint of the earlier house, building a spacious and bright year-round home. The aftermath of Hurricane Hugo also proved to be the genesis of her third novel, *The Fireman's Fair*, which recounts the story of a Charleston bachelor, living on a barrier island, who reexamines his life in the wake of a devastating hurricane.

The new house stands on stilts. The story-and-a-half structure contains three bedrooms, a kitchen, a living room, and a writing space. But the central passage, a multi-purpose room functioning as an entry hall, dining room, and sitting area, sets the tone, or, rather, its wall of southeast-facing windows does. The ocean no longer laps just outside because sandbar by sandbar, tide by tide, the shoreline has continued to widen. A broad green strip of wax myrtle now defines the foreground, but beyond is an unbroken vista of the ocean reaching to the horizon.

The house is unpretentious. As its owner says, "I wanted this place to be the kind of house that when children walk in, they laugh out loud." It's a house with comfortable furniture, bright Fiestaware in its kitchen cabinets, and an eclectic array of Haitian art, sculpture, flea market portraits, books, and other objects. There's no rigid scheme, and teenage Lucille may well have spoken for her creator when she says in *Rich in Love*, "I bet half the cases of clinical depression in women are caused by *House Beautiful*." Josephine Humphreys is clearly not among the victims: Her house is welcoming, the light and sea air tumbling in through glazed doors and large windows.

CHARLESTON'S HISTORY IS ALWAYS ON display, and Sullivan's Island shares that connectedness to the past. During the Revolutionary War the area was the site of the colonists first decisive victory at the Battle of Mount Pleasant in 1776. Many historic structures survive from colonial days, and Civil War ghosts hover nearby, too, as Fort Sumter sat just across the bay from the island's southern tip. Native American chief Osceola spent time there and, Humphreys reports, "This was also the Ellis Island of

❧ ❦

JOSEPHINE HUMPHREYS

African slaves."

Perhaps it was inevitable that Humphreys would write a historical adventure of her own. Following her three contemporary novels, she set her most recent novel, *Nowhere Else on Earth* (2000), in the 1860s. Ironically, though, she chose as the locale not her steeped-in-the-past Charleston but an upland swamp in North Carolina.

Robeson County was (and is) home to the Lumbee Indians. The Lumbees are a racial minority, and while many are of mixed blood, Humphreys says, "Their Indian identity is primary." The action of *Nowhere Else on Earth* takes place in and around the remote Lumbee community of Scuffletown, little more than a chain of farms and wetlands along the Lumbee River. The book opens during the Civil War, and the Lumbees, nominally on the Confederate side, are besieged not only by marauding Yankee soldiers but also by the Home Guard looking to conscript young men into forced labor at the forts and salt works of the Confederacy.

"The book was in my head," Humphreys says. "But for a long time I felt inadequate to do it. I didn't know how, but, finally I thought, 'I'm just going to start this, and if I'm unable to do it, that's OK.' So I started."

The idea had been planted almost thirty years earlier when she was a teenager. "I met a Lumbee girl on a train. She was extremely beautiful, and she was talkative and bold, things that I wasn't.

"She was in her wedding dress. Not a dress exactly, but a wedding outfit, and she was angry at her husband, who was sitting at the other end of the car. But she was remarkable. A storyteller, witty, funny, and language-loving."

While her first three novels came entirely from her imagination, *Nowhere Else on Earth* recounts a true story. A sixteen-year-old girl named Rhoda Strong is the central character. Rhoda lives with her mother, a strong-willed Lumbee Indian, and her Scots father. In the course of the book, Rhoda leaves her family for the man she comes to love, Henry Berry Lowrie. Though known outside Scuffletown as an outlaw, to his own fiercely independent people Lowrie is a pied piper who manages to keep many of the community's young men safe.

Nowhere Else on Earth has elements of legend. The story is told of a government surveyor who climbed a tree in order to get a sighting across a field near Scuffletown. An ancestor of Rhoda's, suspicious that a land grabber would probably

❧ ❧

A generous screened porch provides a transition between the bright ocean outside and the cooler spaces within.

❧ ❧

JOSEPHINE HUMPHREYS

follow, shot the surveyor. The interloper's bones fell from the tree over a period of many years, and his death proved to be an enduring expression of the fierce independence of the Lumbees. *"Remember the bones"* was a phrase that Rhoda heard often during her childhood.

As historical figures, Humphreys says, "Rhoda and Henry even today are treasured. They're real but also mythical, almost godlike." Both were made-to-order martyrs who happen not to die; they emerge from *Nowhere Else on Earth* as heroic figures and victims of the inherent racism of a culture. Through their own strength of character, they survive and even prevail. In Humphreys's telling, Rhoda and Henry have a surprising majesty, born out of their pride and determination.

Henry is forced to leave Scuffletown for his own safety at the close of the book; although the war is over, the authorities still regard him as a bandit. Despite an abiding love and passion for her husband, Rhoda remains in Robeson County. She couldn't bring herself to leave, she explains, "Because that's what I wanted to do: Stay in the place that was mine, and keep seeing its beauty and keep feeling alive in it and never lose heart until my dying day."

When asked if that was Rhoda talking, Humphreys is quick to respond, "It's a deep Lumbee tradition. I don't know of a place with stronger roots." Her answer seems certain and simple but later she returns to the subject. "Rhoda's longing to stay in the place that was hers? I said the sentiment belonged to her more than to me. But the more I think about it the more clearly I understand that of course my own life has been one long attempt to stay in the place that is mine, loving it and the people in it, even when from time to time that becomes a complicated task."

To put it another way: "Charleston is a city that has a hold on its young," Josephine Humphreys says. She should know, ensconced as she is just across the bay.

Books by Josephine Humphreys

Dreams of Sleep. New York: The Viking Press, 1984.
Rich in Love. New York: The Viking Press, 1987.
The Fireman's Fair. New York: The Viking Press, 1991.
Nowhere Else on Earth. New York: The Viking Press, 2000.

There are few physical remains in Eatonville that Zora Neale Hurston knew in her childhood.

Right: Hurston, circa 1941.

"A Whirlwind Among Breezes"
Zora Neale Hurston
(1891 – 1960)
Eatonville, Florida

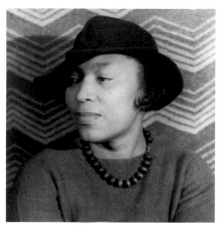

"So I rounded Park Lake and came speeding down the straight stretch into Eatonville, the city of five lakes, three croquet courts, three hundred brown skins, three hundred good swimmers, plenty guavas, two schools, and no jail-house."

From *Mules and Men* (1935)

Both Zora Neale Hurston and her hometown seemed destined for permanent obscurity. Long before she died, her books went out of print, and in the years after her death the spirited place that inspired them seemed about to be swallowed whole by the burgeoning metropolis of Orlando. But in the last generation, Hurston's books and Eatonville have risen to their rightful places in American literature and the history of African-American culture.

"I became aware of my need of Zora Neale Hurston's work sometime before I knew her work existed," wrote novelist Alice Walker in the mid-1970s. After finding her writings, Walker made a pilgrimage to Hurston's unmarked grave. She waded into an acre of unruly weeds and scrub brush and found a three-foot-by-six-foot depression in the Garden of the Heavenly Rest Cemetery that she supposed was the site of Hurston's burial. Walker recounted her search in a 1975 issue of *Ms.* magazine and contributed a foreword to Dr. Robert Hemenway's biography, *Zora Neale Hurston: A*

Literary Biography (1977), a book that resulted from his quest to figure out why Hurston got lost. Together with a coterie of young instructors in nascent Afro-American studies departments at various colleges, Walker and Hemenway fostered an interest in Hurston's works.

Today, Hurston's *Their Eyes Were Watching God* has certifiable status in the American literary canon and Zora Neale Hurston herself is remembered by feminists as well as anthropologists. Hurston died penniless in a segregated Florida nursing home, but her legacy proved her to be a woman of multiple and important parts.

ITS SETTLERS ESTABLISHED EATONVILLE as a "race colony," the name given to all-black communities founded during Reconstruction and the years that followed. Newly freed slaves arriving in central Florida from Georgia, Alabama, and the Carolinas found work in a new town near Lake Maitland, a few miles north of Orlando. Working for white landowners, many of whom were Civil War veterans, they planted the citrus trees for which Orange County would be named and built shacks for their families on other lakes in the vicinity.

After the town of Maitland was organized, a few of the white, affluent, and well-educated town fathers sold some of the early African-American arrivals land nearby. Subsequent subdivisions of that property enabled twenty-seven black men to incorporate their own town in 1887. Eatonville thus become one of the first municipalities in the United States incorporated entirely by settlers of African descent. All of Eatonville's citizens, as well as its mayor, councillors, marshal, and other town officials, were black.

Two years later, a thirty-six-acre parcel in Eatonville became the campus for the Hungerford Normal and Industrial School, a school for Negro children. Modeled after Booker T. Washington's Tuskegee Institute in Alabama, which its first two principals attended, Hungerford taught academic subjects as well as carpentry, animal husbandry, domestic arts, and even the social graces. Many of the students came from Eatonville, which had evolved into a neat grid of modest lots, each large enough for a dwelling and a garden as well as a few animals and fruit trees.

Two churches had been established, including the more recent Macedonia Baptist, when John Hurston first walked down Eatonville's main street in 1890. He had

❧ ❧

felt suffocated back in Notasulga, Alabama, and he found in Eatonville an entirely different prospect. As Booker T. Washington said, "Individuals who have executive ability and initiative have an opportunity [in black-governed towns like Eatonville] to discover themselves and find out what they can do."

Several years later, John Hurston announced his intention to become a pastor to the congregation at Macedonia Baptist. But first he sent for his family. When his wife disembarked at the train depot in Maitland, she was accompanied by their five children. John had never seen the youngest, a baby born after he began his journey to find a new place to live. Three more sons would be born to the family in the coming years, but it was that baby girl, Zora Neale, who would take best advantage of the freedom offered by the town she later called her "native village."

Growing up within the borders of an all-black town, Zora Neale Hurston faced no racial trauma. Her memories of her Eatonville childhood were filled with a sense of community, individualism, and independence. The town seemed peopled entirely with storytellers, who told tales not only about their neighbors. Their "lying sessions," as Hurston later recalled, featured such characters as "God, Devil, Brer Rabbit, Brer Fox, Sis Cat, Brer Bear, Lion, Tiger, Buzzard, and all the wood folks [who] walked and talked like natural men."

The death of her mother when Zora Neale was thirteen launched her on what would prove to be a peripatetic life. She attended school for a time, but mostly she did odd jobs and lived with various relatives before hiring on as a maid for an actress who performed with a Gilbert and Sullivan touring company. During her eighteen months on the road with the repertory theater, she learned a great deal about music and performance, and she also gained skill as a manicurist. Just as important, this first sustained exposure to white people affirmed what she had suspected: The white population consisted of a mix of folks who were good, bad, or more likely somewhere in between, just like the black denizens of Eatonville. This "racial understanding," as she put it, would be basic to her view of race relations for the rest of her life.

She left the troupe in Baltimore, where she enrolled in night school while working as a waitress. She had a conversion experience in a classroom when a teacher read Coleridge's *Kubla Khan*. "This was my world, I said to myself, and I shall be in it,

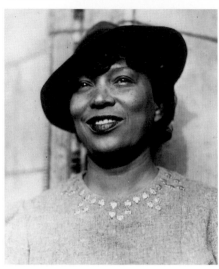

Left: Perhaps the most widely published and best-known image of Hurston, taken by Carl Van Vechten, the writer and critic who recorded many leading artists, writers, and performers in New York's lively cultural scene between the wars. Photo credit: Library of Congress, Prints and Photographs Division, Carl Van Vechten Collection.

Below: Hurston at the New York Book Fair in 1937, the same year Their Eyes Were Watching God *was published.* Photo credit: Library of Congress, Prints and Photographs Division, WPA Collection.

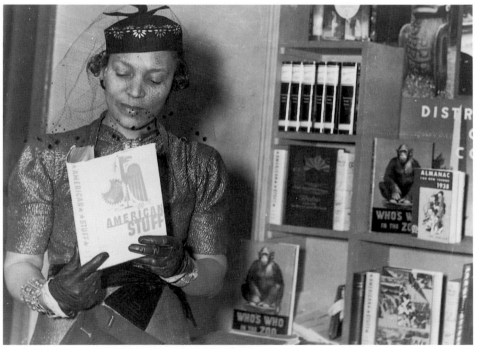

ZORA NEALE HURSTON

and surrounded by it, if it is the last thing I do on God's green dirt-ball." Though she was already in her mid-twenties, she knew she would become a writer.

She gained admission to Morgan Academy, the high school affiliated with what is today Morgan State University, supporting herself by working as a housekeeper for a college trustee. Next she moved to Washington, D.C., and the nation's finest black college, Howard University. There she defrayed some of her school fees working as a manicurist in a black barbershop catering to a white clientele. She advanced her aspirations when her first short story appeared in the university's literary magazine in the spring of 1921. "John Redding Goes to Sea" proved to be a harbinger of the work to come, using as it did the setting, people, and local dialect she had known back home in Eatonville.

Her writing soon won her attention in New York, too, and she left Washington to enroll at Barnard College. There she studied with Franz Boas, the German émigré who founded the first anthropology department in the United States at Columbia University. Boas championed the notion of cultural relativism, believing that cultures ought to be appraised on their own terms, not according to the standards of European civilization. Hurston's first fieldwork involved measuring the skulls of her Harlem neighbors, in an attempt to disprove notions of racial inferiority. "Almost nobody else would stop the average Harlemite on Lenox Avenue and measure his head with a strange-looking anthropological device and not get bawled out for the attempt," poet Langston Hughes observed. "Except Zora, who used to stop anyone whose head looked interesting." Hurston's friends and benefactors soon included photographer Carl Van Vechten and novelist Fannie Hurst, and she reveled in the energy and creative ferment of the Harlem Renaissance, a movement characterized by the likes of writer Arna Bontemps, actress Josephine Baker, musicians Duke Ellington and Louis Armstrong, and athlete-actor-singer Paul Robeson.

In the years to come, Hurston would write four novels, two collections of black folklore, dozens of essays and stories, a much-admired autobiography, *Dust Tracks on a Road* (1942), and even two musicals. Yet her principal inspiration would not prove to be "Harlem City," as she called it. Eatonville, the all-black community of her childhood, would be the wellspring of her literary life.

❧ ❧

HURSTON RETURNED TO EATONVILLE IN 1927 on a fellowship arranged by Franz
Boas. "I hurried back to Eatonville because I knew that the town was full of material
and that I could get it without hurt, harm or danger." The culmination of that work
would come in 1935 with the publication of *Mules and Men*. With Hurston herself as
interlocutor, the loose narrative recounted some seventy-five stories she had collected,
describing along the way the tellers and the circumstances of the recountings.
Folklorist and enthnomusicologist Alan Lomax would describe *Mules and Men* as "the
most engaging, genuine, and skillfully written book in the field of folklore."

Her first novel, *Jonah's Gourd Vine* (1934), was loosely based on her parents'
marriage. John and Lucy (the characters bear the names of Hurston's own parents)
come to live in Eatonville, where John prospers as a preacher before betraying his wife;
the faithful wife subsequently dies in a deathbed scene that closely resembles Hurston's
own mother's passing as she recounted it years later. It's a book informed not only by
Hurston's family story but once again by the mythology of Eatonville that Hurston
was engaged in collecting when she wrote the novel.

Their Eyes Were Watching God appeared in 1937. Her unique voice and imagistic
writing style enrich the novel, but the power that drives it is her protagonist. Hurston
created in Janie Crawford a character who, despite her race, three marriages, and chal-
lenging times, always managed to be independent. The story is framed by Janie's return
to the town she left many years earlier, having seen good times and bad. But her self-
reliance and pride remain intact. "So Ah'm back home agin and Ah'm satisfied tuh be
heah. Ah done been tuh de horizon and back now Ah kin set heah in mah house and
live by comparisons." Throughout the book Janie is an undeniable life force, and in
portraying in such vivid and honest terms Janie's interior life, Zora Neale Hurston's
novel earned places in three distinct curricula as a foundation work of feminism,
African-American studies, and American literature.

Other books followed, including *Tell My Horse* (1938), a second work of
anthropology, this one concerning West Indies folklore. *Moses, Man of the Mountain*, was
an allegorical novel, recounting the biblical story of Moses as a metaphor for black
America. Her autobiography, *Dust Tracks on a Road* (1942), was followed by *Seraph on the
Suwanee* (1948), a novel about a white Cracker plantation family.

≈ ≈

ZORA NEALE HURSTON

Left: Eatonville Town Hall.

Below: There is no Hurston homestead in Eatonville, but the Hurston Museum, a one-time repair garage, has become a combination gallery, office, meeting place, and classroom.

Although she continued writing to the end of her life, none of her subsequent manuscripts attracted a publisher. When she died in 1960, *Time* magazine noted her passing in a brief obituary, characterizing her as a "Florida-born Negro author who explored the world of Negro folklore and magic . . . [and] celebrated the trials and small triumphs of the Southern Negro in a series of novels." She died without enough money to pay for her funeral. Some seven hundred dollars in donations from her friends and publishers paid for her funeral service, and her burial plot was donated by the undertaker. No money remained for a headstone.

EATONVILLE'S LAND AREA BARELY exceeds one square mile. Its borders are nearly indistinguishable from the towns that surround it in the northeast quadrant of metropolitan Orlando. Yet the unique identity of the place remains, as nine out of ten of its some two thousand citizens are black, and millions of people in Florida and across the United States know Eatonville as home to its most memorable citizen.

The townspeople banded together in the late 1980s to fight a proposed widening of the main street, Kennedy Boulevard, from two lanes to five. The road improvement would have chopped the town in half and effectively destroyed its Municipal Park. The battle to block the roadwork produced a pride-of-place in its citizens, leading to the establishment of the Association to Preserve the Eatonville Community, Inc., as well as the Zora Neale Hurston National Museum of Fine Arts.

Since 1989 Eatonville has hosted the annual Zora Neale Hurston Festival of the Arts and Humanities, a vigorous mix of street fair, academic symposium, and celebration of African-American culture. Not that Eatonville is a showplace; its main drag offers little other than a beauty salon and a church. Like the marginalized folk culture that Hurston helped conserve, the town has managed to survive and today is entered on the National Register of Historic Places. As Mrs. N. Y. Nathiri, director of the Hurston Museum, says, "Eatonville is a cultural palette. The town itself represents a focus for Zora Neale Hurston, a community that has become a literary destination and an emotional point of reference for readers."

Zora Neale Hurston proved to be a resilient soul. She devised a strategy for dealing with the ten years she effectively lost after her mother died (she changed her year of birth to 1901); as if to balance out the lost years, in a second decade-long

❧ ❧

span (1933-1942) she produced six of her seven published books and attained national recognition as a novelist and folklorist. She worked throughout her life, often at menial jobs, to support her desire to learn, write, and conduct her research.

Even if she hadn't chronicled Janie Crawford's remarkable odyssey, Hurston's accomplishments as a cultural preservationist constitute an invaluable body of work. Without her, perhaps, Eatonville's stories, people and even the town itself would have been lost, becoming no more than an unnoticed remnant for commuters speeding past. Instead, Hurston's legacy has been to make Eatonville into a most unusual literary destination.

Books by Zora Neale Hurston

Jonah's Gourd Vine. Philadelphia: J. B. Lippincott, 1934.
Mules and Men. Philadelphia: J. B. Lippincott, 1935.
Their Eyes Were Watching God. Philadelphia: J. B. Lippincott, 1937.
Tell My Horse. Philadelphia: J. B. Lippincott, 1938.
Moses, Man of the Mountain. Philadelphia: J. B. Lippincott, 1939.
Dust Tracks on a Road. Philadelphia: J. B. Lippincott, 1942.
Seraph on the Suwanee. New York: Charles Scribner's Sons, 1948.

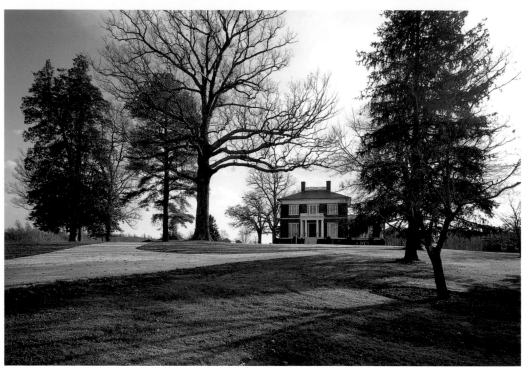

Jan Karon's house seems to possess all that it surveys, set on a small hilltop in the foothills of the Blue Ridge Mountains.

Right: North Carolinian by birth, Karon has found a new home in Central Virginia.

A Visit to Mitford?
JAN KARON
(1937 –)
Albemarle County, Virginia

"The village of Mitford was set snugly into what would be called, in the west, a hanging valley. That is, the mountains rose steeply on either side, and then sloped into a hollow between the ridges, rather like a cake that falls in the middle from too much opening of the oven door."

From *At Home in Mitford* (1994)

Her childhood was spent in the foothills of western North Carolina, but from an early age Jan Karon harbored dreams of city life. "I wanted to get away, to New York, to Hollywood," she remembers. A career in advertising in San Francisco and elsewhere showed her something of the larger world, but thirty years later she decided to return to her North Carolina roots to pursue another childhood dream.

"I began reading as if starved when I was five," she says today, her manner confiding. "But I had a longing from ten years of age to be an author."

Just into her sixth decade, she made a commitment in 1988 to write novels rather than ad copy. She sold her house and moved to Blowing Rock, a village of 1,800 souls almost a mile high in the Blue Ridge Mountains, to be near her family. "I cut my lifestyle more than in half. That meant no more Mercedes-Benzes," she says with a nervous laugh. "But I've never looked back."

167

The transition wasn't altogether easy. When she sat down to write, she was met by a blank page that she didn't know how to fill. "I realized I had nothing to say." She pauses before admitting, "I felt desperate."

Then one day some months later an Episcopal priest strode into her consciousness. In the mental picture that took shape in her mind, he was walking along a village street. "It was such a simple image. But powerful. I got out of bed and sat down at my secondhand computer." Suddenly she had something to say, and she found herself writing of the priest's encounters with a dog named Barnabas and a boy named Dooley.

That was the beginning. The priest's name, of course, was Father Tim, and the village was Mitford, North Carolina.

She has become a bestselling author, but Jan Karon's first fiction didn't appear between hardcovers. She submitted the early tales of Father Tim's town to the editor of her local paper, *The Blowing Rocket.* He liked what he read and began running the stories immediately. To her surprise, Karon found herself writing a serial — move over, Charles Dickens — and for two years the story of Mitford appeared as a weekly column.

Karon practiced her storytelling skills on a small, local readership. Father Tim's regular appearances in *The Blowing Rocket* had one singular advantage: There was almost immediate feedback to her writings. She was no detached and isolated writer trying to imagine how her readers would respond. She encountered them every day, as she walked along the street or picked up her mail at the post office. The townspeople of Blowing Rock became so involved with Father Tim and Cynthia, the neighbor to whom he is attracted, that they felt emboldened to advise Karon on story lines. They told her the outcomes *they* wanted.

In part, her immediate rapport with her audience was a consequence of her earlier career. "I love selling," she says with the confidence of someone who does it well. "And advertising prepared me to be an author. You cut to the chase. You have to go right to it. You get down to your story and your characters. Advertising helped me enormously."

Karon's stories are not plot-driven, and Mitford is not Peyton Place; it is a sleepy town where day-to-day life is ordinary. It's an old-fashioned town that seems

❧ ❧

JAN KARON

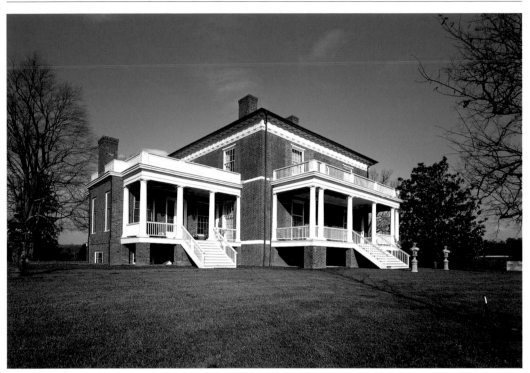

The restoration involved much work on the main block of the house and a total reconstruction of its kitchen wing, incorporating Chippendale lattice railings, Doric entablature, and other period details.

nestled in a simpler time; as Karon says, "There's no cussin', no overt sex, and very little dysfunction."

If the formula runs counter to most fiction these days, it does offer a sense of peace. The characters engage one another as members of a community. People disagree, yet there is always a sense of common purpose. And there are common places, too, as almost everybody frequents the Main Street Grill, a diner filled with familiar faces, as well as Father Tim's church, Lord's Chapel. Mitford is the sort of place where everyone is known to everyone else, where it's second nature for people to look out for other people's children. Father Tim is the filter for the stories, his point of view that of a benevolent but plain man. Karon points out happily that the word "parson" derives from the same Middle English roots as "person."

She has managed to endow Mitford with a kind of rural universality. It's a place with town meetings and parish meetings, a village just out of reach of the worst of the problems that bedevil big cities. The pastoral milieu is one Karon knows, having grown up on a farm, and she has created a country town that Anthony Trollope might have recognized. Karon herself speaks warmly of English novels of the rural village where a finite set of players enacts small dramas that ring true to a very much larger universe of people. Some of her characters speak in a Southern, Appalachian dialect, but at times it is possible to imagine she's writing of a town almost anywhere. Mitford, North Carolina, could just as well be Mitford, Massachusetts, or Mitford, Manitoba.

Part of the appeal of Jan Karon's books is the sense of reassurance that life in Mitford evokes. Not a little of that comes from religious faith, both her own and her readers'. Most of Mitford's populace, like Father Tim and Karon herself, share a Christian belief system. Scripture offers them solace and solutions; even the dog, Barnabas, responds to Bible readings. Her writings are not explicitly evangelical, but they are consoling. "I want to share my faith," she says. "I don't want to preach or convert."

She's careful when she talks about her faith. It's of evident importance, not only to her writing but to her life. But she draws a nice distinction regarding its impact on her literary creations. "I am an author of faith," she observes, "an author who happens to be a Christian. But not a Christian author."

❧ ❦

JAN KARON

The Jeffersonian geometry of the room suits the mix of antiques that Karon has assembled.

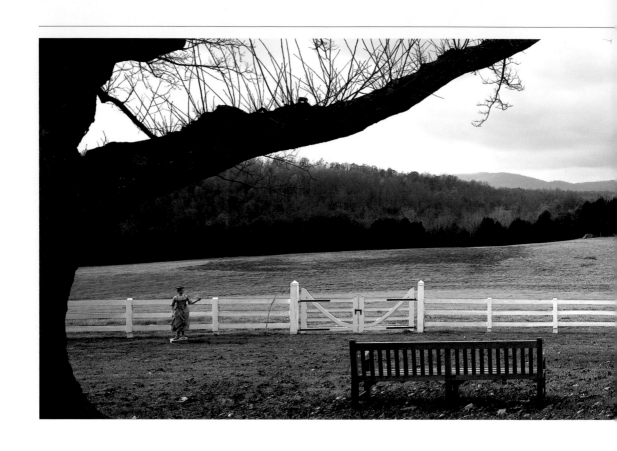

JAN KARON

Jan Karon: "The countryside made its way into my heart and spirit."

THE SUCCESS OF HER MITFORD BOOKS allowed Karon to reinvent her life once again. This time she elected not to change careers — she's still writing novels — but to move to the vicinity of Charlottesville, Virginia. There she took on an architectural project that she describes as "the biggest thing I've ever done in my life."

When she decided to relocate, she shopped around. "I looked at twenty-eight properties before I saw this house. Then I had to deal with the consequences.

"If I had known how much work it was, I wouldn't . . . no, well, now when I see a flock of geese fly over, I say, 'This is what I came for.' Now I'm glad I've done it."

The house she bought sits at the crown of a steep hill. Its vistas are panoramic, as the house overlooks the verdant Virginia countryside, much of it open farmland that once was part of a substantial plantation. Karon's holdings today consist of a bit more than a hundred acres, but from the house it feels like thousands.

The first owner was a physician and farmer, but upon examination, the historical record grows more intriguing. Another branch of the family owned another Central Virginia property, one called Edgemont, which was almost certainly designed by Thomas Jefferson. Jefferson's own house is roughly a dozen miles away. It's inevitable, then, that the question arises: *Did Jefferson design Jan Karon's house, too?*

The answer is a slightly ambiguous, *No, not exactly.* That is to say there is no documentary evidence whatsoever that suggests a direct link to Mr. Jefferson's hand; still, his influence is undeniable. In 1769 when Jefferson began building Monticello, there were few skilled builders in Central Virginia. By the time Karon's house was built between 1816 and 1820, Jefferson had assembled the manpower to build not only Monticello but also his "Academical Village," the University of Virginia. That meant that more than a hundred designer-builders were indoctrinated by their patron in the manner we now call Jeffersonian Classicism. That style became the local vernacular, meaning that in Mr. Jefferson's neighborhood it became *de rigueur* to have tetrastyle porticoes (porches with four columns across the front), symmetrical plans, triple-sash windows, and other Jeffersonian elements. Karon's house is no exception, and, while it was not designed by the great man, its Jeffersonian pedigree is certifiable. The builder is thought to have been William B. Phillips, a veteran mason who worked at the University

JAN KARON

and, in a long building life, would build many Jeffersonian buildings, including court-houses and a home for the former president's grandson, Thomas Jefferson Randolph.

Karon is the house's ninth owner. When she purchased the property, in the year 2000, the structure had been little altered; the less sanguine news was that the house required top-to-bottom restoration. After living in the house for almost a year ("It was in a dilapidated state," she says mildly), she moved to a modest farmhouse on the 109-acre property. A small army of craftsmen then set about rebuilding the foundation, chimneys, and other brickwork, replacing deteriorated bricks and repointing. A new roof was installed ("That cost more than my first house"). New wiring was required, as was new plumbing. A 1950s wing on the west side of the house was demolished; in its place rose a generous new kitchen constructed in a style compatible with the main block of the house.

The work took almost three years. Karon's regard for historic authenticity was one factor in the prolonged process. "We had to find the essential heart and character of this house," she explains, "and stay true to that under my stewardship." The result is a showplace with a rich range of original details now on display. The mantels are of King of Prussia marble; the hardware is largely original, as are the doors and windows. Plus there's a rare herringbone-pattern floor in the entry passage that, not accidentally, resembles the one in Monticello's hall.

KARON'S NEWSPAPER COLUMNS WERE the basis for her first book, *At Home in Mitford* (1994). It has been followed by seven others, but Karon expects that *Light from Heaven*, the ninth in the series, will be the last of the Mitford volumes. But there have been gift books, as well, and a couple of children's titles.

She embarked upon a spectacular life change at midlife; she celebrated her fiftieth birthday before abandoning advertising to try her hand at writing fiction. Her success enabled her to take on the considerable task of caring for an important historic house some years later. Her willingness to make such changes suggests that she very much means what she says when she asserts, "There's so much to be done in our middle years." She says it emphatically, then adds, "If people have a dream . . ." Her voice trails off, but her gaze is steady. She sees her personal reinventions as important, not only to her but to her audience. If Jan Karon's books have provided inspiration —

✎ ✎

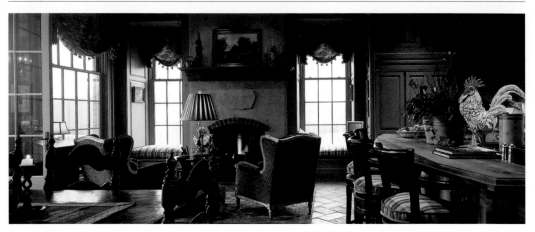

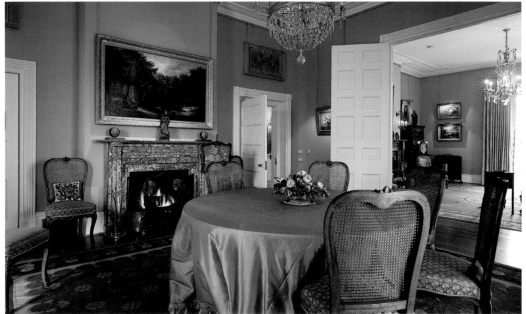

Top: Karon's inspiration for the kitchen and sitting room was Beatrix Potter's kitchen at her farm, Hilltop, in England's Lake District.

Bottom: The dining room: as grand — or as intimate — as you wish.

JAN KARON

and many, many of her readers report that indeed they have – then Karon herself is an inspirational figure. She has become an important presence to many in her audience. And she hears from them directly. She estimates she has answered some 25,000 letters since she began writing about Mitford.

In her writing, too, she's moving on. With the Mitford series drawing to a close, she's planning two books, one set in Ireland and the second in England. "I want to write gentle mysteries," she says, identifying them as "somewhat in the Agatha Christie vein."

So Jan Karon sets off in a new direction. If the past is any indicator, she will succeed once again, just as she did in her girlish quest to see the larger world, her mid-life career change, and her restoration efforts on her historic home. After all, the creator of Mitford became a writer acting on the heartfelt belief that there's no place like home, and then managed to persuade many people that its name is Mitford.

Books by Jan Karon

At Home in Mitford. Elgin, IL: Lion Publishing, 1994.
A Light in the Window. New York: The Viking Press, 1995.
New York: These High Green Hills. New York: The Viking Press, 1996.
Out to Canaan. New York: The Viking Press, 1997.
A New Song. New York: The Viking Press, 1999.
A Common Life. New York: The Viking Press, 2001.
In This Mountain. New York: The Viking Press, 2002.
Shepherds Abiding. New York: The Viking Press, 2003.

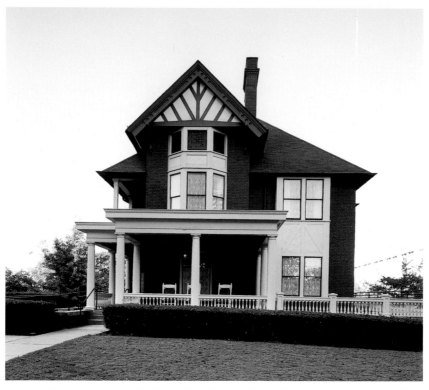

The front façade of the apartment building belies Margaret Mitchell's nickname for the place, "The Dump." The home was built in 1899 in the then-popular Tudor Revival style, its brick walling relieved by characteristic half-timbered panels.

Right: Margaret Mitchell seated at her portable typewriter.
Photo credit: Kenan Research Center at the Atlanta History Center/Kenneth G. Rogers Collection.

"The Dump on Tight Squeeze"
MARGARET MITCHELL
(1900 – 1949)
Atlanta, Georgia

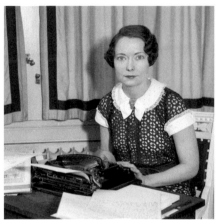

"Hope was rolling high in every Southern heart as the summer of 1863 came in. Despite privation and hardships, despite food speculators and kindred scourges, despite death and sickness and suffering which had left their mark on nearly every family, the South was again saying, 'One more victory and the war is over.'"

From *Gone with the Wind* (1936)

All authors aspire to the success of Margaret Mitchell. Her one and only novel sold faster than any other book ever had and earned her the Pulitzer Prize for fiction in 1937. The film based upon it made movie history, winning the Academy Award for best picture in 1939 while thrilling audiences and setting box office records for generations. In a way that few books have done, *Gone with the Wind* became essential to the mythology of her region.

In order to sell other books, publishers ever since have adopted the encomiums thrust upon *Gone with the Wind* such as "epic," "sweeping," "monumental," and "the greatest love story of all time." And, indeed, the love story of Scarlett O'Hara and Rhett Butler, thanks to the movie as well as the book, holds a unique place in America's popular culture. Yet Scarlett's story is less than original; like the whalebone cage beneath a Victorian crinoline, the outlines of Thackeray's *Vanity Fair* can be discerned in the characters and wartime circumstances. Miss Mitchell knew what she was doing, having assured her older brother years earlier, "Any good plot can stand retelling."

She made the story hers, incorporating the passions from her own life. What made the book, as Tom Wolfe has said, "one of the great *tours de force* in literary history," was Margaret Mitchell's melding into Scarlett O'Hara's life story the larger tale of her region's defining conflict.

MARGARET MITCHELL WAS BORN IN Atlanta, a fifth-generation Georgia citizen. Her mother was an active suffragist. Her mustachioed father, a lawyer by profession, helped found the Young Men's Library Association and the Atlanta Historical Society. She had one sibling, her brother Stephens, five years her senior, and not a little of her tomboy childhood was spent trying to keep up with him. Her tree climbing, baseball pitching, and horseback riding earned her the nickname "Jimmy."

In her schooldays she and her brother had the run of a twelve-room, two-story Victorian house. Though a capable rider, at age ten she sustained the first of a series of injuries to her left leg in a riding accident; her biographers since have been crediting her recuperative time in bed with providing her with time to pursue her taste for reading. But there was also ambition lurking: At fourteen she wrote, "I want to be famous in some way — a speaker, artist, writer, soldier, fighting statesman or anything nearly."

Margaret's teenage years were spent in a substantial new house on Peachtree Street, its façade sporting a brace of white columns. She attended private schools and matured into an engaging and attractive woman. At eighteen, she stood four feet, eleven inches tall, weighed barely ninety pounds, and, slim like Scarlett O'Hara, is said to have had a nineteen-inch waist.

She matriculated at Smith College in 1918 and shortly became "Peggy" Mitchell to all but her family. That winter her mother died in the influenza pandemic, and at the close of her freshman year, Margaret returned home to manage her father's household. Once back in Atlanta, she made her social debut but outraged her upper-crust peers with some overtly sexual behavior they regarded as rebellious. In 1922 she married, though her choice of a husband proved to be as ill-considered as it was precipitous.

"Red" Upshaw's chief appeal for Peggy Mitchell may have been his unpredictability, and he proved to be abusive and a ne'er-do-well, unable to profit even from

❧ ☙


MARGARET MITCHELL

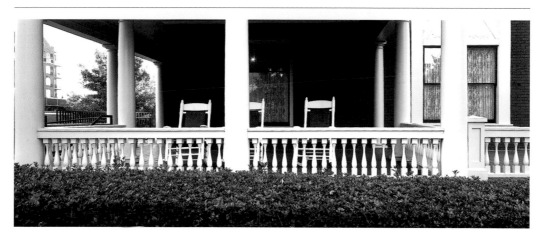

The porch at the Margaret Mitchell House on Peachtree Street.

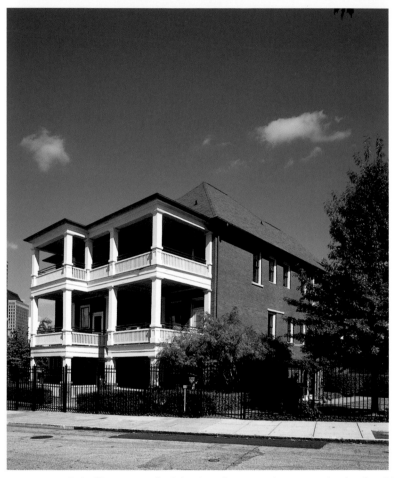

Some apartments in the building remained inhabited until 1978, when it was abandoned and boarded up. Purchased by preservationists, it was designated a city landmark in 1989. Only after two fires (1994 and 1996) was the restoration completed, and in 1997 the home opened as the Margaret Mitchell House Museum.

MARGARET MITCHELL

bootlegging. But the marriage did have one fortuitous side effect. Just four months after the ceremony, given her husband's inability to maintain a steady income, Peggy Mitchell sought work. Newspaper writing appealed to her, and though her attempt to land a job as the first woman in an all-male newsroom failed, she did manage to persuade the editor of the Sunday Magazine at the *Atlanta Journal* to hire her at a salary of $25.00 a week.

In a little more than four years at the paper she wrote more than a hundred features, numerous book reviews, and filled in periodically as the society columnist and advisor to the lovelorn. She became something of a star, interviewing celebrities (Rudolf Valentino, for one) when they came to town. She also found time to research a range of stories concerning the lives of independent women from the past.

Having escaped her first marriage, on July 4, 1925, she married John Marsh, a man as gray and unremarkable as Upshaw had been colorful. The couple moved into an apartment off Peachtree Street. The accomplished young newspaperwoman tacked two cards on its entry door, one bearing the name "Mr. John R. Marsh," the other "Miss Margaret Munnerlyn Mitchell." In doing so, she shocked her neighbors and amused her friends. But she also made a statement about her name (she had fought in the divorce proceedings to have her maiden name restored) and her hard-earned liberty.

A few months after she and Marsh were married, her childhood leg injury flared up; she also complained of abdominal pains. Marsh, who himself tended to somatic disorders, proved a devoted nurse. One of his jobs during Mitchell's convalescence was to keep her shelves stocked with reading material. "Which was quite a job," he remembered a few years later, "first, because she had already read so many books, and second because she reads so rapidly."

One day he brought her a typewriter, offering it with the words, "Madam, I greet you on the beginning of a great new career." The words may ring apocryphal (not least because Mitchell herself offered so many versions of how her novel got written), but the implication was that the long-suffering John, the most ardent believer in his wife's talent, wanted Peggy Mitchell to write a book of her own.

COMPLETED AT THE TURN OF THE TWENTIETH CENTURY, the Cornelius J. Sheehan house on the southwest corner of Peachtree and Tenth Streets suited its genteel neigh-

borhood. Still, the one-family, two-story residence with the generous porch soon became an anachronism in an increasingly commercial neighborhood. By 1906, the Sheehans had departed, and within a few years, a subsequent owner moved the house forty feet back from the bustling north-south thoroughfare that Peachtree had become. Today, the house is one of the last residential survivors in a twenty-first-century neighborhood of ten- and twenty-story towers, its most immediate neighbors being commercial offices, the Reserve Bank of Atlanta, and a hotel.

By the time Peggy Mitchell and her new husband arrived, the Sheehan house had been divided into ten apartments. The one they rented had neither of the two generous front parlors, and the broad front porch was at the other end of the place; their quarters were in the basement, and they entered from Crescent Avenue, at the rear of the building. It was the best they could afford.

"The Dump on Tight Squeeze," as she referred to the place, seemed Lilliputian to Mitchell, accustomed as she was to the grander and more spacious quarters of her father's houses. The flat consisted of two rooms plus a short hall, bath, and kitchenette. She decorated the small spaces with heirloom Victorian furniture, china, and silver, along with "so many books," as one friend remembered, "they hardly left room for the wedding presents." Despite the size of the place, they entertained often. The sitting room also functioned as her writing room, so she would hide her typewriter with a towel when visitors arrived. Mr. and Mrs. Marsh would remain in residence for seven years, during which time Mitchell began and wrote virtually all of *Gone with the Wind.*

She composed in the morning, writing in pencil first on newspaper copy paper, then transcribing her scribbles on her portable typewriter. She began her immense novel in 1926, writing the last chapter first. She wrote the entire book out of sequence, finishing an approximation of a first draft in 1929. The plot and basic characterizations remained unchanged in subsequent rewrites despite the fact that, said Mitchell, "the first chapter was written last, written in fact several months after the book sold."

Before the book found a publisher, it remained for six years in labeled envelopes stowed in various places in the small apartment. Mitchell had refused to show it to anyone except her husband. Mitchell's secrecy about her book was penetrated only

⤳ ⤳

MARGARET MITCHELL

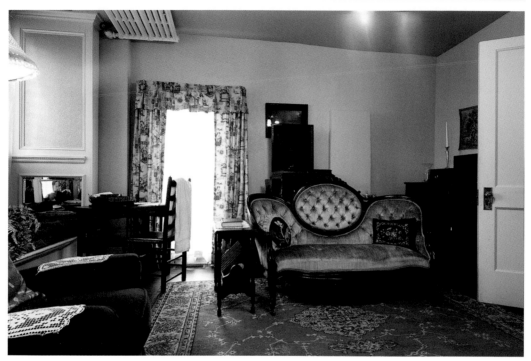

Margaret Mitchell's husband, John Marsh, bought her a used 1923 Remington portable typewriter in 1926. She set it on an old sewing table in the corner of their sitting room.

The scale of the apartment is small; a short hall connected the sitting room (foreground) to the bedroom at the rear.

MARGARET MITCHELL

on an April evening in 1935 when, having denied its very existence that day at lunch, Mitchell impulsively handed the immense and disorganized manuscript to an executive for the Macmillan Publishing Company who was visiting Atlanta on a scouting trip. Why she chose that moment to break her silence about the book has never been adequately explained, but within hours the Macmillan editor was smitten with the pages he had read. Within weeks a contract had been agreed to, and in June of the following year *Gone with the Wind* arrived on bookstore shelves.

IN RETROSPECT, MARGARET MITCHELL'S writing of the book can be seen as inevitable. From childhood, she had a natural propensity to tell stories. She loved to write: Her brother remembered she was "always writing something, ever since she was big enough to hold a pen." But *Gone with the Wind* would be the sum total of her literary legacy, since her personal papers and manuscript materials were destroyed at her request after her death. The rest of her surviving oeuvre consists only of a sheaf of newspaper articles and one apprentice work, a novella titled *Lost Laysen*, written at age fifteen or sixteen for a teenage boyfriend and published posthumously after it was discovered among his papers. After her masterpiece was published, she apparently wrote little, devoting herself to volunteer work for the Red Cross and other organizations and providing patronage to a number of favored causes, including the underwriting of dozens of scholarships for African-American students at Atlanta's Morehouse College.

Margaret grew up hearing her grandparents and their contemporaries refight the Civil War years at Sunday-afternoon gatherings, with the men recounting the battles, the women life at home. Her grandfather had sustained two gunshot wounds to the head at Antietam, and as he told the tale of making his way home from Maryland after being left for dead, he allowed the children to touch the grooves in his skull left by the minie balls.

As a young girl, Margaret summered in Jonesboro with maiden aunts. There the Civil War had left its imprint on the landscape. Her mother's immigrant ancestors had established a medium-sized cotton plantation, once owning thirty-five slaves. Her family managed to hold on to the land, as did some other prosperous survivors who inhabited one-time plantation houses, but Mitchell also saw many abandoned, crumbling mansions dating from antebellum days. The Old South was an almost tangible

❧ ☙

Top: At six-foot-one, John Marsh towered over the petite (four-eleven) Peggy Mitchell, but they slept in an antique bed with a three-quarter mattress.

Left: The tiny kitchen at the end of the Marshes' railroad apartment.

MARGARET MITCHELL

presence to the survivors of the war, and a family joke had it that impressionable Margaret was twelve before she realized that the South had lost the war.

The manner in which her several biographers have marshaled Mitchell's life facts into literary inevitability may seem too pat; in the same way, though, there's a symmetry there with Mitchell's view of Southern history in *Gone with the Wind*. She wrote the book at a time when the Old South was romanticized and segregation was the norm. Though some of the book's slaves are devoted and wiser than their masters, the African-American characters in the book had no existence beyond the borrowed light of those who owned them. To sustain a larger view today more recent correctives are necessary, such as Edward P. Jones's Pulitzer-Prize–winning novel of a black slave-owner, *The Known World* (2003), and even *The Wind Done Gone* (2001) by Alice Randall, the parody of Mitchell's book from the point of view of a slave that gained instant status when the Mitchell estate attempted to suppress it on copyright grounds.

Whatever the criticism to be cast at Margaret Mitchell's stereotyping of black characters, however, *Gone with the Wind* remains a book that has moved and enthralled generations of readers as have few others. The narrative compels the reader through its thousand-plus pages, but its message, according to Mitchell herself, was uncomplicated. She told an interviewer when the novel appeared in 1936, "If the novel has a theme it is that of survival. . . . I wrote about the people who had gumption and the people who didn't."

Margaret Mitchell Marsh died in 1949, killed crossing the street three blocks north of "the Dump," at the intersection of Peachtree and 13th Streets, struck by an off-duty cab driver. Her legacy remains the mammoth book that has given pleasure to millions all over the world.

Books by Margaret Mitchell

Gone with the Wind. New York: Macmillan Publishing Company, 1936.
Lost Laysen. New York: Scribner, 1996.

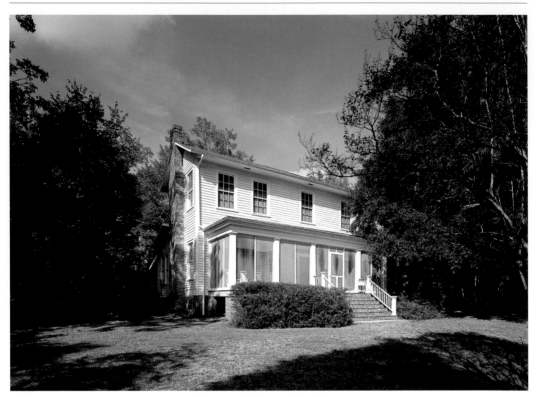

Flannery O'Connor's Andalusia.

Right: Mary Flannery and one of her peacocks on the front steps of Andalusia.
Photo credit: Joe McTyre/Atlanta Constitution.

"Nothing Happens Nowhere."
FLANNERY O'CONNOR
(1925 – 1964)
Milledgeville, Georgia

"We live 4 miles from Milledgeville on the road to Eatonton in a two-story white farm house. The place is called Andalusia. Any time in the afternoon would be fine but if you drop me a card when you plan to come, I will make it a point to be here."

From a letter to a friend, Ben Griffith (1955)

Although Flannery O'Connor died more than forty years ago, the invitation she penned to a new friend still rings strangely true. Time has wrought certain changes to the farmhouse and its surrounding acres, but the place remains much as she knew it. Today, Flannery O'Connor's Andalusia welcomes literary pilgrims who seek a different angle of approach to her enigmatic writings.

When her daughter died in 1964, Regina Cline O'Connor left Andalusia, moving to the in-town home she owned on 311 West Greene Street in Milledgeville (rhymes with *Village-ville*). In the decades after Flannery's death, Regina continued to visit Andalusia, at times returning almost daily. She began donating manuscripts and other documentary materials to Flannery's alma mater, the school that is now Georgia College & State University. The donations helped inspire studies of O'Connor, and today the college has become an essential stop for scholars. In 1976, Regina permitted a production company to visit Andalusia to film an adaptation of her daughter's short

story, "The Displaced Person," which starred Irene Worth, John Houseman, and an unknown Samuel L. Jackson. When the show aired on the Public Broadcasting System, viewers saw a spruced-up Andalusia, since Regina had persuaded the producers to stabilize several of the outbuildings which, with disuse, had grown dilapidated.

By the time of her own death in 1995 at age 99, Regina O'Connor had established a charitable trust in her daughter's name. Today, the Flannery O'Connor-Andalusia Foundation owns the land, surviving outbuildings, and the house. Inside the dwelling, the rooms are much as they were when the writer was taken for the last time to nearby Baldwin County Hospital, where she died just after midnight on August 3, 1964. But upon seeing the well-worn crutches poised beside her bed at Andalusia, one can almost imagine the footfalls and the odd syncopation of her crutches as she made her way to the front passage to greet her visitor.

MARY FLANNERY O'CONNOR DID NOT spend her entire life at Andalusia. Born in Savannah, she lived her first thirteen years in Georgia's original and most elegant city. As the child of Catholic parents, she attended parochial schools until the failure of her father's real estate and construction business forced her and her mother to move to Regina's childhood home in Milledgeville. Having taken a job in Atlanta with the Federal Housing Administration, Edward Francis O'Connor Jr. visited on weekends until his health deteriorated and he rejoined his family full-time.

At thirteen, Mary Flannery found herself in welcoming and familiar environs on Greene Street. She herself had spent summers in Milledgeville, and her mother had grown up in the town, where the family roots extended back more than a century. She was in her third year at Milledgeville's Peabody High School when, in February of 1941, her father died. He suffered from systemic lupus erythematosus, an ailment in the arthritis family in which the immune system attacks the tissues of the body, producing

Right top: The staircase in the central passage, the work of country craftsmen.

Right bottom: The modest kitchen got a significant update when O'Connor bought a new refrigerator with the proceeds from the sale of her story, "The Life You Save May Be Your Own."

FLANNERY O'CONNOR

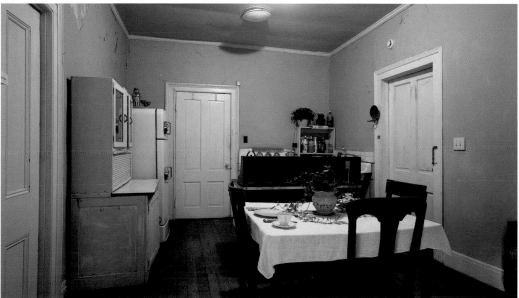

The horse barn once housed numerous horses; today only Flossie, a mule, lives there.

❦ ❧

FLANNERY O'CONNOR

joint pain and a rash on the nose and cheecks. Over time, serious complications such as kidney disease also can develop.

During World War II, O'Connor completed an accelerated course at what was then Georgia College for Women. Studious and brainy, she cared little for the social and sexual mating games of the other co-eds. She lived at home (GCW was just a block from her house) and contributed stories, essays, and poems to student publications. She also drew satirical cartoons that earned her favorable comparisons to Ogden Nash. In her byline she began styling herself "Flannery O'Connor." Papers she wrote for her classes revealed a tendency to the "bizarre," according to one of her instructors, as well as an unorthodox writing style. Her refusal to conform to the expectation that her writing should be ladylike and grammatically exact led her to major in sociology, thus avoiding the strict regime of required English courses. As one of her teachers observed years later, "Mary Flannery was herself, decidedly, from the time she was a little girl."

After graduation in 1945, she won a scholarship to the State University of Iowa to study journalism. When enrolling in the Writers' Workshop there, she impressed its director both with her strong Southern drawl and her "pure talent." Iowa was then among a handful of institutions offering M.F.A. degrees in creative writing, and by the time O'Connor earned hers, in 1947, some of the stories she wrote to fulfill her thesis requirements had already been accepted for publication. An early draft of the opening four chapters of a novel earned her the Rinehart-Iowa Fiction Award, providing a $750 stipend as well as giving Rinehart the option to publish the completed book.

Work progressed on the novel during the autumn of 1949 and winter of 1950 at the Yaddo Foundation, the artists' colony outside Saratoga Springs, New York. For a time O'Connor worked in a furnished room she rented in New York City, but she actually completed the first draft of her novel — by then titled *Wise Blood* — at the home of friends, Sally and Robert Fitzgerald, in Ridgefield, Connecticut. As the year came to a close, joint pains and fever led to her hospitalization and, early in 1951, resulted in a diagnosis. Like her father, she was found to have lupus erythematosus; unlike him, she would be treated with large doses of corticosteroids, the side effects of which would contribute significantly to her physical decline in the coming years. By

≈§ §≈

The cow barn, central to the function of the dairy farm and, later, to O'Connor's story
"Good Country People."

FLANNERY O'CONNOR

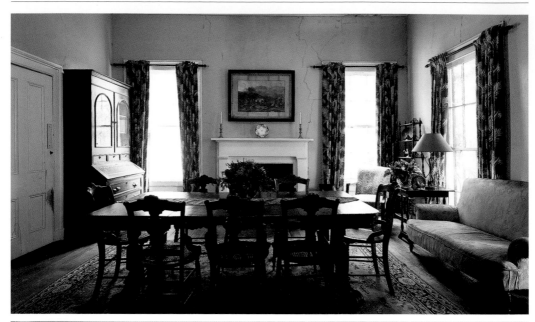

FLANNERY O'CONNOR

March 1951, O'Connor had moved permanently to Andalusia, where her mother became her primary caregiver. Andalusia remained her home for the final thirteen years of her brief life, and all of her books appeared after she took up residence in what previously had been Andalusia's first-floor parlor.

SHADOWED BY OAK TREES, THE HOUSE stands tall, central to the activity of the farm. Once a much larger estate of some 1,700 acres, the property had been subdivided by the time mother and daughter O'Connor took up residence, leaving the main house situated amid a 554-acre dairy farm.

Tobler Creek bisects the acreage. The varied landscape includes wetlands, hayfields, pastures, woodlots, and a pond for livestock. In the vicinity of the house stands an array of agricultural buildings, including a large cow barn, calf barn, and a milk processing shed. Nearby are the water tower, pump house, equipment shed, and a two-car garage that, in O'Connor's time, was surrounded by wire runs for the domesticated fowl she kept as a hobby. When she first knew the place, the family called it Red Sorrel Farm in honor of her uncle's sorrel-colored horses. Quite by happenstance, she met a descendant of an earlier owner on a bus traveling to Atlanta. She learned the house had once been known as Andalusia after the ancient province in the south of Spain. Since 1947 the farm has borne that name.

The original house, one room deep with two rooms flanking a central hall on each floor, was constructed before 1860. It's a classic center-hall colonial, though, in the local architectural vernacular, it is termed "Plantation Plain." A broad, hip-roofed porch stretches across the front façade, and three additions extend off the back, the last built during O'Connor's invalid years to provide a sitting room to replace the parlor that had become her bedroom.

Left top: Regina O'Connor made the curtains for a room filled with Cline family heirlooms.

Left bottom: The first-floor bedroom where O'Connor worked, her desk just a step from her bed, her crutches at the ready.

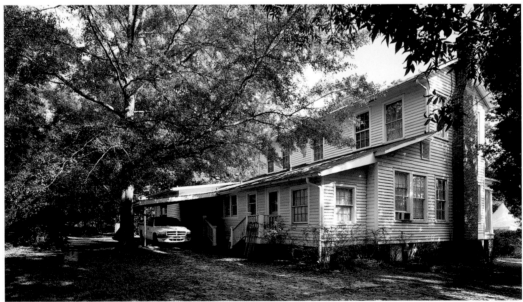

FLANNERY O'CONNOR

Between flare-ups of her disease, O'Connor often took the short journey to Milledgeville for Mass and to see friends and family. Periodically she traveled around the country for lectures, and once even to Europe to see the sights and visit her friends, the Fitzgeralds. She shared the house with her mother, and an African-American couple, Jack and Louise Hill, lived in the nearby cottage. Hired hands lived in tenant houses on the property and helped with farm chores. Her mother managed the property as a dairy farm in the 1950s, and the life of the farm bustled about them as Regina watched over her daughter's fragile health.

During the last decade of her life, O'Connor became famous, yet Andalusia remained a place of privacy, where she could work and conserve her limited energy. As a student at Iowa, Flannery O'Connor had established a ritual of writing every day at the same time for an uninterrupted period; during her years at Andalusia, typically she worked four hours in the morning. She spent afternoons reading, meeting visitors, and pursuing her hobby, tending to her chickens, peafowl, geese, and other birds.

She recorded the place in piecemeal fashion in her letters, but its inhabitants, buildings, and landscapes became embedded in her work, essential to the settings, surface, and sense of place in her fiction.

"THE GREAT ADVANTAGE OF BEING A SOUTHERN WRITER," observed Flannery O'Connor, "is that we don't have to go anywhere to look for manners; bad or good, we've got them in abundance. We in the South live in a society that is rich in contradiction, rich in irony, rich in contrast, and particularly rich in its speech." In her novels and thirty-odd short stories, O'Connor vividly re-creates the "manners" of her locale—broadly speaking, its culture, rituals, and character.

Left top: Though called the "Nail House" (O'Connor's Uncle Louis probably stored hardware in it), this structure in O'Connor's time was flanked by bird runs to contain and protect her chickens, ducks, guineas, geese, swans, and peafowl.

Left bottom: Over the decades, a kitchen, pantry, farm office, and other spaces were grafted onto the rear of the house in single-story, shed-roofed additions.

Called Hill House, this tenant dwelling was home to Jack and Louise Hill during much of O'Connor's time on the farm. In need of complete restoration today, the house, having been constructed in the 1820s, probably predates the main house.

&⸘&

FLANNERY O'CONNOR

While the manners provided the backdrop, the stories that she told also featured what she regarded as the other key element of fiction, namely the "mystery." For O'Connor, the mysteries included the portrayal of grace, the tragicomic, and the moments of revelation. Her mysteries take readers and critics alike far afield from the neatly circumscribed existence she and her characters inhabited, yet she never sought to make herself mysterious. She left voluminous wry and sharp letters and essays in which she slips into dialect, offering engaging observations regarding her life and art. She was a devout Catholic, subject to the suffering occasioned by lupus and its complications; she knew she would die young, just as her father had done. She regarded happy endings and sentimentality as anathema. Perhaps inevitably, her writings tended to be dark and violent. Yet her work remains translucent; its ambiguity allows for personal readings and widely varied, paradoxical interpretations, one of the many reasons for its broad appeal.

One way to consider the mysteries of Flannery O'Connor's fiction is with an appreciation for the manners of her particular place. Whatever their spirituality, her characters' lives remained quotidian: Her people tended to be plain, rural folk of the sort she knew in Milledgeville. If her work is filled with intimations of redemption and revelation, equally there are worldly tensions that drive their fictional lives. O'Connor recorded a changing world, one in which racial tensions emerged, economic tides threatened to engulf the bucolic countryside she knew so well, and a larger world encroached. In her letters she acknowledged the "peculiarity" that characterized her work and scoffed when she was called "a writer of the realistic school." She allowed that "I won't ever be able entirely to understand my own work or even my own motivations."

She is recalled today in part thanks to a range of black-and-white images from her years at Andalusia, many of which come complete with an apt visual metaphor. When her picture was taken, the author was regularly accompanied by one of her favored peacocks. They are creatures of surpassing beauty, with what appear to be eyes in their tails. Yet peafowl are also notably dirty and destructive birds. In offering his distinctive display, the peacock seeks not aesthetic admiration but a rutting sexual allure. As with O'Connor's prose, the peacock leaves one with the sense that all is not exactly as it seems.

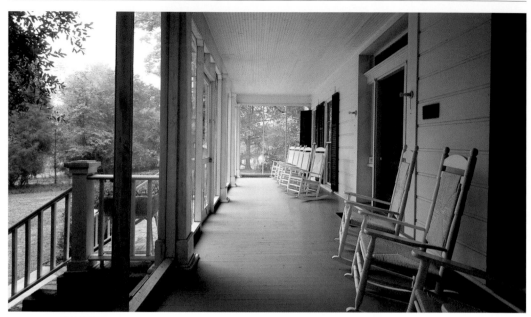

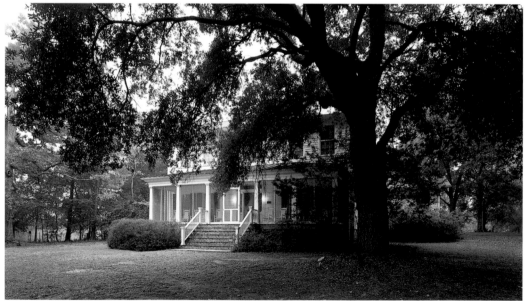

FLANNERY O'CONNOR

⩓

THE FLANNERY O'CONNOR ANDALUSIA FOUNDATION opened Andalusia to the public in 2003, and work continues on restoring the property as a literary landmark. In addition, the Foundation hopes to develop nature trails and establish a writers-in-residence program, goals entirely compatible with the life and inclinations of the home's most important denizen.

O'Connor's literary executor, Robert Fitzgerald, once wrote, "Flannery was out to be a writer on her own and had no plans to go back to live in Georgia." Circumstances conspired to change that, and her failing health brought her home. There, more than anywhere else, she came to understand that, as she once scolded a student, "Nothing happens nowhere." The somewhere of her unique fictions owed much to the farm called Andalusia.

Books by Flannery O'Connor

Wise Blood. New York: Harcourt Brace & Co., 1952.
A Good Man Is Hard to Find. New York: Harcourt Brace & Co., 1955.
The Violent Bear It Away. New York: Farrar, Straus & Cudahy, 1960.
Everything that Rises Must Converge. New York: Farrar, Straus & Giroux, 1965.
Mystery and Manners. New York: Farrar, Straus & Giroux, 1969.
The Complete Stories. New York: Farrar, Straus & Giroux, 1971.
The Habit of Being. New York: Farrar, Straus & Giroux, 1979.
Flannery O'Connor: Collected Works. New York: Library of America, 1988.

Left top: The trees have obscured much of the view, but during the many hours Flannery O'Connor spent on this porch, much of the activity of the farm was within sight.

Left bottom: The live oak that shades the house was a sapling planted during Flannery O'Connor's residence.

⩓ ⩔

The lush plantings and brick wall make Patchett's garden feel comfortably cloistered.

Right: She lives alone, aside from the lively presence of her dog, Rose, an abandoned Jack Russell-terrier-and-Chihuahua mix she adopted when running one day in a nearby park.

ANN PATCHETT

(1963 –)
Nashville, Tennessee

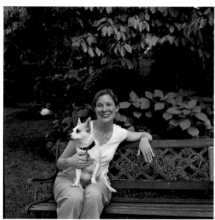

"Even though I swore I would never do it, subscribing as I do to Thomas Wolfe's theories about going home again, I moved back ten years ago, and it looks like I'm staying."

From "Destiny Delivered," *Preservation Magazine* (2004)

Ann Patchett's life, like her fiction, knows no pigeonhole. Born in Los Angeles, she moved to Tennessee with her mother a week before turning six. She spent the next dozen years in Nashville, most of them on a farm not far from town. Four years of college in suburban New York launched her on the road to being a writer, which involved a master's degree earned in Iowa City; magazine pieces for *Seventeen*, *Vogue*, and *Bridal Guide*; and a series of grants, fellowships, and teaching jobs that took her to Montana, Provincetown, Kentucky, and Cambridge.

Yet her first novel emerged only after she returned to Nashville and spent a year waiting on tables.

"This is where I'm from," she explains. "It is my landscape."

Her relationship to Tennessee is complex. Her ties are familial, as she and her mother share daily responsibilities for Ann's nonagenarian grandmother. There's a man in her life there too, a physician for whom her mother once worked. Karl lives three

❧ ☙

Left: Patchett wrote Truth and Beauty *in her bed, using a cookie sheet as a lap desk. "I was mourning and working at the same time."*

Below: The place seems a reflection of a mind that is curious but cautious; when looking at her rooms, one is not surprised to hear her explain, "I am troubled by wasted space."

ANN PATCHETT

blocks away and for the last decade has been what Patchett calls her "spousal equivalent." Still, she rarely writes about Tennessee and has no Southern accent, having taken her father's advice when he, remaining back in California, counseled against acquiring a regional lilt.

Ann Patchett resembles her books. She's pretty, precise, and, unlike many writers, seems very much in command of her writing life. If, like her protagonists Rose, John Nickel, Sabine, and Roxanne Coss, she has found herself in a circumscribed place, hers is a larger universe.

ANN PATCHETT'S FIRST NOVEL, *The Patron Saint of Liars* (1992), set the tone for the acclaim her novels would receive and marked out the emotional territory that engages her. "After all," she says, "most writers write the same book over and over. Don't you think?"

For Ann Patchett what is the key ingredient of that "same book"?

"The construction of family," she says quickly. "Groups of strangers, coming together."

Her categorization is a useful half-truth, as a quick overview of the work demonstrates. In *Liars*, she portrayed a group of young women thrown together by circumstances (they're all pregnant) who reside at St. Elizabeth's, a home for unwed mothers in Kentucky. *Taft* is a world apart but fits the same thematic profile, as a motley group of individuals from damaged families find themselves very much together in a bar in Memphis. The title character in *The Magician's Assistant* literally finds entry to a family she didn't know she had in a bleak town in Nebraska. Finally, in her most recent novel, *Bel Canto*, Patchett puts her characters in grave danger — radical militants in an unnamed South American country take an array of international guests hostage at a birthday party — and that precipitates a most unlikely coming together when the harmonics of human kindness replace the menace of the captor-captive relationship.

Her novels have something else in common, too: There's always a rude and often violent shock that fundamentally changes the microcosm Patchett has created; she makes it, then she breaks it, before she brings us to resolution.

"We're just birds on a wire," she explains, without apology. "That's life, because sooner or later you fall off."

⋅⋅⋅

IN HER OWN LIFE, ANN PATCHETT witnessed at first hand the perilous descent of a delicate bird.

Lucy Grealy gained national fame when her memoir, *Autobiography of a Face,* appeared the same year as Patchett's second novel, *Taft,* in 1994. But the friendship of Lucy Grealy and Ann Patchett started earlier. They had a passing acquaintance as undergraduates at Sarah Lawrence College but became apartment mates when they both gained entry to the Iowa Writers' Workshop after graduation. Lucy had been a star at Sarah Lawrence, despite a face disfigured by a childhood bout with cancer; Patchett's visibility had been of lesser magnitude. "People liked my work but had trouble remembering me."

Over the next two decades, they took turns winning fellowships and earning book contracts while falling in and out of love with various men, confiding in each other at every turn. As their writing reputations grew, the constant Patchett attempted to anchor her friend's chaotic life, one defined by her face (Lucy had thirty-eight surgeries over a period of twenty-five years, a restoration process that proved impossible to complete). Grealy had moments of glittering success, but she would die just short of her fortieth birthday of an overdose of heroin.

Patchett had railed against her friend's drug use, but the reality of her best friend's end stunned her. "I just took to bed," she remembers. "It was kind of like being a lobster and my shell was off." She felt compelled to write her way through the experience, and three weeks after Grealy's death in December 2002, Patchett finished a magazine piece that would be published in *New York* magazine. A week later, she was at

Right top: Along with several others, her home was built in the mid-1980s in what was once the generous backyard of a large, turn-of-the-twentieth-century house.

Right bottom: Her writing space over the garage is large, though not tall since it is built into the eaves. The walls are lined with bookshelves and photographs, with her desk and computer set before a large window in the gable.

ANN PATCHETT

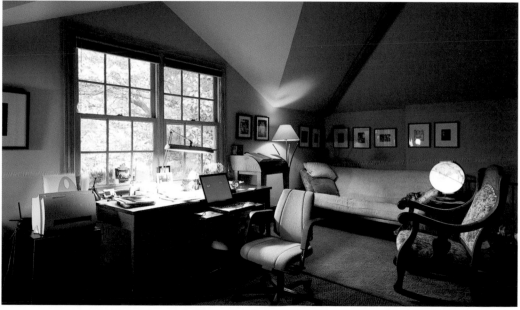

work expanding it into a book. "It was a piece of cake writing that book compared to writing a novel," she says ruefully. "After I wrote it, I just had to type it up. I had no guard and wanted to remember her good and bad."

The memoir *Truth and Beauty* is the result. At times it reflects the immediacy of its composition: vignettes, asides, and excerpts from Grealy's letters interweave with a partial chronology of the string of operations that Patchett helped see her friend through. The book assays the writer's life, too, as Lucy and Ann seek and find literary success and fame. There's much girl talk of men, sex, love, and hope. While *Truth and Beauty* is a small book, its subject is immense and universal. Instinct makes us want to see Lucy's deformity but Patchett takes her readers behind the mask, reveling in the intersection of love and friendship.

Ann was the protector, Lucy the protected. The book that records their complex relations is a tribute to a friendship that brimmed with love and dependence; the tragedy is that the death of the talented Grealy made the book necessary. But its candor and insights make *Truth and Beauty* one of those books that, quite by misdirection, sends the reader into his or her own past.

"It was a sad task," Patchett says of writing the book, "that turned out to be a happy task."

Bel Canto (2001) is Patchett's latest and most successful novel, a book that explores the power of art in the face of politics and violence.

The story came out of the headlines when Patchett found herself preoccupied with the takeover of the Japanese embassy in Peru by the terrorist organization Tupac Amaru. She adopted the factual framework of the four-month siege but imagined what life must have been like inside the embassy compound. She placed at the story's center an accidental captive, an American opera singer named Roxanne Coss, who proves to be the catalyst that transforms an act of political violence into something else altogether. Once she begins to sing, the calendar seems suspended, the days defined by her beautiful singing, the months in captivity a time of almost utopian cooperation between captives and captors.

Some have described the book with that damning-with-faint praise cliché *tour de force*. In truth, it was no small feat to tell a compelling story whose action

ANN PATCHETT

unfolds almost entirely within the confines of a single room, the parlor of the vice president's mansion. Just as Hitchcock did in *Lifeboat*, Patchett uses the sense of confinement to shape the narrative. She did her homework, studying up on the Stockholm syndrome, the observed phenomenon in which kidnap victims over time can become complicit with their captors and their goals. Although she was not an opera buff before writing *Bel Canto*, her research led her to an affinity for the art form that floods the pages of the book.

The armature of the story thus became not guns and politics but music and passion. There's a moment when Roxanne sings and even one of the rebel generals is overwhelmed. "Had she not been singing all along? The sound was no more beautiful when her voice was limber and warm. Their eyes clouded over with tears for so many reasons it would be impossible to list them all. They cried for the beauty of the music, certainly, but also for the failure of their plans. . . . All of the love and the longing a body can contain was spun into not more than two and a half minutes of song."

There's an ineluctable logic to the story that's almost too perfect — the coincidence of events at the beginning, the Japanese accountant who happens to be a pianist, the French chef, the beautiful woman disguised as a soldier, the symmetry of the ending. But in Patchett's hands the true story of the Peruvian hostage crisis is forgotten, replaced by imagined events that assume the shape of a fable. When Roxanne Coss produces beautiful sounds, she makes love suddenly possible in a place where one might least expect to find it.

THE PATH TO ANN PATCHETT'S DOOR takes the visitor on a series of Nashville streets of diminishing size, the last one a quiet cul-de-sac. She bought the house, the first she has owned, in 2000. After apartments and rentals and time spent back in her mother's house as an adult, she says, "It's nice to make noise and feel like I'm not intruding." And the neighborhood feels familiar, as her favorite cousins in childhood grew up just down the street.

The compact two-bedroom home has a surprisingly spacious feel. The ceiling in the living room rises in a tall curve; doors to the rear open onto the private walled garden. A comfortable kitchen, dining room, and vestibule complete the main floor, and over the garage is what she calls the "bonus room."

Throughout the house, artwork is on display. In the living room are a late nineteenth-century Dutch oil painted in the contemplative mode of Vermeer; a stark black-on-black canvas of a horse painted by contemporary New York artist Joe Andoe; and a photograph by Melissa Ann Pinney. Patchett's tastes in furniture are eclectic, too, producing a decorating scheme that is neither spare nor studied; there's an exactness more interesting than merely neat. A sense of organization pervades the house as objects have their places, rooms their purposes.

She is, after all, a disciplined writer. She recalls writing her second novel this way: "I had spent the winter out west, methodically chipping away at my second novel, stacking up the pages at my regular steady pace." She writes on her computer, not in longhand, and remarks, "I don't save drafts. I edit as I go along. When I finish, I'm pretty much done."

She writes in this house, doing what she knew she would do at age five. "Never wanted to do anything else," she says in her no-nonsense way. "I've always known what I wanted to do."

ANN PATCHETT IS NOT A BASHFUL WRITER. While *Truth and Beauty* has none of the exhibitionism of confessional memoirs, it is a deeply revealing, honest, and personal book. She takes chances, too: Though a white woman, she imagined John Nickel, her protagonist in *Taft*, as an African-American musician turned bar manager in music-mad Memphis. Nickel confronts no insult-hurling racists; the shading is subtler than that. He lives in a world where the races coexist and interracial relationships happen, but there's a subtle undercurrent, too, of a time in which not only the police engage in racial profiling. Patchett says her next novel will be set in Boston, with race relations at its core.

Just as her novels differ in important ways, no two photos of Ann Patchett seem to look the same. Yes, her fine hair is usually pulled back to reveal her soft features. But hers is a face that in photographs holds much in reserve; some of that reticence, perhaps, enables her to wield the kindness and affection she confers on her characters.

As with so many writers, it is possible to deconstruct much of her fiction into facts from her life. Patchett's characters often meet with medical situations — having babies, surgeries, being sewn up; her mother is a nurse, her stepfather a doctor. She

❧ ❧

ANN PATCHETT

worked as a waitress, just as Fay Taft did. She admits that Patty Hearst is "a life-long passion of mine" (Patchett was ten when the dramatic kidnapping occurred). Yet hers are books that, despite sharing some mundane details with her own life, were born of her imagination. If, as Ann Patchett says, she writes the same novel each time out, then she peoples them with distinct individuals set down in imagined environments that reflect both the dangers of the real world and a slightly fabled view of how happier communities might function.

ANN PATCHETT RECOGNIZES A PARTICULAR DEBT to an elder from Jackson, Mississippi. "Eudora Welty has been hugely important in my life," she says, her carefully modulated voice rising slightly. "She makes the fact I've returned to Nashville to take care of an aging relative seem right. She's validation that you can live an important life of the mind wherever you are."

Unprompted, she adds a memory. "I went to her funeral. Heard about it on NPR. I put a black dress in the car, got up, and left." It was all so matter-of-fact, so necessary, so obvious.

"It was beautiful," she concludes.

For Miss Welty and Miss Patchett, it is always the people who define the place.

Books by Ann Patchett

The Patron Saint of Liars. Boston: Houghton Mifflin Company, 1992.
Taft. Boston: Houghton Mifflin Company, 1994.
The Magician's Assistant. New York: Harcourt Brace & Company, 1997.
Bel Canto. New York: HarperCollins, Inc., 2001.
Truth and Beauty: A Friendship. New York: HarperCollins, Inc., 2004.

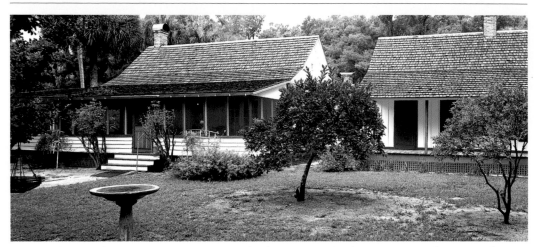

Rawlings gifted the house to the University of Florida, which after her death in 1953 used it as a faculty residence. Conditions deteriorated over time, and later the farm became the property of the Florida Department of Natural Resources, which restored it as the Marjorie Kinnan Rawlings State Historic Site.

MARJORIE KINNAN RAWLINGS

"For This Is an Enchanted Land"
MARJORIE KINNAN RAWLINGS
(1896 – 1953)
Cross Creek, Florida

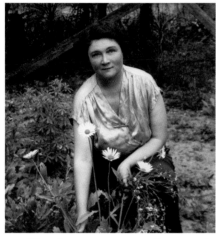

"We all need, I think, a certain remoteness from urban confusion, and while this can be found in other places, Cross Creek offers it with such beauty and grace that once entangled with it, no other place seems possible."

From *Cross Creek* (1942)

I have used a factual background for most of my tales," admitted Marjorie Kinnan Rawlings, "and of actual people a blend of the true and the imagined." To read her writings set in central Florida is to appreciate how much the backwoods country and her Cracker neighbors came to be essential to her work.

Yet Marjorie Kinnan [*kin-ANN*] was born in a different milieu. Her father worked in the U.S. Patent Office, so Marjorie's childhood was spent in suburban Washington, D.C. A frequent and welcome escape from their middle-class routine was to a dairy farm her father owned a few miles away along Maryland's Rock Creek. A man of scientific bent, Arthur Kinnan experimented for the U.S. Department of Agriculture with seeds, crop rotation, and cattle breeding, and young Marjorie (called "Peaches" by her father) found the atmosphere of the farm stimulating and congenial. Her affinity for the land grew with summer visits to her maternal grandparents' farm in Michigan.

217

While these early experiences presaged her own later lifestyle in Florida, farming was never a part of her conscious life-plan; from an early age, she wanted to be a writer. At eleven, she won two dollars for a story that appeared on the Sunday children's page of the *Washington Post*. In high school, another story was published, this one in *McCall's*, earning its author seventy-five dollars. She went on to enroll at the University of Michigan, where she promptly declared herself an English major. She joined the staff of the university's *Literary Magazine*, which published her poems, stories, profiles, and book reviews. In the person of its editor, she also encountered her future husband, Charles Rawlings.

After earning their degrees, they briefly went in different directions, he to military service (World War I was raging in Europe), she to New York to try to make her literary fortune. She found temporary work at the Y.W.C.A. writing for the organization's publications and also produced manuals for the Boy Scouts. Upon his release from the army, Chuck joined her in New York and they were married in 1919.

Full-time employment proved elusive in New York so they welcomed a friend's steer to jobs in Louisville. He became a reporter and she a feature writer for the *Courier-Journal*. Two years later a job offer from Chuck Rawlings's father to join the family business of making and selling shoes lured them back to Chuck's hometown of Rochester, New York. Marjorie kept busy writing features for the *Rochester Evening Journal* and, later, a new magazine called *5 O'Clock*.

A vacation proved the turning point in Marjorie's life. In March 1928 she and Chuck steamed down Florida's east coast, disembarking at the mouth of the St. John's River in Jacksonville. A journey inland introduced them to an area she called "the last of Florida's frontier," a region of marsh and hummock, home to the Florida "Crackers," who got their name from early arrivals in Florida and Georgia, nineteenth-century cowboys who herded wild cattle using leather whips that "cracked." Everything about the place charmed the Rawlings: the remoteness, the watery landscape, the intimate connection between the land and its inhabitants who hunted, fished, and cultivated the soil.

The young couple resolved to find a small citrus farm, where they could earn a living off the land while establishing themselves as writers. Within months, they learned of a seventy-two-acre property with some four thousand orange, pecan,

❧ ❧

MARJORIE KINNAN RAWLINGS

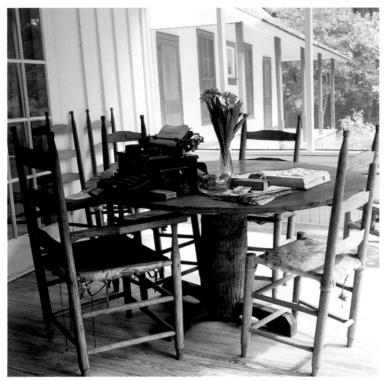

Rawlings often wrote on the porch, on a handmade cypress tabletop mounted on a palmetto palm log pedestal.

grapefruit, and tangerine trees. Using what means they could assemble, including Marjorie's modest inheritance from her mother, they put down $7,400 of the $9,000 purchase price. In November 1928, they took up residence in Cross Creek, Florida.

THEIR NEW HOME WAS NOT THE STANDARD ISSUE smell-the-ocean and worship-the-sun Florida escape. The Atlantic was seventy-five miles away, and in those days, the tiny settlement of Cross Creek consisted of a handful of dwellings that was home to seven families. Located midway between Ocala and Gainesville, the Rawlings's citrus grove was part of the Scrub, a delicate local ecosystem consisting of scrub pine forests and countless streams. The area was dotted with wetlands, sometimes called "wet prairies."

If the unfamiliar landscape was beguiling to the transplanted Yankees, the people and the wildlife proved equally entrancing. A year after her arrival, Marjorie posted a batch of stories to an editor at *Scribner's Magazine*. These were slightly recast anecdotes about her new neighbors in Cross Creek, portraying their isolated rural lives. They were accepted for publication and appeared in the magazine in 1931 as "Cracker Chidlings: Real Tales from the Florida Interior." The stories announced the arrival of a new voice. When her next submission was forwarded to the desk of Scribner's head editor, Maxwell Perkins, Rawlings would find herself a literary mentor.

Perkins, the legendary editor of Hemingway, Fitzgerald, and Thomas Wolfe, encouraged her to write a full-length novel. She researched the Cracker life by spending ten weeks as a boarder in a family of moonshiners. Her first novel, *South Moon Under* (1933), was the result, and it met with the approval of her moonshiner friend who, after reading the book, told her, "You done a damn good job, for a Yankee." The literary establishment in New York agreed, as the book was chosen by the Book-of-the-Month Club, received enthusiastic reviews, and quickly made its way onto the bestseller list. But it was a bittersweet time for Marjorie. Her marriage had grown troubled and the success of *South Moon Under* coincided with Charles Rawlings's permanent departure.

She kept working. New stories appeared in the *Saturday Evening Post* and *Harper's*. She won the O. Henry Memorial Short Story Contest. Her second novel, *Golden Apples* (1935), got good notices, but it was her third, *The Yearling*, that brought her broad acclaim. Although she insisted that its publisher never describe the book as a

⋅⋖ᵹ ᵵᵌ⋗⋅

"juvenile" title, the coming-of-age tale has been a staple of young people's recommended reading lists ever since its publication.

The Yearling tells the story of Jody Baxter, a twelve-year-old boy living with his parents in the Florida Scrub in the years just after the Civil War. They eke out a bare existence in a clearing, confronting a murderous bear named Old Slewfoot, a violent and ill-tempered neighbor, and a rattlesnake bite that nearly kills Jody's father. Jody adopts a fawn, names him Flag, and, to the consternation of his mother, raises him as a pet. The book recounts a year's events, leading to a climax in which the deer, having become destructive, has to be shot. At the novel's end Jody finds he has abandoned the simple pleasures of his childhood pastimes and assumed the burdens and responsibilities of manhood.

The Yearling spent almost two years on the bestseller lists, won the Pulitzer Prize as the best novel of 1938, and, in 1947, became a motion picture starring Gregory Peck. It was translated into more than thirty languages and made Marjorie Kinnan Rawlings an important literary figure.

A collection of stories, *When the Whippoorwill*, followed in 1940, but it was in 1942 that *Cross Creek* and *Cross Creek Cookery* were published, completing her informal cycle of books about her adopted home. The first was a memoir of her life and neighbors, as well as an appreciation of the flora and fauna of the place. Her voice is that of a wise storyteller seated on her porch — where she often wrote, sometimes in longhand, sometimes on her L.C. Smith portable typewriter — telling the tales of the friends and neighbors who, the reader understands, are as likely as not to saunter by as the story unfolds. Throughout her career Rawlings's writings won the admiration of naturalists, as she was a keen observer of birds, of which a great variety inhabit the Scrub, among them herons, eagles, egrets, and cranes, as well as other wildlife, including swamp snakes and alligators.

Cross Creek provided her with an abundance of new and native foods that she brought to her table. She learned to cook rattlesnake, squirrel, alligator steak, turtle eggs, and blackbird pie, in some cases having acquired the meat herself with her .22 rifle. "White bacon" (a.k.a. salt pork) was a staple of her vegetable cookery, which included such freshly harvested local specialties as mustard greens, okra, asparagus, hearts of palm (called swamp cabbage at the Creek), chayote squash, mangoes, guava,

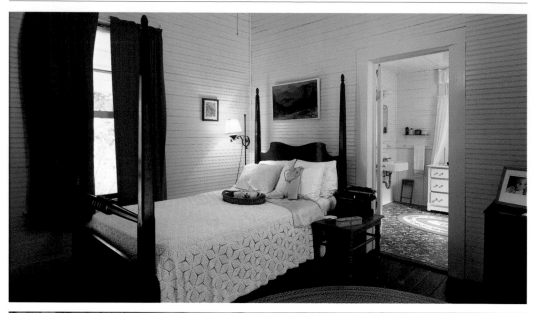

MARJORIE KINNAN RAWLINGS

and cassava root. Her breads ranged from the staple of cornbread to hot biscuits and hush puppies. Jellies became a specialty, and she used ingredients like the roselle, mayhaw, the wild hog plum, and the scuppernong grape. Her *Cross Creek Cookery* proved an intriguing mixture of the local bounty with more traditional American recipes, not a few of which were based on the cookbook her mother-in-law had sent her shortly after her marriage, the *Boston Cooking School Cook Book* by Fannie Merritt Farmer.

When paired with her fiction, Rawlings's life at the Creek, as recounted in her memoir, might lend itself to literary deconstruction. Yet at a more elemental level, the artifice is transparent and a simpler reality seems apparent. A cultured and sophisticated urban woman came to inhabit a primitive world and found herself captivated. The flora, fauna, and the natives all united to inform and enrich her literary output.

THE FARMHOUSE MARJORIE AND CHUCK RAWLINGS purchased was built in 1884, but it was only in 1925 that it was moved to its present site, dragged atop log rollers by mules. Two other separate structures were linked to it by porches, yet it remained a rudimentary dwelling. There was one faucet in the kitchen and a privy outside.

The house was typical of the local vernacular, constructed in the so-called Cracker style. It was built on pilings of rocks and bricks to keep the wood-framed structure off the ground. Such houses were knocked together quickly and inexpensively of local pine and cypress boards. The one amenity standard to the Cracker-style home was a wide porch, an essential escape from the broiling Florida sun.

The design was well adapted to the climate. The Rawlings house had tall ceilings (ten feet), with the kitchen located in a separate ell off the back to keep the heat away from the living quarters. It wasn't a large house (though the previous owners had raised eleven children there), and Rawlings spent most of her years at Cross Creek living alone. In the 1930s, as her earnings allowed, she improved the house, enlarging the

Left top: Most of the furniture in the house today, including the bedstead, belonged to Rawlings.

Left bottom: Though her countrified kitchen featured only a wood-fired cookstove, Rawlings wrote a best-selling cookbook about the local cuisine, Cross Creek Cookery *(1942).*

Left: When she acquired the house, the out-house was indeed necessary, given the absence of indoor facilities.

Below: The porch was an essential space in the days before air conditioning in central Florida. Note, too, the 1940 Oldsmobile just beyond.

❧ ❧

MARJORIE KINNAN RAWLINGS

front porch, adding screens (she had several bouts with malaria), buying a generator to provide electric light, and installing two bathrooms.

Rawlings's house was a reflection of her paradoxical presence in the Scrub. She grew accustomed to sharing her habitat with rattlesnakes and alligators, to cooking her food on a wood-burning stove. But she still served her guests dinner on Wedgwood china and wine in crystal goblets. They sat at table on Connecticut-made Hitchcock chairs. Unlike her neighbors, she varnished her heart-pine floors and added French doors to her living room to let light in.

Today, the house has been to restored to its late 1930s appearance. Beneath the carport there is a 1940 Oldsmobile like one she owned. The books on the shelves belonged to her, as did most of the furniture. The rustic house reflects both its local origins and Rawlings's more worldly tastes.

RAWLINGS'S GREATEST SUCCESSES WOULD BE *The Yearling* and *Cross Creek*, both of which were a direct consequence of her isolated life on her citrus farm. Ironically, the fame that accompanied their publication would end her quiet idyll there. Readers soon came to catch a glimpse of the author and her special place, and she found herself seeking refuge elsewhere.

In 1939 she purchased a cottage near St. Augustine. While she never stopped visiting Cross Creek, she spent less and less time there, especially after she bought another small house in Van Hornesville, New York, in 1947. She began spending summers at her New York dwelling (she called it her "Yankee house") and completed her last novel, *The Sojourner*, there. That book was an ambitious fable, set on a northern farm, its text dense with its author's philosophy of life. It is not accidental, perhaps, that the book, published after Maxwell Perkins' death, has a catchall quality and lacked the focus and dramatic intensity of her Florida fiction.

The Sojourner also came after a great hiatus in her writing career. Following the publication of *Cross Creek*, one of the neighbors portrayed in the book sued Rawlings for libel, asserting the book had caused her pain and humiliation. The suit took almost six years to adjudicate. Though the result was a pyrrhic victory for the plaintiff (a damage award of $1), the real loss was Rawlings's deeply felt connection to Cross Creek. It was as if the enchantment the place had held over her imagination was broken.

❧ ❦

Her fame had brought her the opportunity to meet many of the other major literary figures of her day. Wallace Stevens dined at Cross Creek (she didn't much like him). The swapping of hunting stories cemented her friendship with Ernest Hemingway, and she and F. Scott Fitzgerald got drunk together. Robert Frost regarded her adoption of her Florida neighbors as akin to the connection he had forged with his community in Vermont. Margaret Mitchell Marsh, whose sudden success with *Gone with the Wind* in 1936 preceded Rawlings's by just two years, became a valued friend and confidante.

Another friend was Zora Neale Hurston. Rawlings had encountered other African Americans in her own Florida neighborhoods, where there were two "colored families." At first she was bemused and curious about them, but over time her interactions with them and with the many African Americans who worked for her as cooks and gardeners, brought her to acknowledge the need for "full equality." She would die before civil rights became a viable national movement, but her relationship with Zora Neale Hurston suggests the evolution of her thinking. The first time Hurston visited Cross Creek, Rawlings gave her accommodations in the tenant house where her servants lived. On her next visit, Hurston was invited to stay in the house just like any white guest, to the outrage of some of Rawlings' neighbors.

Rawlings was by inclination a naturalist and anthropologist rather than by training. She saw the essential humanity in her Cracker neighbors; the richness of the climate, the flora and the fauna of the Scrub, touched each of her senses. The watery world of the Creek teemed with life, and Marjorie Kinnan Rawlings experienced it in transcendental fashion. She died in 1953 of a brain aneurysm at age fifty-seven, but for the decade when she was open to the experience and striving to put it on paper, she brought the Scrub to vibrant life in the pages of her books.

Books by Marjorie Kinnan Rawlings

South Moon Under. New York: Charles Scribner's Sons, 1933.
Golden Apples. New York: Charles Scribner's Sons, 1935.
The Yearling. New York: Charles Scribner's Sons, 1938.
When the Whippoorwill. New York: Charles Scribner's Sons, 1940.
Cross Creek. New York: Charles Scribner's Sons, 1942.
Cross Creek Cookery. New York: Charles Scribner's Sons, 1942.
Jacob's Ladder. New York: Charles Scribner's Sons, 1950.
The Sojourner. New York: Charles Scribner's Sons, 1953.
The Secret River. New York: Charles Scribner's Sons, 1955.

The Taylor home, within easy walking distance of Mr. Jefferson's university.

Right: Eleanor Ross Taylor and Peter Taylor at their gate in Charlottesville.
Photo credit: Ray Lustig/Washington Star.

In the Tennessee Country

PETER TAYLOR and ELEANOR ROSS TAYLOR

(1917 – 1994) (1920 –)

Charlottesville, Virginia

"As one walks or rides down any street in Nashville one can feel now and again he has just glimpsed some pedestrian on the sidewalk who was not quite real somehow, who with a glance over his shoulder or with a look in his disenchanted eye has warned one not to believe too much in the plastic present and has given warning that the past is still real and present somehow and is demanding something of all men like me who happen to pass that way."

From *A Summons to Memphis* (1986)

Peter Hillsman Taylor was an inveterate revisitor. In his writings, he returned repeatedly to the Tennessee of his youth and to a social stratum that Robert Penn Warren characterized in his introduction to Taylor's first story collection as the "urban, middle-class world of the upper South." Yet Taylor's fiction is not the least provincial.

Taylor's world was certainly circumscribed, and his works are miniatures of social nuance and, very often, regret. Nothing is overstated, and his plots are unremarkable; broken engagements, late-in-life marriages, and past business betrayals are about as dramatic as the events in Taylor's fiction get. More than one critic in the past took a dismissive line in assessing Taylor, seeing him as a chronicler of social niceties. Beneath the polish, however, people are doing battle, sometimes with themselves, usually with

their pasts, typically within their families. His people are often disappointed at their failed lives, even if they prefer to hide their pain.

His portraits of the upper classes tend to be less than adoring – as Taylor himself once remarked, "I am somehow drawn to all the vulgarities and pretensions of society and at the same time despise them." That paradoxical view helped elevate his portrayal of a narrow demographic into an important body of stories and novels that represent a broad band of human experience.

NOW IN HER MID-EIGHTIES, Eleanor Ross Taylor is a small, self-contained woman, but she warms quickly when she talks of her late husband. "Peter was very gregarious and social," she remembers. Their parties are fondly recalled by many, with Peter a smiling, welcoming presence, a man of wit and always with a story to tell.

In the course of their long marriage, Peter and Eleanor forged fast friendships with many of the finest literary minds of their generation. Having matriculated in Memphis at Southwestern (now Rhodes College) in 1936, Peter studied with Allan Tate. Invited to dine at Tate's home, he was greeted by his teacher's wife, the novelist Caroline Gordon. At Tate's suggestion, he later transferred to Vanderbilt in Nashville to work with poet, critic, and teacher John Crowe Ransom, perhaps the era's most distinguished man of letters. At Vanderbilt Peter became friends with an older student, poet and fellow Tennessean Randall Jarrell. They followed Ransom to Kenyon College, Taylor as an undergraduate and Jarrell as an English instructor and tennis coach. In Gambier, Ohio, Taylor met and roomed with poet Robert Lowell, who also would remain a lifelong friend. Immediately before the outbreak of World War II, Peter studied at Louisiana State under the tutelage of poet and novelist Robert Penn Warren and critic Cleanth Brooks.

Taylor was drafted in 1940, after having attempted to avoid service as a conscientious objector. He would serve five years in the Army, but in 1943 he and Eleanor Ross were married, shortly before he was to be shipped off to England. The marriage endured for fifty-one years.

Their list of literary friends grew longer. As well as Jarrell and Cal Lowell and his wife, Elizabeth Hardwick, their circle came to include Jean Stafford, Eudora Welty, and Katherine Anne Porter. "One of the things that made people like Peter so much

❧ ❦

PETER TAYLOR and ELEANOR ROSS TAYLOR

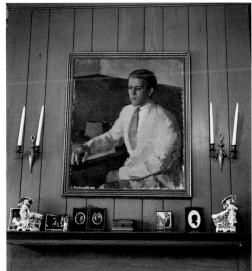

Left: A portrait of Peter Taylor at age seventeen, painted by his Memphis girlfriend at the time, Virginia Jett.

Below: The sitting room in the Taylor house, with a characteristically eclectic array of furniture.

❧ ❧

was his great social appetite," observed his biographer, Hubert McAlexander. "He was really interested in people, and he was a great observer of the life around him."

His friends' lives were full of events. The cumulative list of dramas the Taylors observed included multiple divorces, numerous affairs, an apparent suicide (Randall Jarrell's), and periods of madness (Robert Lowell's). But Peter and Eleanor brought up two children, wrote their books, and found new generations of writers to instruct. Ann Beattie, James Alan McPherson, and John Casey were among those befriended by both Taylors and to whom Peter gave important literary direction. Their debt to him, as a friend and teacher, is apparent. As Casey observes, Peter Taylor was "the champion of the short story in both senses of the word."

PETER TAYLOR'S LAST NOVEL, *In the Tennessee Country*, was published in 1994. The title fit the book nicely, but, in a more general way, "in the Tennessee country" is also a rubric that characterizes much of Taylor's literary output.

He was Tennessee-born (hometown: Trenton, Tennessee). His father, an attorney seeking work in the hard times of the Depression, moved the family to Nashville, St. Louis, and finally to Memphis. The sense of dislocation that resulted proved an enduring source for the son whose first novel, *A Woman of Means* (1950), is set in St. Louis. It is a story told by a boy, recently arrived in the city, who seeks a new equilibrium with the help of his stepmother. Taylor's story collection, *The Widows of Thornton*, tells the tales of several families, black and white, who hail from Thornton, Tennessee, but now live elsewhere. More than three decades later, Taylor published what would be his best-known novel, *A Summons to Memphis* (1986), which explores the social and emotional costs of a family's sudden relocation from Nashville to Memphis. A sense of place, whether lost or adopted, is central to Taylor's work.

The Taylor bloodlines in Tennessee run deep. Peter's surname, in fact, came from both sides. His father was a West Tennessee Taylor; his mother, from East Tennessee, was Governor Robert Love Taylor's daughter. Ironically, Peter often chose Middle Tennessee, and specifically the state capital, Nashville, as the setting for his stories, among them *In the Miro District* (1977). And even when he didn't, the standards of Nashville society were usually the gauge by which the quality of life in other cities was to be judged.

❦

PETER TAYLOR and ELEANOR ROSS TAYLOR

Taylor's teaching life would prove peripatetic, as he took teaching posts at the Women's College of the University of North Carolina at Greensboro, Kenyon College, Ohio State University, the University of Chicago, Indiana University, Harvard, and other schools. But his post at the University of Virginia proved to be the most enduring. He was appointed Commonwealth Professor of English in 1967 and, aside from occasional sorties for semesters as artist-in-residence at other institutions, taught there until his retirement.

Even so, Peter remained a Tennessean at heart, rather like the memorable title character in *Miss Lenora When Last Seen* (1963). Miss Lenora was an eccentric and aristocratic schoolteacher being dispossessed of her family property by eminent domain (a new school was to be constructed on the site). She chose not to fight the proceeding but instead simply left town, embarking on a road trip in her 1942 Dodge convertible. As the story unfolds, her exact whereabouts are unknown, but as the narrator tells us, "She seems to be orbiting her native state of Tennessee."

Another dispossessed Tennessean, namely Peter Taylor, did the same thing for decades in his stories and novels. In the end, however, he did return home. Though he was a resident of Charlottesville at his death in the autumn of 1994, he left specific instructions that his remains be interred on the Cumberland Plateau in Sewanee, with its broad vista of what he termed "the long green hinterland that is Tennessee."

UPON ARRIVING IN VIRGINIA, THE TAYLORS first inhabited the house that William Faulkner owned when he taught at Charlottesville. Soon they bought a house on a quiet cul-de-sac where they would reside for decades — Eleanor still does — but Peter's adventures in real estate didn't cease. In Virginia he bought and sold an eighteenth-century farmhouse, a cabin in the Blue Ridge Mountains, and two farms. There were also part-time residences for brief periods in Sewanee and Key West. In "Dean of Men," from *The Collected Stories of Peter Taylor* (1969), he wrote about how houses can be currency at colleges, denoting status or favor. He was a student of architecture, able to recognize from afar the bones of an antique house obscured from most people's view by the accretions of later additions and renovations. And he acknowledged the importance of "the small old world we knew," in which people came from the countryside and the old family house meant a great deal.

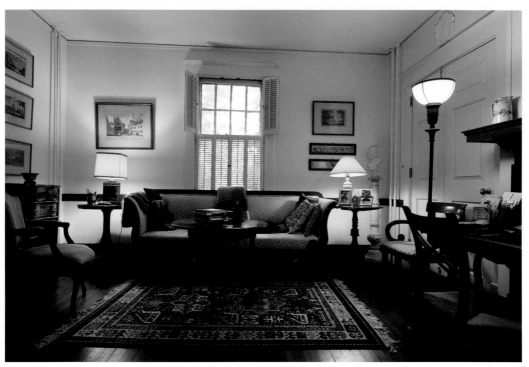

"Peter was a frustrated architect and interior designer," Eleanor recalls.

❦

PETER TAYLOR *and* ELEANOR ROSS TAYLOR

Friends remember the Taylors settling into temporary quarters — a semester away, perhaps, or a vacation rental — and how they had made the place theirs. "No matter how long they'd been there, it looked like they'd been there for years," John Casey recalls.

ELEANOR ROSS TAYLOR WAS BORN IN North Carolina, where she too was a student of Allan Tate and Caroline Gordon Tate at the Women's College of the University of North Carolina (now the University of North Carolina at Greensboro). Later she studied with Donald Davidson at Vanderbilt. But Eleanor and Peter met at the Tates' home.

Like her husband, she wrote stories in the early days, but after their marriage, finding the time proved difficult. Her poetry became her focus, the continuing discipline of writing important to her. "Peter said he wrote stories to find out what he thought," she recalls. After a pause, she nods, and remarks, "I guess that's what I write poems for."

Eleanor remembers the literary ferment of the postwar years. She and Peter were living in faculty housing in Greensboro across the hall from the Jarrells. Eleanor, still a young poet working to find her voice, was reluctant to seek the older Jarrell's advice, but Peter insisted. She remembers Peter literally leading her by the hand, a sheaf of her poems in his other hand, and walking her across the hall. Jarrell's criticisms were kindly, as well as insightful and instructive, and he helped get some of Eleanor's early work published. He would later write the introduction to her first collection, *Wilderness of Ladies* (1960).

Her work has been compared to the poems of Emily Dickinson, Marianne Moore, and Elizabeth Bishop. She herself acknowledges an enduring admiration for Edna St. Vincent Millay. "I read her as a teenager and just fell in love. She gave me a feeling of being able to approach everyday life in my poems."

Her poems are not formal exercises; her voice on the page is idiomatic. As with Peter Taylor's work, the subject matter isn't anger or violence. The small events, her insights into life, those are her materials.

"I'm constructing my own brierpatch," she wrote in "Always Reclusive." She finds guidance in a gardening book.

"The blackberry permitted its own way,
is an unmanageable plant." Here's a
variety called *Taylor*: "Season late,
bush vigorous, hardy . . . Free from rust."

That's it. Don't let my brierpatch rust.

One can imagine her, in her garden, doing battle with the unruly blackberry, both with her hands and in her mind.

Since her husband's death in 1994, Eleanor Taylor has led a quiet life, remaining in the Charlottesville home they shared. She has survived another death in the family, that of her daughter Katie in 2001. It was an immensely painful parting for her, one she muses on in a poem, "Our Lives Are Rounded with a Sleep." "Has she gone back," the poet wonders. "And will she know the place?/Who's that?/Or does it matter who is there,/in that blank space."

In the title poem from her most recent collection, *Late Leisure* (1999), she is at work embroidering. She describes herself as "past my expiration date," but she makes us (and perhaps herself) a promise.

I'll work through color changes
almost photosynthetic;
I'll search out chairs by windows
in south-facing rooms;
 I'll never work by artificial light.

Watching her, talking to her in the house she shared with Peter Taylor, it is apparent she has been true to her promise. Her hair is white, her glasses large, but there is an evident strength that endures. As she says in her plain, unadorned way, "I memorize poems. That's what I do to find calm and help me sleep."

PETER TAYLOR WAS A MAN WHO, observing a passerby in the street, seemed instinctively to understand his expression and to be able to imagine his story.

⤳ ⤶

PETER TAYLOR and *ELEANOR ROSS TAYLOR*

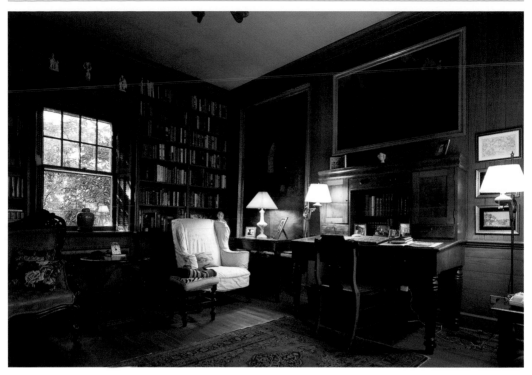

Peter Taylor's desk: a suitably antique object, perhaps, from which to consider generations of Tennesseans?

237

His narrators were Southern gentlemen, as Taylor himself was. His patrician voice seemed innately averse to the gauche, the grotesque, and the vulgar. Eccentrics were a minor specialty of his, but his view was always affectionate, never sentimental. His prose was crafted with such care that the colloquial and the cultured melded seamlessly.

Despite the appearance of his stories in many magazines — chief among them the *New Yorker*, where his work appeared more or less regularly for decades — and the periodic publication of collections between hard covers, Peter Taylor for many years was a writer's writer, relatively unknown to the general public. Then, at the age of seventy, he was awarded the 1987 Pulitzer Prize for *A Summons to Memphis*. It was a late-in-life gift that came with some small celebrity and a broader recognition of his work.

"Peter loved Tennessee and loved being Southern," remembers Eleanor Ross Taylor. In substance and manner, Peter Taylor is Tennessee's answer to Jane Austen. Despite the considerable historical remove, both writers portrayed people who were all members of "the right set," people who were genteel but not of unlimited means.

His writing has also been termed Chekhovian; indeed, both authors portrayed societies perched at the precipice of radical change. Their characters tread carefully, their fictional lives a balancing act. On the one hand, there's the confident, pastoral past; on the other is knowledge that the equilibrium of their lives grows ever more delicate as they enact familiar social rituals in a changing world.

Like Austen's and Chekhov's, Taylor's work transcends its region and manner, revealing much about the humanity of his characters. Seen through the patina of style and fashion, the substance of life glimmers from Peter Taylor's prose just as it does from Eleanor Ross Taylor's poems.

PETER TAYLOR and ELEANOR ROSS TAYLOR

Books by Eleanor Ross Taylor

Wilderness of Ladies. New York: McDowell, Obolensky, 1960.
Welcome Eumenides. New York: George Braziller, Inc., 1972.
New and Selected Poems. Winston-Salem: Stuart Wright, 1983.
Days Going/Days Coming Back. Salt Lake City: University of Utah Press, 1991.
Late Leisure. Baton Rouge: Louisiana State University Press, 1999.

Books by Peter Taylor

A Long Fourth and Other Stories. New York: Harcourt, Brace and Company, 1948.
A Woman of Means. New York: Harcourt, Brace and Company, 1950.
The Widows of Thornton. New York: Harcourt, Brace and Company, 1954.
Happy Families Are All Alike. New York: McDowell, Obolensky, 1959.
Miss Lenora When Last Seen, and Fifteen Other Stories. New York: I. Obolensky, 1963.
The Collected Stories of Peter Taylor. New York: Farrar, Straus & Giroux, 1969.
In the Miro District. New York: Alfred A. Knopf, 1977.
The Old Forest and Other Stories. Garden City, New York: The Dial Press, 1985.
A Summons to Memphis. New York: Alfred A. Knopf, 1986.
The Oracle at Stoneleigh Court. New York: Alfred A. Knopf, 1993.
In the Tennessee Country. New York: Alfred A. Knopf, 1994.

Christopher Tilghman in his place, where the fields and the water meet.

Right: Tilghman's writing pattern is variable. At times in his life, he has risen early and worked from 5:00 to 7:30. "That was one way," he says. "But sometimes I write in spurts, working all night, alone at this table. I have a lovely office in Charlottesville, but I like this bare table, my computer, the pages in hard copy, and Number 3 pencils. In fact, I do a lot of scribbling on paper. Thinking it out on paper without the distance of the computer is important."

CHRISTOPHER TILGHMAN

The Father's Place
CHRISTOPHER TILGHMAN
(1946 –)
Centreville, Maryland

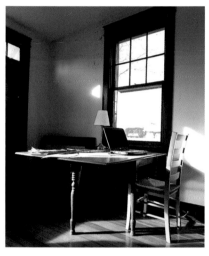

"Between the clay banks of the Eastern Shore of Maryland and the brackish waters of the Chesapeake Bay there is a beach a thousand miles long. . . . [There] the rolled farmland and mirrored water meet so seamlessly that on hazy days the big mansions, their pecans and honey locusts like sails, seem to be making their way, somewhere, on the shimmer of the Bay."

From "On the Rivershore"

These opening lines from the first story in Tilghman's debut collection, *In a Father's Place* (1990), set the scene for more than a single short story. The location, a sea-level farm on the saltwater shore, has been Tilghman country for more than three centuries. Christopher Tilghman himself is now into his third decade of writing about the place and its people.

Tall, slim, and clean shaven, he is given to considered pauses in conversation. When at the family farm, the Hermitage, he glances often toward the Chester River, that shoreline with the ancient trees and the gulls, herons, and other bird life. He's not distracted so much as forever aware of where he is.

"The connection between this place and my writing," he says, "simply can't be overstated."

His thinning, wind-blown hair and slightly weathered complexion give him the air of a sailor, but he looks a good deal younger than a man not far from sixty. He

published a much-admired first novel, *Mason's Retreat*, in 1996. A second story collection, *The Way People Run*, came out in 1999. A second novel, *Roads of the Heart*, appeared in the spring of 2004. But he's been writing about Maryland's Eastern Shore since he was a teenager.

Born and schooled in New England, he was a summer Southerner who spent his boyhood vacations on the family farm. The Eastern Shore of Maryland in those days had a lost-in-time quality, thanks to its isolation. Until the Chesapeake Bay Bridge opened in 1952 when Tilghman was six, the farmers and the watermen lived entirely apart from the urban life of Annapolis and Baltimore, both just twenty-odd miles away by water but half a day's journey by car. Thanks to its separation from the mainland, many people native to the Eastern Shore even today speak a unique and richly accented dialect, as do some of Tilghman's characters.

"The summer I was fifteen I did two important things," Tilghman recalls. "I was alone here, my two older brothers were off somewhere. First I read *Let Us Now Praise Famous Men*." His father, an executive at Houghton Mifflin in Boston, had recently republished the book at the imprint he ran, the Riverside Press. Long out of print, the James Agee classic, illustrated with Walker Evans's uncaptioned photographs, portrayed the world of proud but impoverished Alabama sharecroppers in the 1930s. The plain honesty of the people and the images, as well as Agee's self-conscious candor, proved irresistible to the teenaged Tilghman. "That single book got me thinking about the ways you can respond to the world."

And his world that summer was the Hermitage. "The second thing I did was write a novel. It was a family novel, and I did it through the agency of this place." He pauses, casting a glance toward the family graveyard, where the stones, all of which bear the name Tilghman, reach back to the seventeenth century. "Even then I sensed there was something deeply spiritual here."

IN THE YEARS TO COME, that first novel was forgotten and eventually lost, never to see publication. And Tilghman's wish to be a writer gave way to a desire to play music, one he satisfied playing bass ("with a little saxophone thrown in") in a jazz combo during his undergraduate years at Yale. He earned his degree, majoring in French, but upon graduation he found himself confronted by a hard choice. It was the summer of 1968

❧ ☙

CHRISTOPHER TILGHMAN

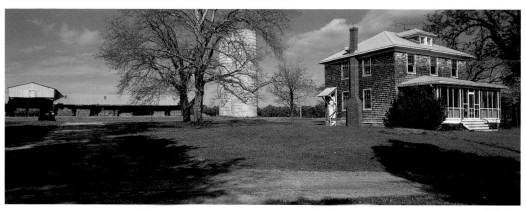

Top: A plain but serviceable farmhouse at the Hermitage has proved an invaluable refuge for Tilghman. Literally, he goes there to work — "I repair there for my writing — you know, crash writing weeks. It's been my MacDowell Colony, if I have one."

Bottom: The stable became a garage, which since the 1920s has housed a Model T Ford, unused for decades.

❦

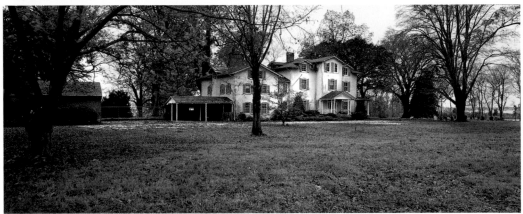

Top: Another restored structure on the Tilghman farm is a mule barn, center, flanked by an implement shed and a corn crib on the left and a second corn crib and granary on the right.

Bottom: The main house, though still crammed with family furniture and portraits, is Victorian eccentric. A substantial seventeenth-century house on the property burned down in the eighteenth century; most of the subsequent house also burned. The house today has an eighteenth-century wing that is connected to the nineteenth-century structure by generous porches overlooking the water.

CHRISTOPHER TILGHMAN

and his draft board was poised to call him, so he enlisted in the Navy and spent much of his three-year hitch as an ensign in the Mediterranean, blessedly far from Vietnam.

On shipboard one night in the North Atlantic he rediscovered his writer's vocation. "I was on watch, standing on the bridge. I was cold and miserable but I suddenly knew that what I really wanted to do was write fiction."

When he got out of the Navy in 1971, he moved to New Hampshire to practice what he calls "rural survivalism." He lived largely outside the cash economy, working in a sawmill and building houses ("I got to be a very good plumber," he laughs). And he wrote. Another novel emerged, one that eventually made its way into the hands of publisher Seymour "Sam" Lawrence. Tilghman remembers Sam Lawrence's response to the book as being crucial to his commitment to his craft. "He was someone who knew I wasn't wasting my time, and he said to me, 'You're a born writer.'" Those words have stayed with Tilghman. Even today when he tells the story he repeats Lawrence's phrase, *"You're a born writer,"* as if it were some sort of incantation. Despite the fact that Lawrence rejected the book, Tilghman recalls, "His unasked-for affirmation mattered deeply."

His apprenticeship was not yet over, however, and he actually burned some pages of another novel before moving on to other works. One day he decided to write a novella ("It's a perfectible form," he says with shrug, as if to explain). He wrote a detailed outline that ran to some thirty pages. It was to be a "peacetime naval story," its protagonist "a guy who finds being at sea gorgeous." Once he was satisfied with the outline, he sat down at his Smith Corona electronic typewriter to expand it. He found he couldn't. "I realized I had no more to say."

Frustrated and at a loss as to what to do next, he showed the pages to a friend, who told him it was really very good. "But there's no dialogue," Tilghman protested. His friend told him that was OK. After all, the friend assured him, "It's a short story." Tilghman was stunned at the realization. "Norfolk, 1969" shortly became his first published story, appearing in the *Virginia Quarterly Review* in 1980.

FOR A TIME HE BECAME A student again, attending a writing program at Bennington College (his wife dispatched him there with the words, "You have to write yourself out of Bennington"). Later he began teaching workshops. He joined a writers' group that

met weekly to talk and read, and he wrote corporate reports to help pay the mortgage. By then he had two sons (a third would arrive several years later). His fiction began to appear in magazines, including the *New Yorker*, the *Sewanee Review*, and *Ploughshares*. He found an agent and a publisher.

He began work on a new novel. That book, which would become *Mason's Retreat*, and a number of the stories from that period signaled an essential change in Tilghman's work. He had spent years becoming a writer, but only when he decided to locate his characters on the Eastern Shore did his fiction take on its unique, Tilghmanesque quality. "I had never set up shop here as a painter might," he says, "erecting his easel, preparing his paints, unfolding his spindly little stool, and then looking out at the landscape as if to say, 'OK, beach, show me what you got.'"

Once he tried that, he found that the ghosts of a hundred Tilghmans were there to guide him. There were the childhood memories of hothouse summers spent by a suburban kid amazed at the energy of the busy farm around him. He saw anew the complex social strata. He himself was a privileged member of the wealthy landowning class, but nearby were farming families who worked the land. Within sight on their crab boats were the watermen. Near at hand were African Americans — servants and laborers, descendants of former slaves, some of whom had been owned by Tilghmans. The thousand-acre farm, with its meandering shoreline, became his Yoknapatawpha County, complete with characters and conflicts and a rich history.

IF THE SMELL OF SALT AIR PERMEATES most of Tilghman's writings, so does a consciousness of what the Hermitage (or, in its fictional guise, the Retreat) represents. Tilghman's own father gave him a warning as a young man. "Take pleasure and meaning from this place and these people," he advised. "Take a tiny amount of pride, but don't get trapped by a feeling of privilege. Don't let it get ugly and social. Know its worth."

Today, abandoned agricultural buildings have collapsed, and great ornamental trees are being choked by vines. The silos survive, but the dairy cows are gone. Some five hundred acres remain in tillage, producing small grains (a rotation of wheat, soybeans, and corn). Tilghman says that one of the appeals the place has for him is its "aura of decay."

❧ ❧

CHRISTOPHER TILGHMAN

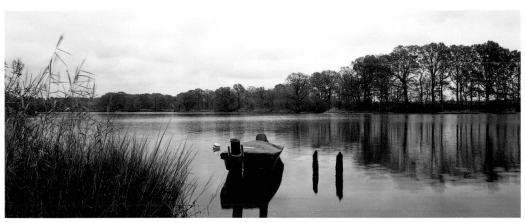

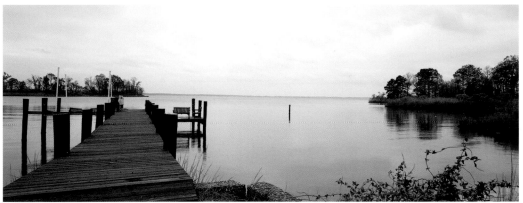

Top: For Tilghman, living by the water has meant that there have always been boats at hand.

Bottom: One meandering boundary of the farm is formed by the Chester River, which empties into the Chesapeake Bay just a short distance downstream.

᪥

The slave quarter at the Hermitage is a rare survivor. Tilghman says that before he and his brothers decided to restore the building, he heard a little voice that said, "If you guys let that fall down, I'll haunt you to the end of your days."

❦

CHRISTOPHER TILGHMAN

In his fiction, Tilghman distances himself from his aristocratic past, calling the Retreat "the ancestral home of the once-influential Mason family." In life, he spends weekends, vacations, and writing visits there, inhabiting a modest Foursquare house that for many years was home to the manager of the dairy farm. The main house remains the residence of his widowed stepmother, while his brothers spend their visits in other plain houses on the property.

The sprawl of outbuildings and fields that constitute the Hermitage brings to mind a moment in the title story of his first collection, *In a Father's Place*. The father of the piece, Dan, tweaks his son's literary-minded girlfriend when she refers to the family manse and its graveyards, in Derrida-speak, as "the essential past."

Initially bemused at her description, Dan recovers and retorts, "I often think the greatest gift I could bestow on the kids is to bulldoze the place and relieve them of the burden." That's vintage Tilghman, encompassing Dan's (and his own father's) recognition of the risks inheritance poses, as well as the young woman's failure to see beyond the Chippendale antiques and the ancient family portraits.

Tilghman has come to recognize the worth of the Hermitage as a stepping-off point for his work. But the threshold separating the fictive from the actual is surprisingly immediate. At first, the reader might conclude there's a symmetry in Sebastian, the adolescent lad who is at the fulcrum of *Mason's Retreat*, being the age Christopher Tilghman was when he wrote his teenage novel. The character arrives from someplace else, just as the writer did, and becomes enraptured by the Retreat. Sebastian attaches himself to a black farm laborer named Robert (inexperienced with "Negroes," he had been advised by his mother to pretend not to notice skin color). Sebastian and Robert become friends, to the degree allowed then by unbreachable separations of race and class. In life, Tilghman recalls with evident warmth a friendship with a black man, Raymond, who worked at the Hermitage. "I followed this enigmatic old black man around all summer."

The fictional Robert and the real Raymond . . . ?

"He's the only character drawn from life I've ever done," allows Tilghman.

Yet there is nothing nostalgic and little that is overtly autobiographical about Tilghman's writings. The climactic event in *Mason's Retreat* involves Sebastian's attempt to sail away from a family conflict. His father has sold the property, and the boy is to be

249

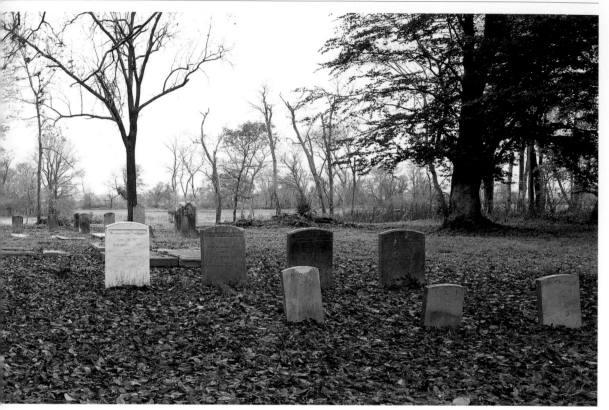

The sense of marching back through time is almost palpable in the Tilghman graveyard.

CHRISTOPHER TILGHMAN

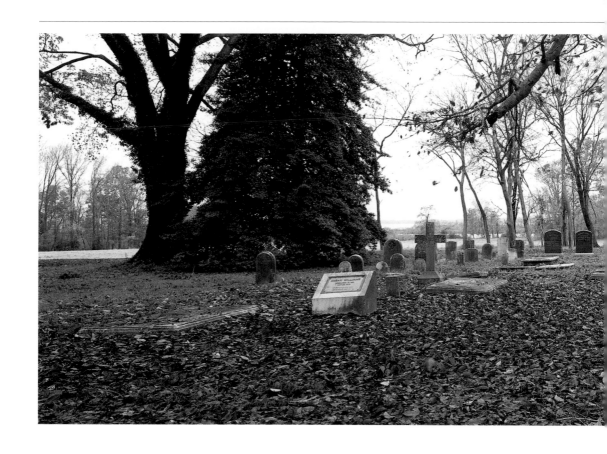

separated from Robert and the farm he has come to recognize as his home. In his late-night escape, the wind rises, and the waters of the Chesapeake swamp his borrowed sailboat. For the reader, the realization of what has happened is visceral — the boy drowns — but Tilghman softens things by veiling the events in a dreamy ambiguity.

Not surprisingly, perhaps, he wrote the scene at the Hermitage. "I do most of my good work at night," he explains. As he remembers that particular night, he seems cautious, even years later, as he handles the memory. "Sometimes I work all night, alone in the house, with rock music blaring in the background." He looks out a window, at the water topped with a few whitecaps.

"When I finished that scene, it was about three in the morning. I called my wife back home." He fidgets even as he tells the story, a decade later. "It took a while for her to answer. We talked a little, then I . . . I demanded she go check on our three sons. Just look at their heads on their pillows."

He hadn't found it easy to kill off Sebastian, who was not so much older than Tilghman's eldest son. "I was very freaked," he recalls. "But I had to go there."

Tilghman the novelist didn't simply reenact a family story, because there was no equivalent event in Tilghman lore to draw upon. Yet, he allows, "The novel did begin with a story, one about the telling of family tales."

THESE DAYS TILGHMAN SPENDS MOST of his time in Charlottesville, where he teaches creative writing in the University of Virginia M.F.A. program. He has lived in Massachusetts and Connecticut and New Hampshire. He's written about the sea and about Montana. But much of his work continues to belong to Maryland's Eastern Shore.

His most recent novel, *Roads of the Heart*, begins and ends there (his main character, we learn, never regarded it as "a burden, returning to or departing from his native ground. The fact was that he still found this landscape exotic, a secret, a private store of strength"). A new novel will be set there, too, one that features Mary Mason, the (imagined) maiden lady who inhabited the Retreat in the nineteenth century. It will be an opportunity to portray the era when slavery ended (family records reveal that the last of the Tilghman slaves were "sold south" in 1860). The place that has nurtured his writings continues to offer sustenance. As Tilghman explains, "Family is the one unchangeable thing, the people you were raised with." He stops, then adds quickly, "And back in time, too."

⤐ ⤏

CHRISTOPHER TILGHMAN

To regard Tilghman's work as a function of geography or history is to miss the point. Tilghman's world is full of fathers and sons. When he tells a story, the action is rarely confined to one moment in time; more often the narrative is framed by a recollected view, by a character who, much later, gazes back. As often as not that character — and, perhaps, Tilghman himself — seeks mercies as he explores the memories of his imagined characters, some of whom are, as one of them expressed it, "prisoners of family history." His is a world of faith, of hopes and disappointments, but ultimately a place where, as another character says, one can be consoled that despite family scars "the blood begins fresh with each child."

To see the place that has inspired him in person, or in the photographs in these pages, in no way diminishes Tilghman's writings. To the reader of his fiction, a glimpse of the Hermitage may provide mere texture, a curiosity revisited but not resolved. What matters is that Tilghman found his voice when, after more than fifteen years of striving to be a writer, he imagined himself back on that thousand-mile-long rocky beach, the one lined with cattails and cordgrass.

Books by Christopher Tilghman

In a Father's Place. New York: Farrar, Straus & Giroux, 1990.
Mason's Retreat. New York: Random House, 1996
The Way People Run. New York: Random House, 1999.
Roads of the Heart. New York: Random House, 2004.

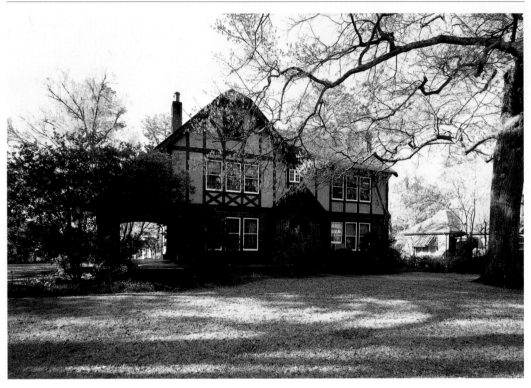

An enormous water oak tree shadows the front yard. It was a sapling when the Weltys arrived in 1925.

Right: Eudora Welty at work in her mother's garden.
Photo credit: Mississippi Department of Archives and History

A Sheltered Life
EUDORA WELTY
(1909 – 2001)
Jackson, Mississippi

"The events in our lives happen in a sequence in time, but in their significance to ourselves they find their own order, a timetable not necessarily — perhaps not possibly — chronological. The time as we know it subjectively is often the chronology that stories and novels follow: it is the continuous thread of revelation."

From *One Writer's Beginnings* (1984)

A s an adolescent," Eudora Welty remembered, "I was a slammer of drawers and packer of suitcases." Whatever her rebellious tendencies as a teenager, however, her adulthood did not prove to be a series of departures. Aside from college years spent in dormitories and, much later, an occasional semester spent teaching in Northern universities, she lived virtually her entire life in her hometown of Jackson, Mississippi. Her journeys would prove to be of another sort.

Eudora Alice Welty was born in 1909 on North Congress Street. Her father was an Ohio-born Yankee, her mother a West Virginian descended from Virginia stock. They had come to Jackson when her father, Christian Webb Welty, took a job with Lamar Life Insurance as its youngest officer.

That Eudora Alice would be a writer was not preordained; that she would have a passion for books was perhaps inevitable. Her childhood home was always full of books, among them a set of Dickens that her mother had been given as a girl. The books had been a bribe, offered by Chestina Andrews's father, to persuade her to cut

❧ ☙

*When the restoration is complete, the Welty House will be restored to the mid-1980s, when
its owner lived there alone and had reached the pinnacle of her fame.*

EUDORA WELTY

her hair (a wrong-headed notion afoot at the time held that long hair would sap a child's strength). Chestina so cherished those books that when a fire engulfed her home, she braved the flames, racing back into the burning house to throw them, and herself, out a window to safety. The set of books survived in more ways than one, as they would be memorialized in Miss Welty's novel *The Optimist's Daughter* (1972). "In the other bookcase," Miss Welty would write, "there was the Dickens all in a set, a shelf and a half full, old crimson bindings scorched and frayed and hanging in strips." As if endowed with a feline's nine lives, Dickens's oeuvre survives today, still on a shelf in Chestina Welty's bedroom.

Eudora attended public schools in Jackson, then pursued her studies at Mississippi State College for Women and the University of Wisconsin. After earning her bachelor's degree, she went on to the Columbia University School of Business in New York before returning to Jackson. There she found work at a local radio station and as a stringer for the *Memphis Commercial Appeal*. Her first full-time job was as a junior publicity agent for the Works Progress Administration, which gave her the chance to travel around her home state. She became an accomplished photographer, too, mastering a craft that informed her writing. Looking back on that time, she observed, "Photography taught me that to be able to capture transience . . . was the greatest need I had I learned that every feeling waits upon its gesture; and I had to be prepared to recognize the moment when I saw it. These were things a story writer needed to know."

In 1936, her first story, "Death of a Traveling Salesman," was published, announcing the arrival of a new voice. The story was a transforming experience for the young Eudora. "[In] writing 'Death of a Traveling Salesman' . . . I had received the shock of having touched, for the first time, on my real subject: human relationships." The story also proved to be the opening gambit in what would be the first of two productive periods in her writing life. In the course of the next twenty years, she would publish three novels (*The Robber Bridegroom*, *Delta Wedding*, and *The Ponder Heart*), as well as four collections of short stories.

Miss Welty's life was destined to have its share of sudden transitions. The death of her father was one: A transfusion of blood donated by her mother went terribly wrong, and her father died as mother and daughter watched. Another was her abandonment of photography when, in 1950, she left her Rolleiflex on the Paris Metro

and, miffed at her own absent-mindedness, refused to replace it. In the mid-1950s, family events conspired to separate her from her typewriter, too, resulting in a long hiatus from her writing. The break was occasioned by the illness of her mother and brothers and it was only after her mother and surviving brother died, within a week of each other in 1966, that she was able once again to devote herself to writing.

Her novel *Losing Battles* appeared in 1970, breaking her silence; it was a book she had taken to calling her "long story," at which she had worked fitfully during her mother's extended illness. Her 1972 novel, *The Optimist's Daughter*, emerged more quickly, telling the story of a dying parent tended by a daughter. Her collected stories followed, along with a memoir of her childhood, *One Writer's Beginnings*, a book that, against all odds, became a bestseller.

Miss Welty lived her long life close to home, devoted to family duties. Perhaps it is only fitting, then, that her finest fictions unfolded within the circumscribed environs of a Southern, white middle-class family milieu. She was a writer whose natural instinct was not to reach out to the world, but rather to look deeply into her own feelings in order to create a cast of characters, who, while encountering the full range of human folly, inhabited stories that, as she herself said, "all begin with the particular, never the general."

IN 1925, SIXTEEN-YEAR-OLD EUDORA MOVED into the new home at 1119 Pinehurst Street along with her parents and two younger brothers, Walter and Edward. Today, the Belhaven neighborhood is a historic district, its streets lined with handsome homes. But when Christian Welty had the house designed and built for his young family, the Welty place was on the outskirts of town on a gravel road. It would prove to be the house in which Miss Welty would spend her entire writing life.

When constructed, the home was a stylish upper-middle-class dwelling; today, it looks unpretentious and very much of its time. The architectural mode is Tudor Revival, with a half-timbered exterior of brick and stucco relieved by wooden timbers. The interior of the house is of a piece with the exterior. This is not a house where the past has been erased with radical renovations. The kitchen has a bare four-foot fluorescent light fixture in the ceiling and an old iron sink. There was not a great deal of extra money after Christian Welty's untimely death in 1931, so Eudora and her mother took

❦ ❧

In Miss Welty's bedroom, the shelves are heavy with books by friends and other writers she admired.

❦ ❧

in boarders into the 1950s. And Miss Welty felt no need to transform the place even when she had the means to do so late in life. The house remains unaltered, a record of her family's time in residence.

One doesn't have to imagine the ghosts. There are portraits Miss Welty commissioned, one of Christian, the father who was stricken with a disease he had never heard of (leukemia), and another of Chestina, who lived out a thirty-five-year widowhood. There's the palpable presence of the daughter, Eudora, who resided here until her death, after the passage of another thirty-five years, in July of 2001.

Along with her papers, Welty bequeathed the property to the Mississippi Department of Archives and History. The house is undergoing a restoration, with much basic work to be done to stabilize a deteriorating foundation, install air conditioning, update wiring, and complete plastering, painting, and other repairs.

In the most important room in the house, the sense is of a different sort of work. On the shelves, Eudora Welty kept Chekhov's writings near at hand, along with Faulkner's and those of Virginia Woolf. V.S. Pritchett, the British writer and critic, was a long-time correspondent of hers and his fiction and criticism are represented. There's a copy of the fairy tales of the Brothers Grimm (without which, perhaps, her first novel, *The Robber Bridegroom*, might not have been possible), along with an edition of *The Iliad*.

There are framed photographs of her literary friends, among them Katherine Anne Porter, who wrote the introduction to her first collection of stories; her *New Yorker* editor, William Maxwell, and his wife, Emily; and her friends Reynolds Price, E.M. Forster, and Elizabeth Bowen. There's a picture of Eudora with Kenneth Millar (a.k.a. Ross MacDonald); after she revealed in an interview in the *New York Times* in the 1970s that she had a soft spot for mysteries (especially Millar's), they became friends.

More than anyplace else, it is at her desk where her shade is most evident. Her ritual was to compose her first draft in longhand. She would then type her notes, working for many years on a manual typewriter, initially the red Royal portable she took with her to the University of Wisconsin (her arthritis eventually led her to purchase an electric machine). Her editing regime involved cutting apart the typescript, sentence by sentence or paragraph by paragraph. She would lay the strips out on her bed, then rearrange the pieces to her liking before reassembling them together in their new order, using stick pins. Retyped and re-edited versions would follow, but the cut-and-pinned

❧ ☙

EUDORA WELTY

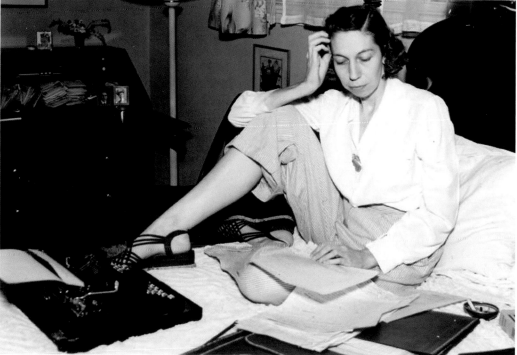

Welty worked as well as slept in her bed, typing and editing in her cut-and-pin style.
Photo credit: Mississippi Department of Archives and History

manuscripts, many of which survive, offer an extraordinary look into the mechanics of Miss Welty's writing.

Downstairs there's a family piano that came and went only to return; the young Eudora played it before it was dispatched to a brother's home for nephews and nieces, but later it was invited back to Pinehurst Street. There's overstuffed furniture, beds, books, tables, and pictures. The sense one gets in surveying the sheer mass of these personal objects, all freighted with meaning and memories, is that they were transformed by Miss Welty's imagination into the kinetic energy that propels her novels and stories.

"I WAS MY MOTHER'S YARD BOY," Miss Welty once quipped. Chestina Andrews Welty planted the garden the year they moved into the house. From the start she recorded her horticultural activities in a journal. She kept seed packets, made garden plans, and later recorded the look of the garden in photographs. Eudora herself was known to climb out her bedroom window onto the roof to get a better camera angle.

Chestina continued working in the garden until her death in 1966, and Eudora maintained it until age and infirmity led her to look to others to begin its conservation in the 1990s. Today, the garden has been restored to the era before 1945 when it was at its most elaborate and mother and daughter shared gardening duties. The daughter always regarded it as her mother's garden.

In a portrait Miss Welty commissioned of her parents, they are posed beneath an arbor in the garden; the original wooden arbor rotted and was demolished but it has been re-created based in part on the evidence of that painting. The arbor, along with other elements of the hardscape, anchors the garden. Some were rediscovered in a careful archaeological examination, among them concrete and brick borders and concrete steps. Stepping stones and trellises have been reintroduced, thanks to photographic evidence. But all are mere stage-dressing for the plant material.

There are forty-odd camellias, together with azaleas, poppies, daylilies, and mature crepe myrtles. In the springtime a perennial border is thick with daffodils (the "Presbyterian sisters," Miss Welty called them, because "they hang together"). There are sweet peas, hollyhocks, irises, hyacinths, chrysanthemums, jonquils, and varieties of lilies. Roses were Chestina's favorite, and they appear in the garden just as they do in

❧ ❧

EUDORA WELTY

The conservators of the house, and her legacy, benefited from Welty's tendency to save everything, from canceled checks to desk diaries with doctors' appointments neatly noted.

❧ ❧

Left: Photographs taken by Eudora and other members of the family have made the garden restoration possible.

Below: Chestina Welty once told her daughter that her garden wasn't for show — rather, it was to be "a learning experience, a living picture, always changing."

EUDORA WELTY

Miss Welty's fiction. Hybrid teas, 'Silver Moon,' 'American Beauty,' and other roses are still found in the Welty garden. Deep at the back of the property is a wilderness garden where once there was a clubhouse for her brothers.

Even during a business-school sojourn in New York, the garden remained a part of Miss Welty's life. Her mother would send camellia blooms to her in Manhattan, dispatching them on the overnight train from Jackson. Her passion for gardening regularly surfaced in her fiction. In *The Optimist's Daughter*, she described her alter ego, Laurel McKelva, at her mother's grave. "Laurel's eye traveled among the urns that marked the graves of McKelvas and saw the favorite camellia of her father's, the old-fashioned *Chandlerii elegans*, that he had planted on her mother's grave — now big as a pony, standing with unplucked blooms living and dead." With gardening, as with so much in her life, details were translated into the pages of her fiction.

"I like the work in the yard," she remarked in 1946, "[I] never get tired, and can think there, or maybe it's dreaming."

ALTHOUGH THE HOUSE IS IN the public domain, it retains the air of a private home and, it seems, people still respect the privacy of one of Jackson's most notable citizens. It's a real house, a home, with a screen door at the front that springs shut with a resounding clap. It's a family house that differs little from others around it.

Miss Welty's legacy includes her books, her house, and her voice, which survives in recordings. It is an unassuming, soft alto. She reads surprisingly quickly, without rhetorical flourishes. Her light Mississippi accent gently elongates a few vowels. The sense is not of pretense but of plain-speaking.

She wasn't a woman who assumed airs, even late in life, when countless awards and honors had been bestowed upon her. Allan Gurganus tells a story of knocking on her hotel-room door in her later years. She was to be the keynote speaker at a banquet, and he had been asked to introduce her. They had agreed upon a time for him to escort her to the hall, and, answering his knock, purse in hand, she walked with him to the elevator.

As they descended, she realized she had forgotten her name tag. He tried to assure her that she needn't worry about it ("Miss Welty, *everyone* will know who you are"). But she fixed him with an intense look and said firmly but politely that, no, she

simply must return to her room to get it. And they did. Even though her tall, Eleanor-Roosevelt-like bearing would have been instantly recognizable to everyone in attendance that evening, she chose not to see herself as a literary celebrity.

She wrote fanciful, mythic fairy tales like *The Robber Bridegroom*, and occasionally she set her fiction beyond the boundaries of Mississippi (stories in *The Bride of Innisfallen* take place on a train in England and in New Orleans). But her best-loved writings are domestic, usually bounded by the branches of a family tree. A wedding, a family reunion, and a death in the family (*Delta Wedding, Losing Battles*, and *The Optimist's Daughter*) are the putative stories told, but Miss Welty's books are less about telling stories than about revealing the way her characters experience them.

She wrote in a comic vein in *The Ponder Heart*; *The Optimist's Daughter* is essentially tragic. In *Losing Battles* and *Delta Wedding* she created families that perform for her as orchestras do, with passages featuring the men, the girls, the women, the children playing independently, yet as part of a seamless whole. As she conducts them, the disparate players work as an ensemble to produce the single, rich oral composition that is her story. She mastered the art of overlapping dialogue decades before Robert Altman made it a cinematic staple with *Nashville* and other movies in the 1970s.

Whatever their differences, all of her books are about acts of love and their consequences. In *Delta Wedding*, George saves the life of an idiot child, endangering his own and threatening the balance of his family; Jack instructs his wife in *Losing Battles*, "Don't give anybody up . . . or leave anybody out. . . . There's room for everything, and time for everybody." Uncle Daniel in *The Ponder Heart* is forever giving things away, while Laurel Hand returns in *The Optimist's Daughter* to the South to nurse her father, only to find herself unwelcome. The stories are indeed about relationships between individuals, within families, and within a broader, but never too broad, community.

Eudora Welty was a writer who saw herself as a "privileged observer," one who by temperament "became the loving kind." With astonishing economy, she wrote about what she knew. She understood that memory, as she put it, "was attached to seeing, that love had added itself to discovery." Like her narrator, Edna Earle, in *The Ponder Heart*, she was wary of "straying too far from where you're known," and she never did. If her personal universe had, by some mix of family obligation and personal choice, remained limited, it was nevertheless encompassing and embracing.

⋐ ⋑

EUDORA WELTY

As Miss Welty told a Harvard University audience in April 1983 in the last of a series of lectures later published as *One Writer's Beginnings*, "As you have seen, I am a writer who came of a sheltered life. A sheltered life can be a daring life as well. For all serious daring starts from within."

Books by Eudora Welty

A Curtain of Green. Garden City, New York: Doubleday, Doran, 1941.
The Robber Bridegroom. Garden City, New York: Doubleday, Doran, 1942.
The Wide Net and Other Stories. New York: Harcourt, Brace and Company, 1943.
Delta Wedding. New York: Harcourt, Brace and Company, 1946.
The Golden Apples. New York: Harcourt, Brace and Company, 1949.
The Ponder Heart. New York: Harcourt, Brace and Company, 1954.
The Bride of Innisfallen and Other Stories. New York: Harcourt, Brace and Company, 1955.
Losing Battles. New York: Random House, 1970.
The Optimist's Daughter. New York: Random House, 1972.
The Collected Stories of Eudora Welty. New York: Harcourt, Brace and Company, 1980.
One Writer's Beginnings. Cambridge: Harvard University Press, 1984.

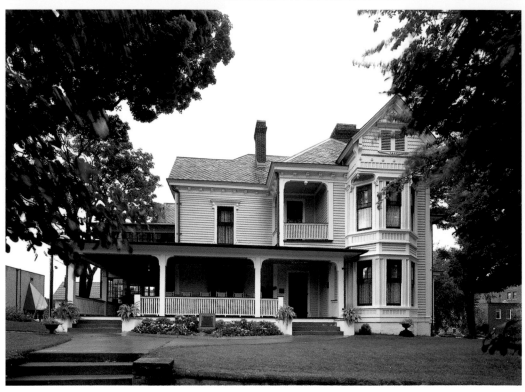

The boarding house that Tom Wolfe knew as a boy and the setting for much of
Look Homeward, Angel.

Right: Thomas and Julia Wolfe on the porch at the Old Kentucky Home.
Photo credit: Pack memorial Library.

Dixieland
THOMAS WOLFE
(1900 – 1938)
Asheville, North Carolina

"In the old house I feel beneath my tread the creak of the old stair, the worn rail, the whitewashed walls, the feel of darkness, and the house asleep, and think, 'I was a child here; here the stairs, and here was darkness; this was I, and here is Time.'"

From "Return," in the _Asheville Citizen_ (1937)

Too often readers seek correlations. Writers are always bemoaning their audience's refusal to distinguish their lives from the work. In the case of Thomas Wolfe, however, biography and art simply cannot be separated.

If every writer looks inward for inspiration and understanding, Wolfe turned himself inside out for all to see. His first book, _Look Homeward, Angel_, is a prototypical American _Bildungsroman_, a novel of formation with Wolfe's alter ego, Eugene Gant, at its core. The book chronicles Gant's birth, youth, and eventual departure for a life beyond the hills that surround his hometown. The story, Gant's family, the neighbors and townspeople, and almost all the factual particulars can be traced back to Wolfe's own childhood in Asheville, North Carolina, a town renamed Altamont in the book.

The parallels include vocational details. Like the author's own father W. O. (William Oliver) Wolfe, W. O. Gant works as a stonecutter; like Julia Wolfe, Eugene's mother runs a boardinghouse. On a sojourn in St. Louis for the 1904 World's Fair, a brother dies of typhoid (in life, as in _Look Homeward, Angel_, the deceased brother was named Grover). The parallels are innumerable.

❧ ❧

In Asheville, Julia Wolfe's boardinghouse bore the name "Old Kentucky Home," but to Eugene Gant and the generations of readers who have identified with his passions and his rite of passage, the place will always be "Dixieland." The house, preserved today as the Thomas Wolfe Memorial, stands as the most tangible symbol of the interconnectedness between Wolfe's life and his first and most-admired book, a work he described not as a novel but as "a book made out of my life."

ASHEVILLE'S SETTING ESTABLISHED ITS DESTINY. Looking east, one sees the Blue Ridge; over the shoulder loom the Great Smoky Mountains. Shadowed in between the rolling hills and valleys lies Asheville itself, at the very heart of the Appalachian chain.

The mountain city of Asheville (its altitude is some two thousand feet above sea level) became a gateway to the American frontier in the early nineteenth century. The paths made by late-eighteenth-century arrivals gave way to roads, among them a plank road that connected Asheville to Greenville, Tennessee, in 1851. Word of Asheville's dramatic beauty soon got around and "The Land of the Sky," as it was dubbed, became a vacation destination for wealthy visitors. The traffic to the emerging resort town increased dramatically with the arrival of the railroad in 1880.

One visitor who arrived by train was George W. Vanderbilt. A grandson of the immensely wealthy railroad and steamship magnate Cornelius Vanderbilt, he determined to create his own personal fiefdom in Asheville. To fulfill his vision he hired Richard Morris Hunt, the most fashionable of New York architects, who designed a 255-room mansion in the French Château style. To surround it, the founding father of American landscape design, Frederick Law Olmsted, created a mix of timberland and pleasure park on the 125,000 acres Vanderbilt acquired. The presence of the estate, which Vanderbilt named Biltmore, added to Asheville's air of elegance and prosperity. The early years of the twentieth century saw the construction of an opera house, banks, churches, and numerous hotels to serve the many visitors. People unable to

Right top: The porch overlooking Woodfin Street in Asheville, North Carolina.

Right bottom: There were beds — often more than one to a room — all over Julia Wolfe's house, even on its enclosed porches. Each room also had a chamber pot and a washstand.

THOMAS WOLFE

᪥

271

THOMAS WOLFE

afford the more luxurious accommodations could find a bed and two meals for $1.00 a day at the likes of the Old Kentucky Home.

The history of the Wolfe house, at 48 Spruce Street, parallels the larger history of Asheville. A prosperous Asheville banker built the house in 1883, just as the city's boom got under way. Constructed in the Queen Anne style, the two-story wood-framed home contained six rooms lit by tall windows. That great fixture of Victorian life, the porch, lined the front. As the citywide boom gained momentum, a major addition more than doubled the size of the original house, creating the larger home that Julia Wolfe purchased in 1906. Thomas Wolfe would describe it in *Look Homeward, Angel* as "a big, cheaply constructed frame house of eighteen or twenty drafty high-ceilinged rooms; it had a rambling, unplanned, gabular appearance, and was painted a dirty yellow."

Ten years after moving in, Julia Wolfe added eleven more rooms along with electricity and modern plumbing. The business prospered — as many as twenty-eight guests per night could be accommodated — and over the next twenty years Julia Wolfe used her profits to purchase perhaps a hundred different pieces of property in and around Asheville and as far away as Florida. She had the means to underwrite her son's education at Harvard and a year in Europe. Eventually Julia's luck turned, and with the crash of 1929 and the Depression years that followed, the good times for Asheville and Julia Wolfe ended. Thanks only to the generosity of others was she able to avoid losing the Old Kentucky Home.

By then Asheville and Julia Wolfe had been made famous by her son's books. Not that their notoriety was welcome. When *Look Homeward, Angel* appeared in 1929, the *Asheville Times* reviewer observed, "Any resident of Asheville who knew this city and its people during the period 1900 and 1920 will not have the slightest trouble in filling in the names of the real persons whom Wolfe made characters in his book . . .

Left top: Boarders had the run of the place, including this sunny space, the so-called sun parlor.

Left bottom: The atmosphere is not that of a family house, especially here in the restaurant-like dining room where there was a bell on each table.

[and] most of the Asheville people who appear in the novel wear their most unpleasant guises." One Ashevillian prepared a *dramatis personae* that decoded the book, identifying which citizens appeared as which of the two-hundred-odd fictional characters in the novel. Tempers were running so high that the librarian at the Pack Memorial Public Library elected not to add *Look Homeward, Angel* to its collections. Local legend claims that no less a personage than F. Scott Fitzgerald, by then a friend of Wolfe, corrected the omission six years later. When Fitzgerald learned the library listed no copies of the book in its catalog, he purchased two at a nearby bookstore and personally presented them.

As its most famous citizen, Thomas Wolfe helped define his hometown in his fictions. Yet the reverse is equally true. The mountains encircling the town contained the world Wolfe knew until, feeling a claustrophobic need to escape, he left for college. He would spend the rest of his short life contemplating his paradoxical relationship with the place.

THOMAS CLAYTON WOLFE ARRIVED WITH the century, the eighth child born to Julia and W. O. Wolfe. He spent the first six years of his life on Woodfin Street, but the "home" Wolfe would memorialize in his fiction was his mother's boardinghouse. Julia and Tom, the baby of the family, moved there in 1906, leaving W.O. and the other children back on Woodfin Street.

The reasons for the division in the family included the unexpected death of Thomas's brother, Grover, in 1904. "I could have given up any child I had," Julia told a Wolfe biographer many years later, "and it could not have hurt any worse." She had already lost her firstborn to cholera. Her husband's periodic alcoholic binges showed no sign of ending; his rheumatism, the wear-and-tear result of years of working stone, made the difficult man even more so. With marriage a continuing trial, Julia wanted to be independent and envisioned the boardinghouse as providing financial security for her family. Although he co-signed the mortgage, W.O. refused for many years to move to the Old Kentucky Home.

Readers of Wolfe's books know the intimate details of Wolfe's childhood. He never had a room of his own in his mother's boardinghouse. At times he shared his mother's tiny room off the kitchen, but he also found himself shifted from guest room

❦

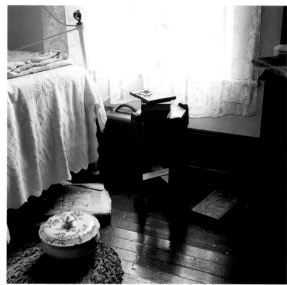

Julia Wolfe's tiny bedroom, where she — and, at times, her youngest child, Tom — slept.

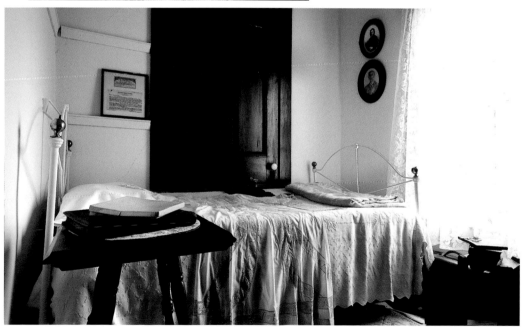

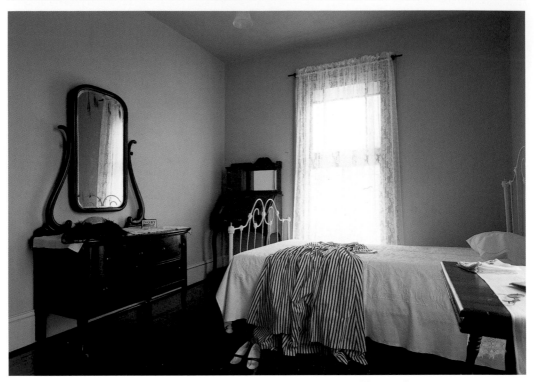

He saw his father die in one bedroom, a brother in another. Yet the Old Kentucky Home was an impersonal place for Thomas Wolfe, one he often shared with two dozen strangers. Today it looks as it did circa 1916.

❦

THOMAS WOLFE

to guest room depending upon the number of boarders. Wrote Wolfe in *Look Homeward, Angel*, life in the house had "all the comforts of the Modern Jail."

Perhaps the luckiest turn of events in his youth was the direct result of one of his first compositions. He entered a competition to gain admission to the North State Fitting School. Upon reading his essay, the headmaster's wife is said to have exclaimed, "This boy, Tom Wolfe, is a genius! And I want him for our school next year." Wolfe recalled the four years he spent under the tutelage of Mrs. Margaret Roberts as "the happiest and most valuable years of my life." She guided his reading of Shakespeare, the Bible, and the Romantic poets. He studied Greek, Latin, and German, as well as history and mathematics. He stammered, but even so won success as a tenacious debater.

He enrolled at the University of North Carolina, in Chapel Hill, a few weeks before his sixteenth birthday. His poetry appeared regularly in the college literary magazine, and he became editor of the student paper. He began writing plays, too, which led to his decision to pursue graduate studies at Harvard's famous 47 Workshop directed by George Pierce Baker. After earning his master's degree he took a job teaching in New York. He summered in Europe in 1925 and, on the sea voyage home, met Aline Bernstein, a set designer nineteen years his senior. Though married, she would become his mistress, patron, and a guiding creative force. Their conversations led Thomas Wolfe, dramatist, to recast himself as Thomas Wolfe, novelist. By the spring of 1928, he had completed the eleven-hundred-page draft manuscript of *O Lost*, the book that became *Look Homeward, Angel*.

THOUGH HE DIED UNEXPECTEDLY OF pneumonia just short of his thirty-eighth birthday, Thomas Wolfe looms large in the story of American letters. In a literal sense, he seemed larger than life, standing six-feet, six-inches tall, his shoulders broad, the bulky cloth of the dark suits he favored adding to his hulking presence. His books, too, tended to be massive. Even after his first editor, the redoubtable Maxwell Perkins at Charles Scribner's Sons, persuaded Wolfe to set aside the original second half of the further adventures of Eugene Gant, the book published as *Of Time and the River* was roughly triple the length of the average novel. His last editor, Edward Aswell at Harper & Brothers, inherited a manuscript so unwieldy that it was stored in packing crates. That

manuscript became *three* posthumous books, the novels *The Web and the Rock* and *You Can't Go Home Again*, and the stories collected in *The Hills Beyond.* Those books recount the story of a new protagonist, George Webber, a man physically smaller than Eugene Gant but temperamentally very much of a piece with his creator.

Thomas Wolfe talked as he wrote, in an outpouring of poetic passion and personal detail. A journalist who interviewed him in 1935 wrote of Wolfe, "Words stream from him as though he were impatient of having to use them to transmit his thought. He stutters a bit in the urgency to say a lot quickly He never speaks in a didactic manner. He makes no pretensions to great wisdom. He is simply without inhibitions."

His size made traditional desks uncomfortable, so he often wrote standing up, at times employing the top of his refrigerator as his writing surface. He was known to settle down to write at midnight and work until daybreak. He once tried writing on a typewriter; the experiment soon proved a failure, as he found his words outpaced his hunt-and-peck skills at the keyboard.

For seven years after the publication of *Look Homeward, Angel* Wolfe didn't return to Asheville. When he did, the editor asked him to write an article for the *Asheville Citizen*. In it he made no apologies. "I have come back now," he wrote. "I have come home again, and there is nothing more that I can say. All arguments are ended: saying nothing, all is said then; all is known: I am home."

The town embraced him, save for a few individuals who remained embittered over their fictional portrayals. In time, even a cameo appearance in Wolfe's fiction came to be regarded as a badge of honor, and those who had been included became envied by other long-time residents who had not been so honored.

THOMAS WOLFE DIED IN 1938, and Julia Wolfe remained in the Old Kentucky Home until her death in 1945. Four years later, Thomas's three surviving siblings sold the house to the newly founded Thomas Wolfe Memorial Foundation, and in July 1949 the house opened as a museum. Later the city of Asheville and eventually the state of North Carolina acquired the property, and today the house operates under the aegis of the North Carolina Department of Cultural Resources.

Unlike many historic homes, the house the caretakers inherited was largely intact. Little spare cash had been at hand after Julia Wolfe's fortunes declined, so the

THOMAS WOLFE

house remained much as Wolfe had known it, its furnishings, decorations, and other contents changing little. An arsonist did extensive damage to the dining room and some of the artifacts in 1998, but in the aftermath of the fire, the restorers cleared away literal and metaphorical cobwebs. When the house reopened in 2004, a series of considered and careful decisions had turned the clock back to 1916.

Today, the Thomas Wolfe house, like the man himself, is an enormous, sprawling place. On the second floor is the bedroom where Wolfe's brother Benjamin Harrison Wolfe died in the influenza epidemic of 1918. Eight years older than Thomas, he had been an avuncular presence in Tom's life and would reappear as a haunting presence in *Look Homeward, Angel*. A boarder's bedroom downstairs was the site of W.O.'s death, in life as it was in *Of Time and the River*.

The dining room establishes the tone. The feel is not of a home but a restaurant. There are separate tables; this is not a place where a family met to rehash the events of the day, laughing and arguing and teasing one another. There is distance here. It is a space for strangers and isolation — no sense of intimacy. One can understand the feelings of the displaced boy who found himself in this house while his father and siblings remained in his birthplace a few blocks away. It's little wonder that Eugene Gant would remark, "I was without a home — a vagabond since I was seven — with two roofs and no home."

Wolfe re-created this house in the pages of his books. Visitors today looking at the dreary sequence of rooms once inhabited by a nameless series of transients, the spaces dimly illuminated by daylight filtered through lace curtains, can imagine they are peering through the scrim of Wolfe's fiction.

Books by Thomas Wolfe

Look Homeward, Angel. New York: Charles Scribner's Sons, 1929.
Of Time and the River. New York: Charles Scribner's Sons, 1935.
From Death to Morning. New York: Charles Scribner's Sons, 1935.
The Web and the Rock. New York: Harper & Brothers, 1939.
You Can't Go Home Again. New York: Harper & Brothers, 1940.
The Hills Beyond. New York: Harper & Brothers, 1941.

ACKNOWLEDGMENTS

FIRST WE MUST THANK the living writers who welcomed us into their homes, they being James Lee Burke and his wife, Pearl; John Casey; Pat Conroy and Cassandra King; Shelby Foote; Allan Gurganus; Barry Hannah and his wife, Susan; Carl Hiaasen and his wife, Fenia; Josephine Humphreys and her husband, Tom Hutcheson; Jan Karon; Ann Patchett; Eleanor Ross Taylor; and Christopher Tilghman. These patient people took time from their lives to answer questions, pose for pictures, and talk of the connectedness between their personal places and their work.

Next we extend our appreciation to the caretakers — namely, the people charged with restoring, maintaining, and explaining the writers' homes that have become museums. Our thanks, then, to Amanda Chenault at the Kate Chopin House, and to Ada D. Jarred, president of the Association for the Preservation of Historic Natchitoches; William D. Griffith, curator and collections manager at Rowan Oak, a property of the University of Mississippi, and his associate, Brooke Coward; Marshall Thomas at Wren's Nest, the Joel Chandler Harris Home; Linda Mendez and Joe Buggy at the Hemingway Home and Museum; Mrs. N.Y. Nathiri, director of the Zora Neale Hurston National Museum of Fine Arts; Anne Nettles, communications manager at the Margaret Mitchell House and Museum; Craig R. Amason, executive director of the Flannery O'Connor-Andalusia Foundation, Inc.; Ranger Sheila Barnes at the Marjorie Kinnan Rawlings Historic State Park; Mary Alice Welty White, director of the Welty House, a property of the Mississippi Department of Archives and History; and Steve Hill, historic site manager at the Thomas Wolfe Memorial, a property of the North Carolina Department of Cultural Resources. All these people took time from their busy schedules to explicate the sites to which they have devoted so much time and commitment.

While the works of the writers, the writers themselves, and the various site managers provided most of the stories, facts, and other information in these chapters, in some instances published biographies also proved to be important sources. The key ones were *Faulkner: A Biography* by Joseph Blotner (New York: Random House, 1974); *Ernest Hemingway: A Life Story* by Carlos Baker (New York: Charles Scribner's Sons, 1969); *Papa: Hemingway in Key West* by James McLendon (Miami: E. A. Seemann Publishing, Inc., 1972); *Wrapped in Rainbows: The Life of Zora Neale Hurston* by Valeria Boyd (New York: Scribner, 2003); *Zora Neale Hurston: A Literary Biography* by Robert E. Hemenway (Urbana: University of Illinois Press, 1977); *In Search of Our Mothers' Gardens* by Alice Walker (San Diego: Harcourt, Brace, Jovanovich, Publishers, 1983); *Southern*

❧ ❧

Daughter: The Life of Margaret Mitchell by Darden Asbury Pyron (New York: Oxford University Press, 1991); *Flannery O'Connor: A Life* by Jean W. Cash (Knoxville: University of Tennessee Press, 2002); "From Agrarian Homestead to Literary Landscape" by Craig R. Amason (*Flannery O'Connor Review*, Vol. 2, 2003-04); *Marjorie Kinnan Rawlings: Sojourner at Cross Creek* by Elizabeth Silverthorne (Woodstock, New York: The Overlook Press, 1988); *Look Homeward: A Life of Thomas Wolfe* by David Herbert Donald (Boston: Little, Brown & Company, 1987); and Ted Mitchell's monograph, *Thomas Wolfe: A Writer's Life* (Raleigh: North Carolina Department of Cultural Resources, 1999).

Others made important contributions, as well. Our literary agent, Gail Hochman, brought to bear her passion, skills, and, especially in the early stages, her networking; thanks, too, to Joanne Brownstein at Brandt & Hochman for help in getting the book launched. At Rizzoli, publisher Charles Miers, editor Jane Newman, and their colleague David Morton were all present at the creation and have seen this book through with patience and enthusiasm. For their expert editorial guidance, the writer is indebted to Jean Atcheson and Kathleen Moloney, thoughtful readers, careful stylists, and grammar mavens; and for their expertise in telling the world about this book, our appreciation to Beth Meszaros, Lynn Goldberg, Pam Sommers, and Camille McDuffie. Thanks, too, to those who helped us reach out to the writers, few of whom we knew at the beginning. Their number includes Dominick Abel; Sue Anderson; Sylvan Barnet; John and Judy Coyne; Liz Dahrenzoff; the late Guy Davenport; Janis Donnaud; James Fox; Jonathan Galassi; Peter Gethers; Phyllis Grann; Maxine Groffsky; Trish Hoard; Maarten Kooij; Ronald W. Miller; Wayne Mogelnicki; Jane Moore; Sherri Scott; Jack Shoemaker; Phillip Spitzer; Amanda Urban; Alice and Susan Lawrence Volkmar; Lynn Waggoner; and Robert Weil.

Finally, our love and thanks for their patience during our numerous expeditions to the South, to Betsy and Doris, editor and designer, respectively, and spouses both.

Visitor Information

Although most of the sites in this book remain private homes, nine are museums open to the public. Phone or Web inquiries in advance of any visit are recommended.

Kate Chopin House

Owner or Administrator: Association for the Preservation of Historic Natchitoches
Mailing Address: 243 Highway 495, Cloutierville, Louisiana 71416
Web Address: http://www.natchitoches.net/melrose/chopin.htm
Phone: (318) 379-2233
Hours: Open Monday through Saturday, 10:00 A.M. to 5:00 P.M.; Sunday, 1:00 P.M. to 5:00 P.M.

William Faulkner's Rowan Oak

Owner or Administrator: The University of Mississippi
Address: Old Taylor Road, Oxford, Mississippi 38655
Web Address: http://www.mcsr.olemiss.edu/~egjbp/faulkner/rowanoak.html
Phone: (662) 234-3284
Hours: Open Monday through Saturday, 10:00 A.M. to 4:00 P.M.; Sunday, 1:00 P.M. to 4:00 P.M.

Ernest Hemingway Home

Owner or Administrator: The Ernest Hemingway Home and Museum
Address: 907 Whitehead Street, Key West, Florida 33040
Web Address: http://www.hemingwayhome.com
Hours: Open daily, 9:00 A.M. to 5:00 P.M.

Zora Neale Hurston's Eatonville

Note: The principal site is not a dwelling but a museum. It is located in a converted commercial building in Hurston's hometown of Eatonville and has rotating exhibits of contemporary African-American artists.
Owner or Administrator: Zora Neale Hurston National Museum of Fine Arts
Mailing Address: 227 East Kennedy Boulevard, Eatonville, Florida 32751
Phone: (407) 647-3307
Hours: Open Monday through Friday, 9:00 A.M. to 4:00 P.M.; Saturday, 2:00 P.M. to 5:00 P.M.

THE MARGARET MITCHELL HOUSE AND MUSEUM
Owner or Administrator: Atlanta History Center
Mailing Address: 990 Peachtree Street, Atlanta, Georgia 30309
Web Address: http://www.gwtw.org
Phone: (404) 249-7015
Hours: Open daily, 9:30 A.M. to 5:00 P.M.

FLANNERY O'CONNOR'S ANDALUSIA
Owner or Administrator: The Flannery O'Connor – Andalusia Foundation, Inc.
Mailing Address: Post Office Box 947, Milledgeville, Georgia 31059
Web Address: http://www.andalusiafarm.org
Phone: (478) 454-4029
Hours: Open Monday, Tuesday, and Saturday, 10:00 A.M. to 4:00 P.M.

MARJORIE KINNAN RAWLINGS HISTORIC STATE PARK
Owner or Administrator: Florida Division of Recreation and Parks
Mailing Address: 18700 South Country Road 325, Cross Creek, Florida 32640
Web Address: http://www.floridastateparks.org/marjoriekinnanrawlings
Phone: (352) 466-3672
Hours: Open Thursday through Sunday, 10:00 A.M. to 4:00 P.M, October through July.

THE EUDORA WELTY HOUSE
Owner or Administrator: The Mississippi Department of Archives and History
Mailing Address: 1119 Pinehurst Street, Jackson, Mississippi 28202
Web Address: http://www.eudorawelty.org
Phone: (601) 353-7762
Hours: Garden open 10:00 A.M. to 2:00 P.M., tours on the half-hour, March through October. The house, which is in mid-restoration, is scheduled to open for public tours in April 2006.

THOMAS WOLFE MEMORIAL
Owner or Administrator: North Carolina Department of Cultural Resources
Mailing Address: 52 North Market Street, Asheville, North Carolina 28801
Web Address: http://www.wolfememorial.com
Phone: (828) 253-8304
Hours: Open Tuesday through Saturday, 9:00 A.M. to 5:00 P.M., and Sunday, 1:00 P.M. to 5:00 P.M., April through October; and Tuesday through Saturday, 10:00 A.M. to 4:00 P.M., and Sunday, 1:00 P.M. to 4:00 P.M., November through March.

INDEX

Page references in **boldface** indicate the page number of an illustration or its caption.

⊰ ⊱

INDEX